SCHIRMER'S LIBRARY
OF MUSICAL CLASSICS

TWENTY-FOUR ITALIAN SONGS AND ARIAS

of the

Seventeenth and Eighteenth Centuries

FOR MEDIUM HIGH VOICE
Library Vol. 1722

→ FOR MEDIUM LOW VOICE
Library Vol. 1723

ISBN 978-0-7935-2554-6

G. SCHIRMER, Inc.

DISTRIBUTED BY

HAL•LEONARD
CORPORATION
7777 W. BLUEMOUND RD. P.O. BOX 13819 MILWAUKEE, WI 53213

CONTENTS

Per la gloria d'adorarvi
For the love my heart doth prize
from the opera "Griselda"

English version by
Dr. Theodore Baker

Giovanni Battista Bononcini
(1672-1750)

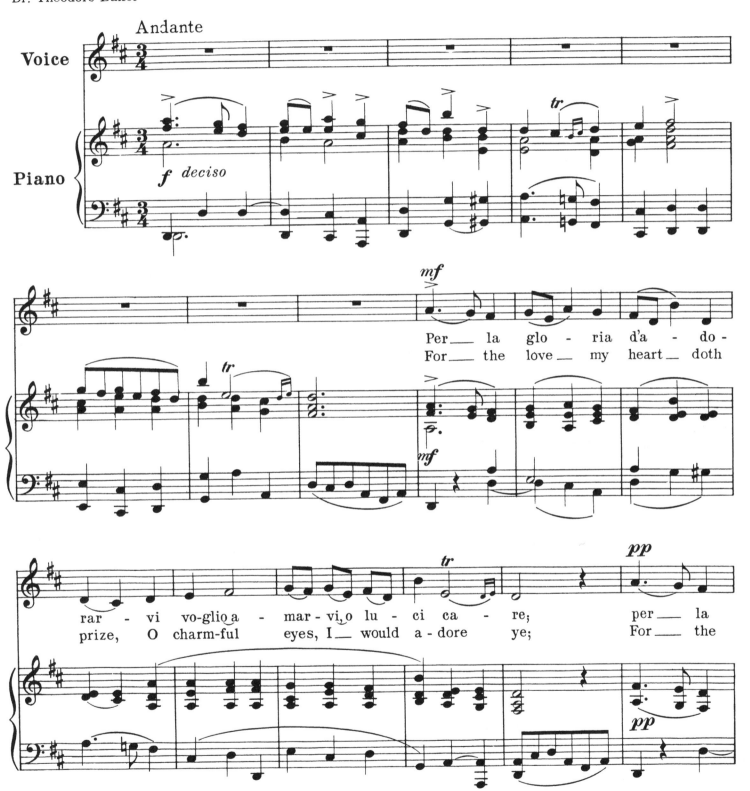

41573 rx

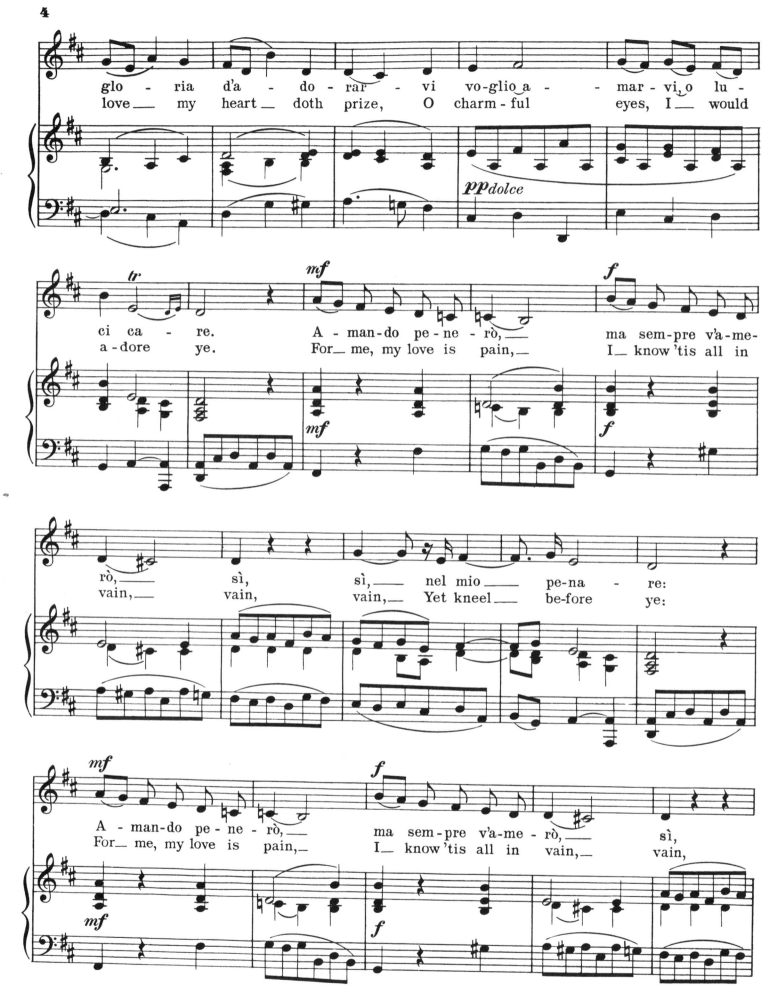

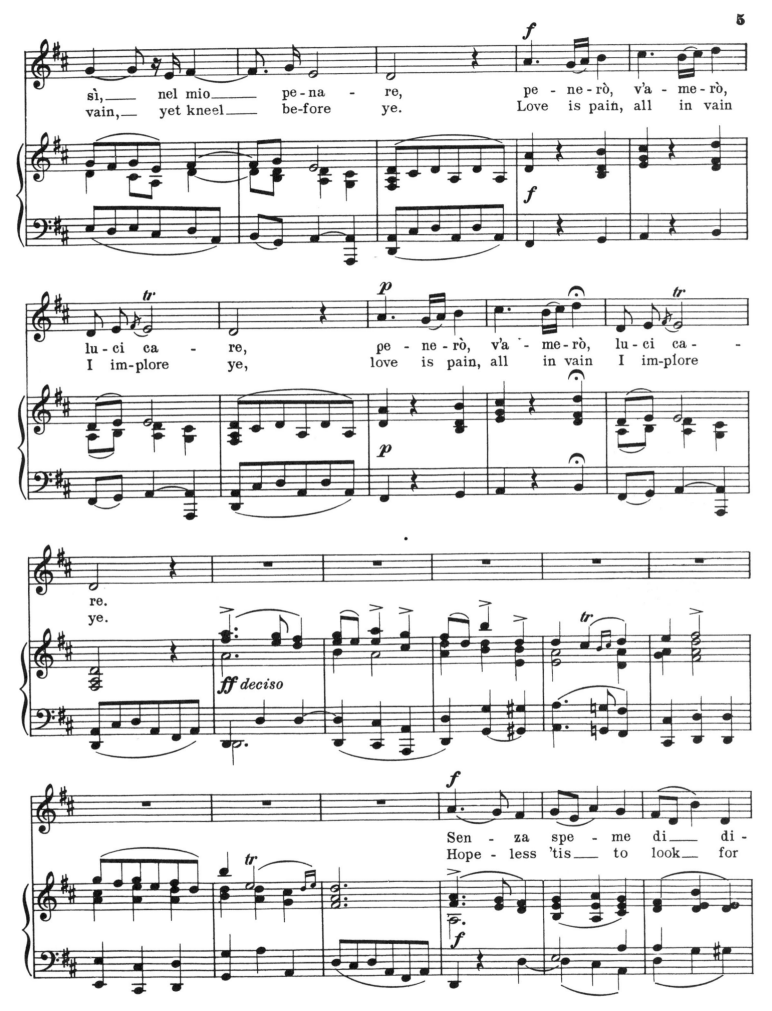

sì,___ nel mio___ pe-na - re, pe - ne - rò, v'a - me - rò,
vain,___ yet kneel___ be-fore ye. Love is pain, all in vain

lu - ci ca - re, pe - ne - rò, v'a - me - rò, lu - ci ca -
I im-plore ye, love is pain, all in vain I im-plore

re.
ye.

Sen - za spe - me di___ di -
Hope - less 'tis___ to look___ for

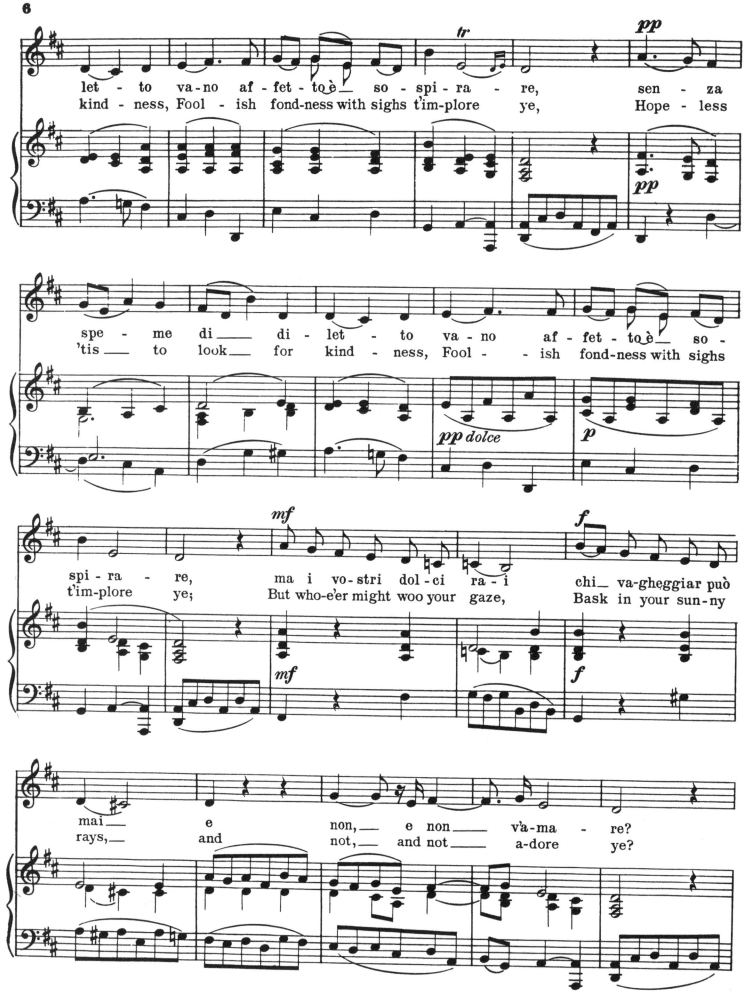

let - to va-no af -fet-to è_ so - spi - ra — re, sen - za
kind - ness, Fool - ish fond-ness with sighs t'im-plore ye, Hope - less

spe - me di __ di - let - to va - no af - fet - to è_ so -
'tis __ to look __ for kind — ness, Fool — -ish fond-ness with sighs

spi - ra - re, ma i vo-stri dol - ci ra - i chi_ va-gheggiar può
t'im-plore ye; But who-e'er might woo your gaze, Bask in your sun-ny

mai __ e non, __ e non __ v'a-ma - re?
rays, __ and not, __ and not __ a-dore ye?

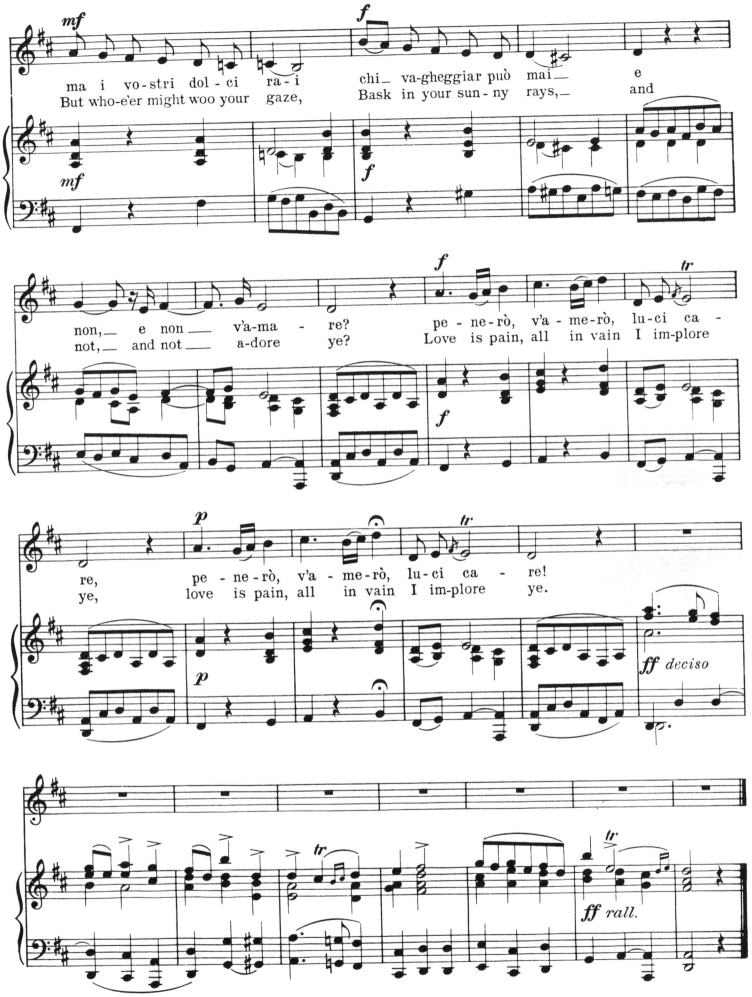

ma i vo-stri dol-ci ra-i chi_ va-gheggiar può mai_ e
But who-e'er might woo your gaze, Bask in your sun-ny rays,_ and

non,_ e non_ v'a-ma - re? pe - ne-rò, v'a - me-rò, lu-ci ca -
not,_ and not_ a-dore ye? Love is pain, all in vain I im-plore

re, pe - ne-rò, v'a - me-rò, lu-ci ca - re!
ye, love is pain, all in vain I im-plore ye.

Amarilli, mia bella

Amarilli, my fair one

Madrigal

English version by
Dr. Theodore Baker

Giulio Caccini
(1546-1618)

Moderato affettuoso

Voice

A - ma - ril - li, mia bel - la, non cre - di, o del mio
A - ma - ril - li, my fair one, Canst thou thine heart to

Piano

p dolcissimo e legato sempre

più f

cor dol - ce de - sì - o, d'es - ser tu ___
doubt e'er ___ sur - ren - der, Doubt of my love, ___

più f

___ l'a - mor mi - o? Cre - di - lo pur: e se ti
___ true and ten - der? Do but be - lieve, for should e'er

mf

mf

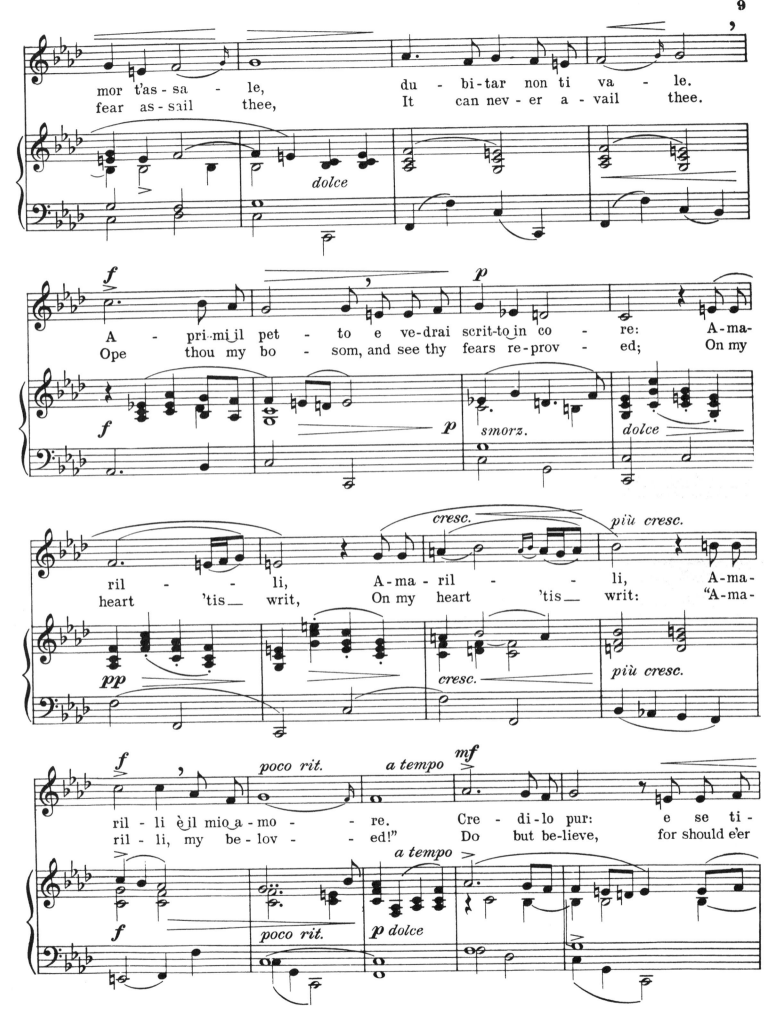

mor t'as - sa - le, du - bi-tar non ti va - le.
fear as-sail thee, It can nev - er a - vail thee.

A - pri-mi il pet - to e ve-drai scrit-to in co - re: A - ma-
Ope thou my bo - som, and see thy fears re-prov - ed; On my

dolce

f *p*

f *p* *smorz.* *dolce*

ril - li, A - ma - ril - li, A - ma-
heart 'tis — writ, On my heart 'tis — writ: "A - ma-

pp *cresc.* *più cresc.*

cresc. *più cresc.*

f *poco rit.* *a tempo* *mf*

ril - li è il mio a - mo - re. Cre - di-lo pur: e se ti
ril - li, my be - lov - ed!" Do but be-lieve, for should e'er

a tempo

f *poco rit.* *p dolce*

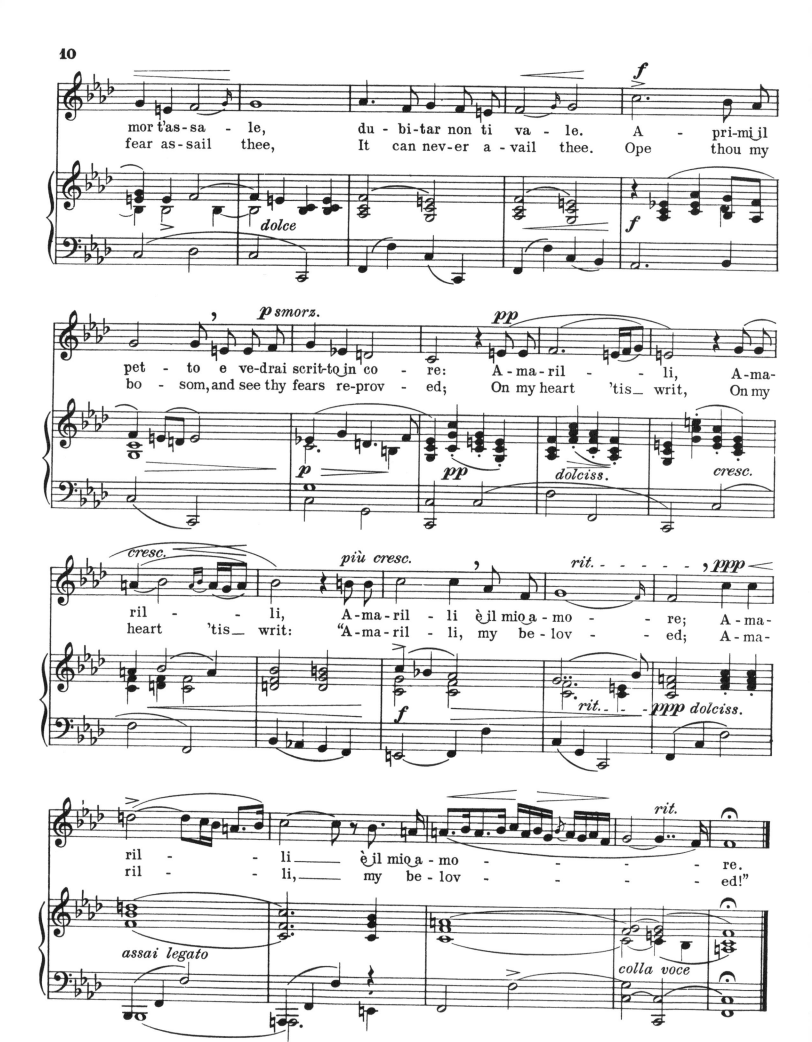

Alma del core
Fairest adored

English version by
Everett Helm

Antonio Caldara
(1670-1736)

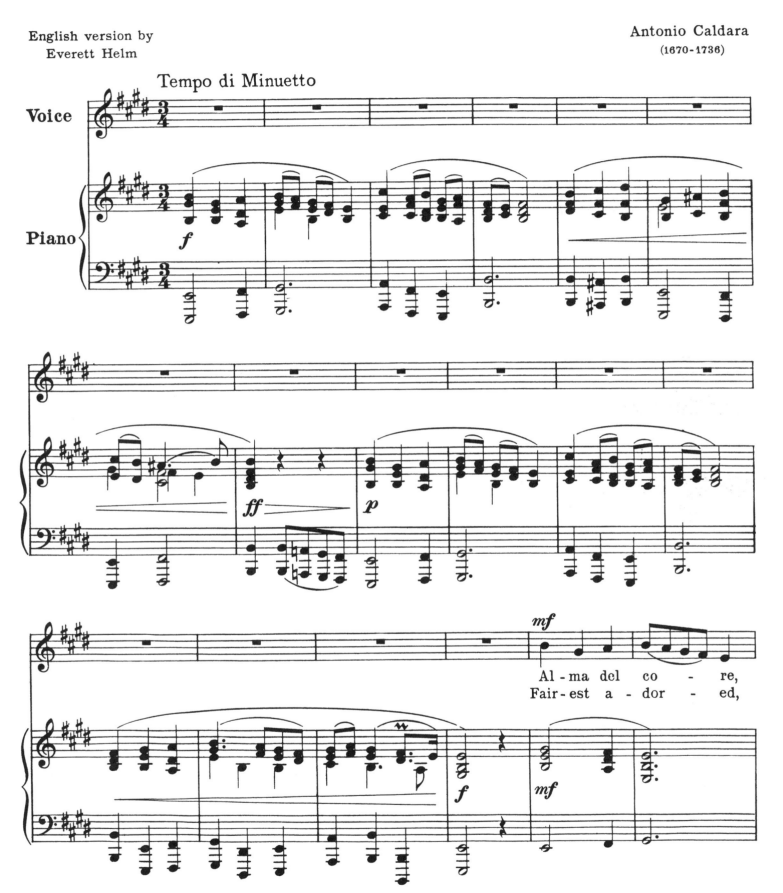

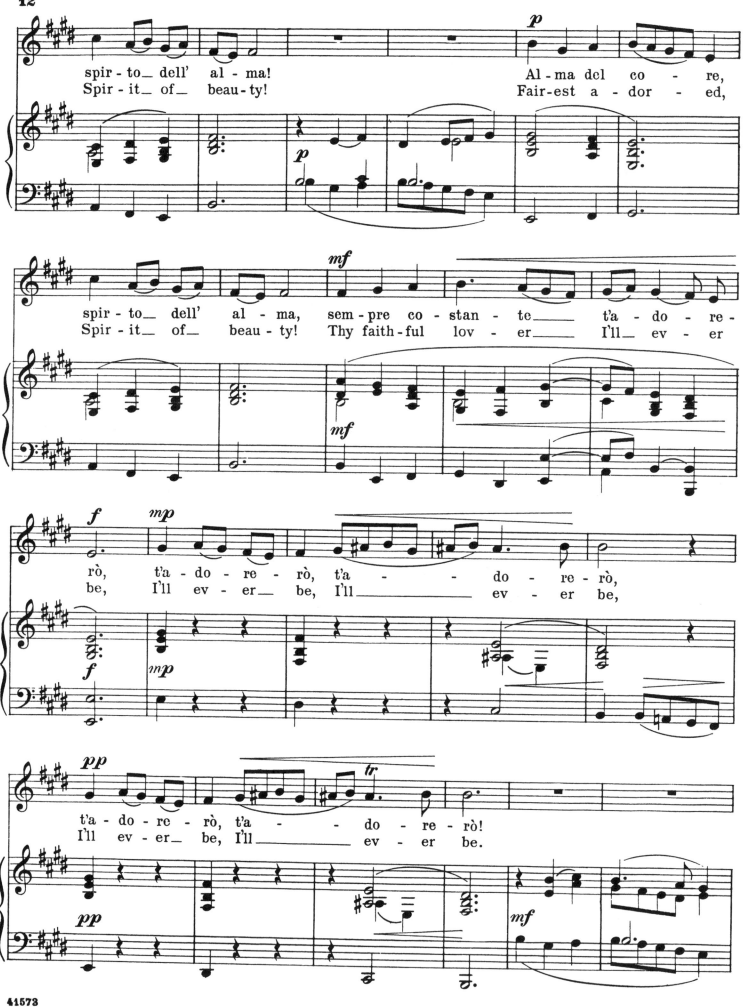

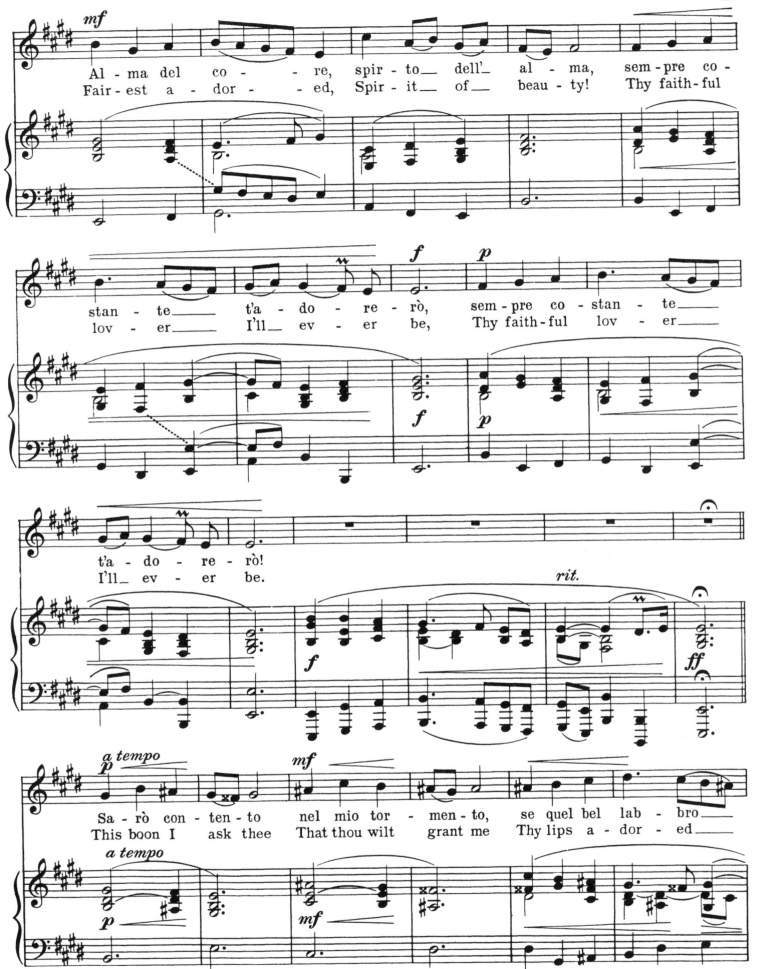

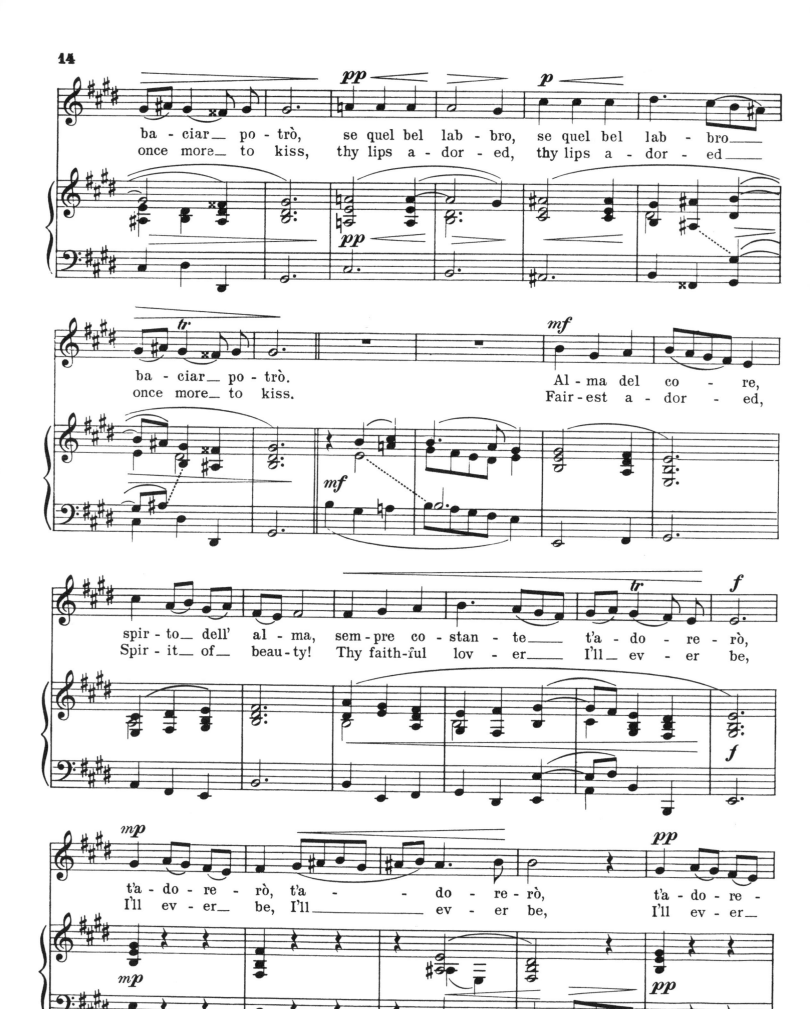

ba - ciar_ po - trò, se quel bel lab - bro, se quel bel lab - bro_
once more_ to kiss, thy lips a - dor - ed, thy lips a - dor - ed _

ba - ciar_ po - trò.
once more_ to kiss.

Al - ma del co - re,
Fair - est a - dor - ed,

spir - to_ dell' al - ma, sem - pre co - stan - te_ t'a - do - re - rò,
Spir - it_ of_ beau - ty! Thy faith-ful lov - er_ I'll_ ev - er be,

t'a - do - re - rò, t'a - do - re - rò,
I'll ev - er_ be, I'll_ ev - er be,

t'a - do - re -
I'll ev - er_

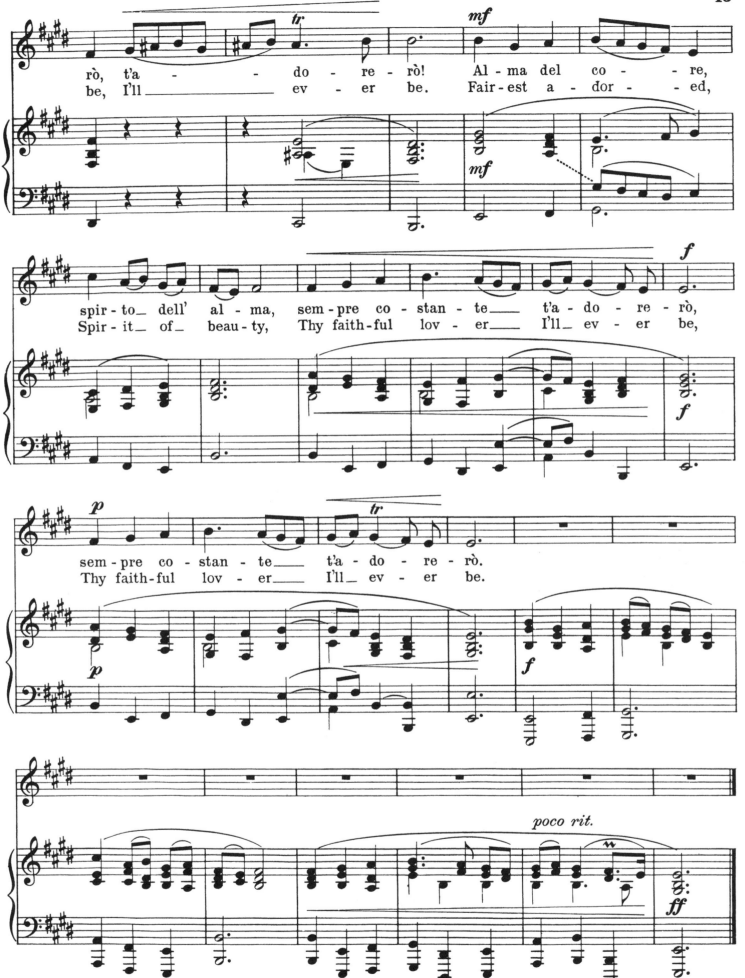

rò, t'a - - - do - re - rò! Al - ma del co - re,
be, I'll _____ ev - er be. Fair-est a - dor - - ed,

spir - to_ dell' al - ma, sem - pre co - stan - te___ t'a - do - re - rò,
Spir - it of_ beau - ty, Thy faith-ful lov - er___ I'll_ ev - er be,

sem - pre co - stan - te___ t'a - do - re - rò.
Thy faith-ful lov - er___ I'll_ ev - er be.

Come raggio di sol
As on the swelling wave
Aria

**English version by
Dr. Theodore Baker**

Antonio Caldara
(1670-1736)

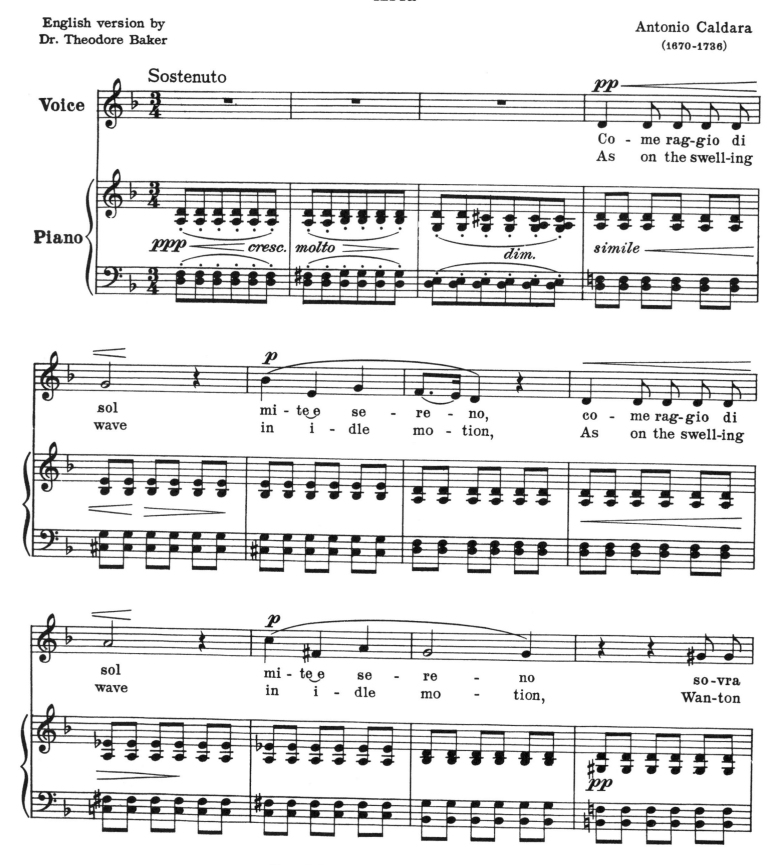

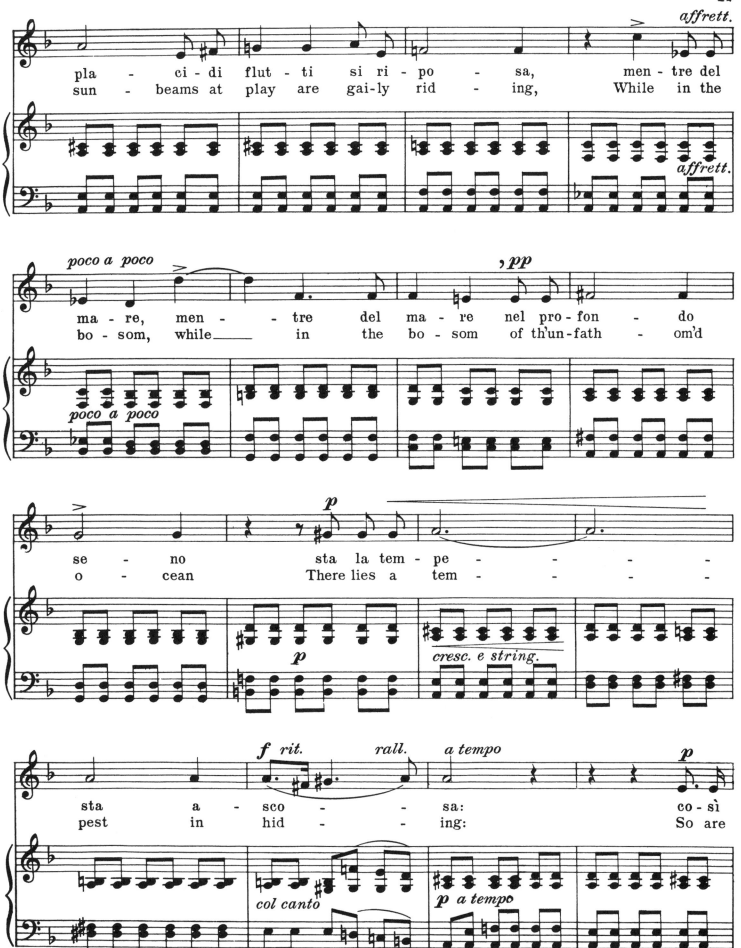

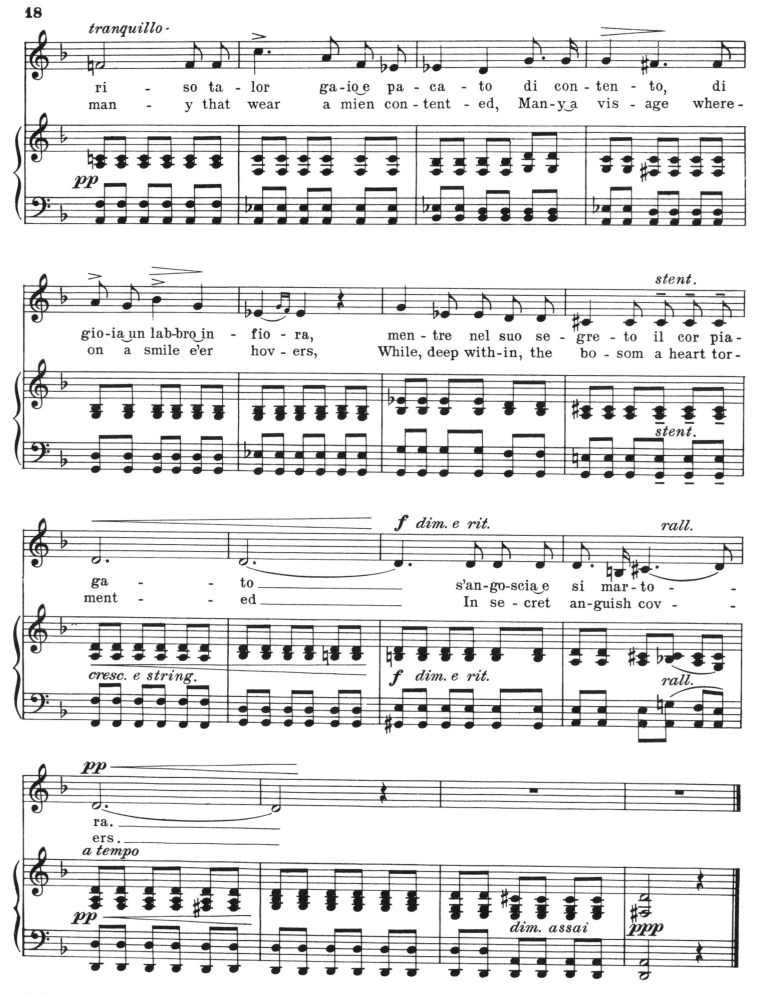

Sebben, crudele
Tho' not deserving
Canzonetta

English version by
Dr. Theodore Baker

Antonio Caldara
(1670-1736)

Seb - ben, cru - de - le, mi fai lan - guir,— sem - pre fe -
Tho' not de - serv - ing Thy cru - el scorn,— Ev - er un -

de - le, sem - pre fe - de - le ti vo - glio a - mar.
swerv - ing, ev - er un - swerv - ing Thee on - ly I— love.

Seb - ben, cru - de - le,
Tho' not de - serv - ing

41573

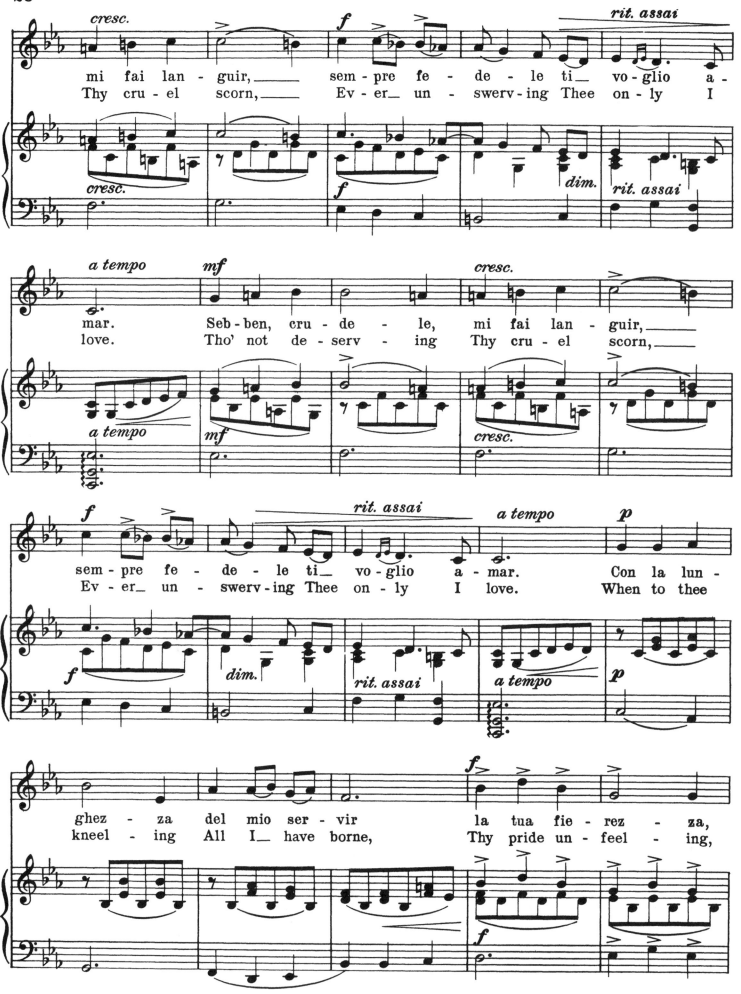

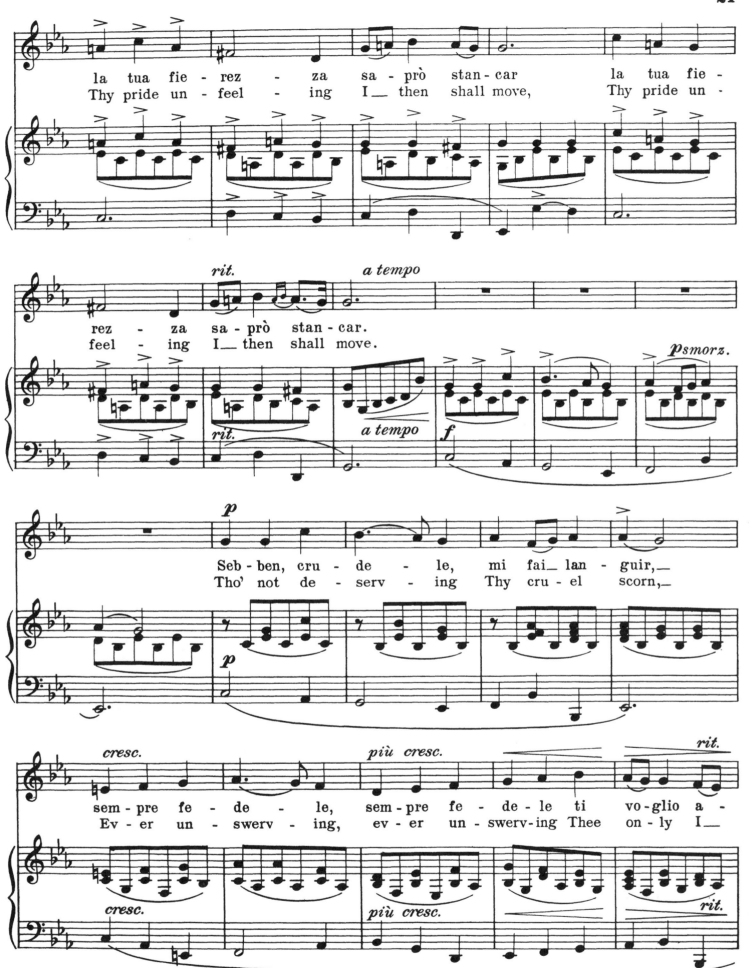

la tua fie - rez - za sa - prò stan - car la tua fie -
Thy pride un - feel - ing I __ then shall move, Thy pride un -

rez - za sa - prò stan - car.
feel - ing I __ then shall move.

Seb - ben, cru - de - le, mi fai lan - guir, __
Tho' not de - serv - ing Thy cru - el scorn, __

sem - pre fe - de - le, sem - pre fe - de - le ti vo - glio a -
Ev - er un - swerv - ing, ev - er un - swerv-ing Thee on - ly I __

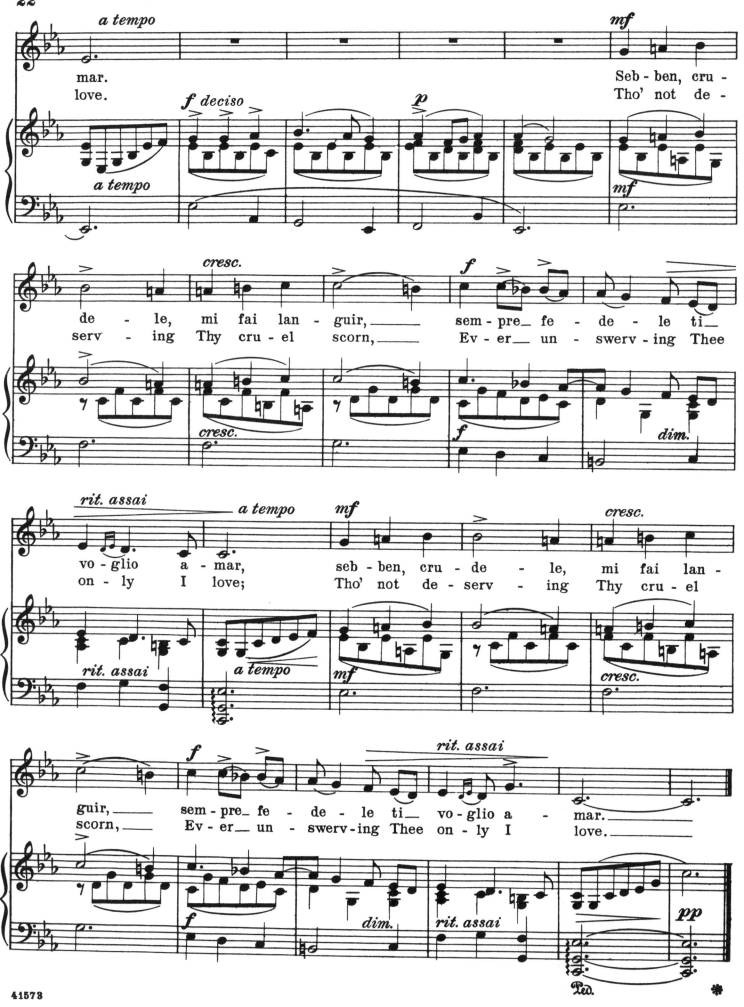

Vittoria, mio core!
Victorious my heart is!
Cantata

English version by
H. Millard

Giacomo Carissimi
(1605-1674)

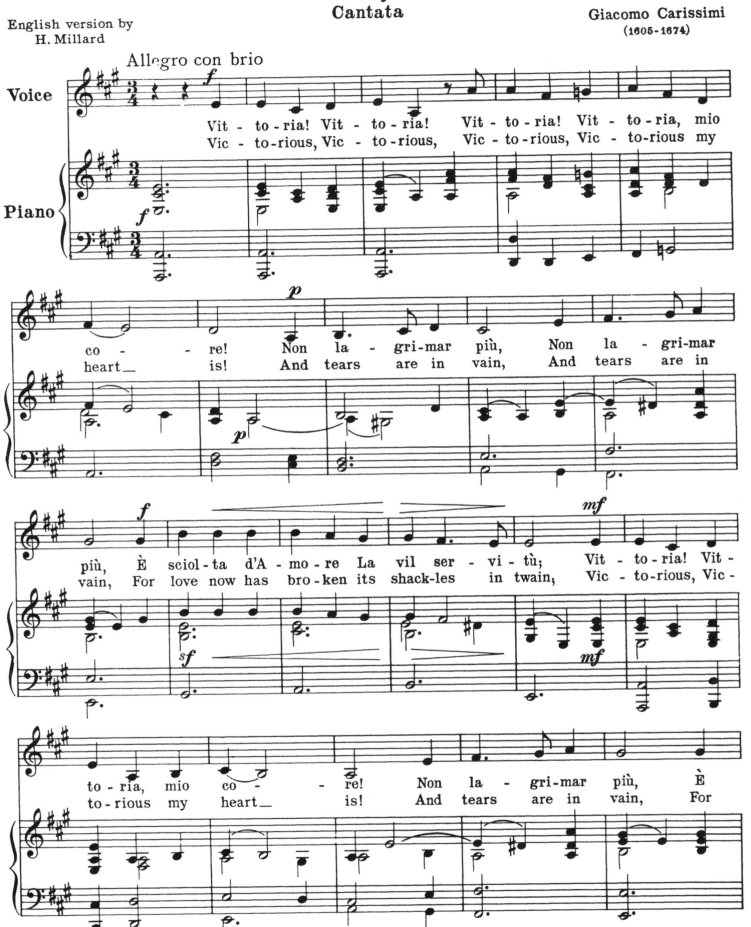

Copyright, 1880, by G. Schirmer, Inc.

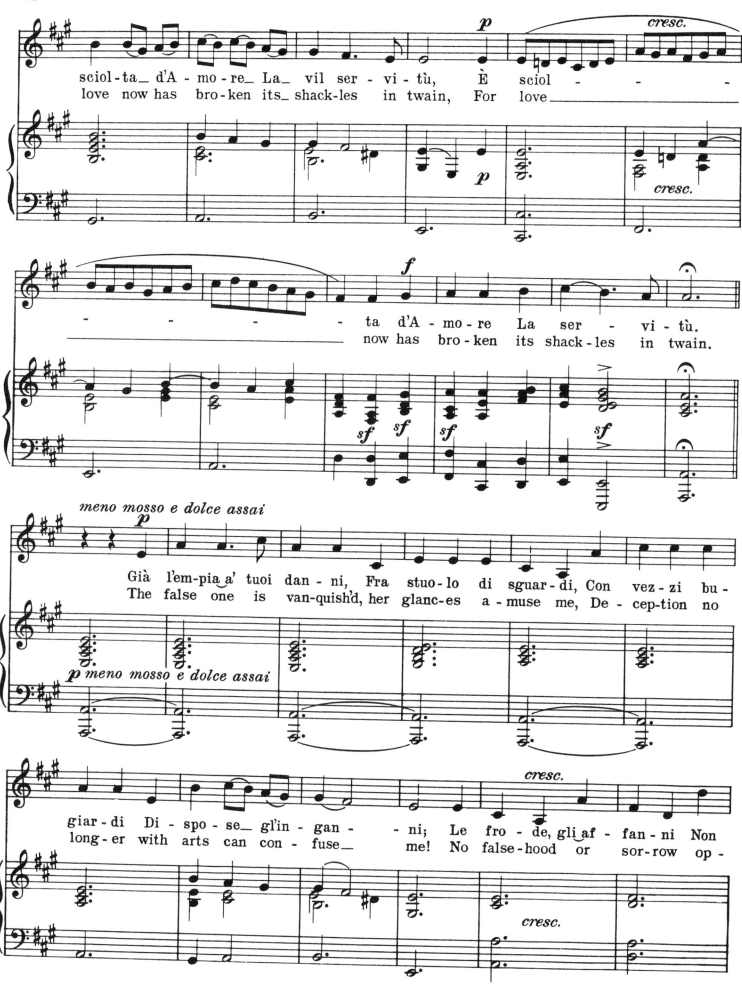

sciol-ta_ d'A - mo-re_ La_ vil ser - vi - tù, È sciol - - -
love now has bro-ken its_ shack-les in twain, For love_____

- - - ta d'A - mo-re La ser - vi - tù.
now has bro-ken its shack-les in twain.

Già l'em-pia_a' tuoi dan - ni, Fra stuo-lo di sguar-di, Con vez-zi bu-
The false one is van-quish'd, her glanc-es a-muse me, De-cep-tion no

giar-di Di - spo-se_ gl'in-gan - ni; Le fro-de, gli af - fan-ni Non
long-er with arts can con-fuse__ me! No false-hood or sor-row op-

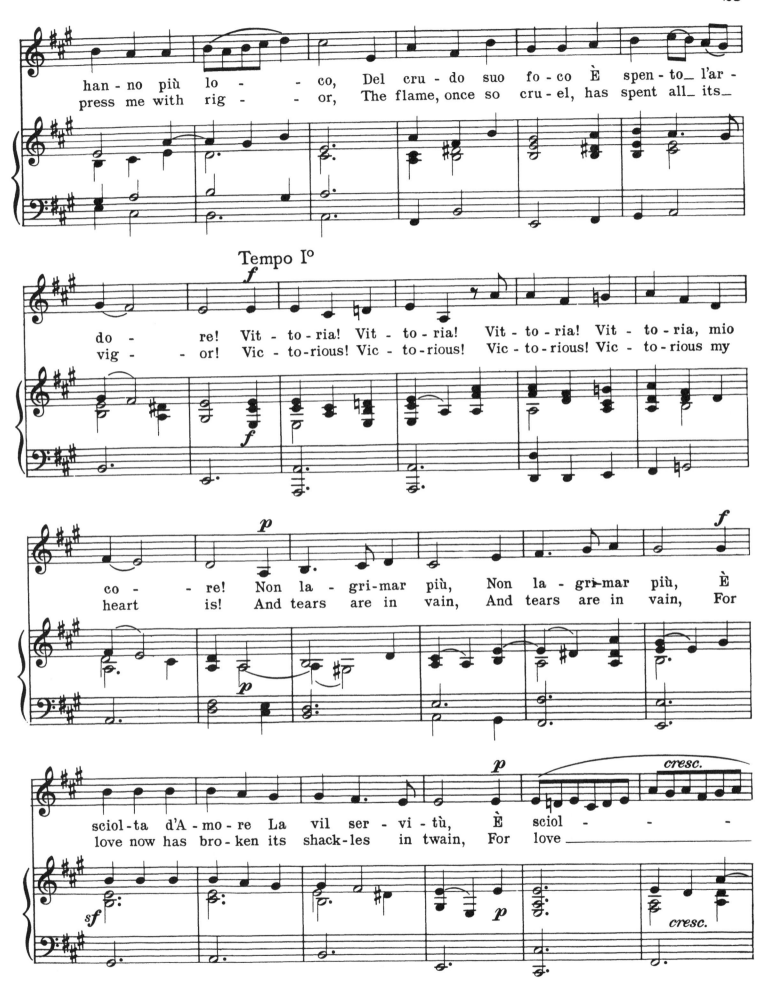

han - no più lo - - co, Del cru - do suo fo - co È spen - to_ l'ar -
press me with rig - - or, The flame, once so cru - el, has spent all_ its_

Tempo I°

do - - re! Vit - to - ria! Vit - to - ria! Vit - to - ria! Vit - to - ria, mio
vig - - or! Vic - to - rious! Vic - to - rious! Vic - to - rious! Vic - to - rious my

co - - re! Non la - gri - mar più, Non la - gri - mar più, È
heart is! And tears are in vain, And tears are in vain, For

sciol - ta d'A - mo - re La vil ser - vi - tù, È sciol - - - -
love now has bro - ken its shack - les in twain, For love _ _ _ _

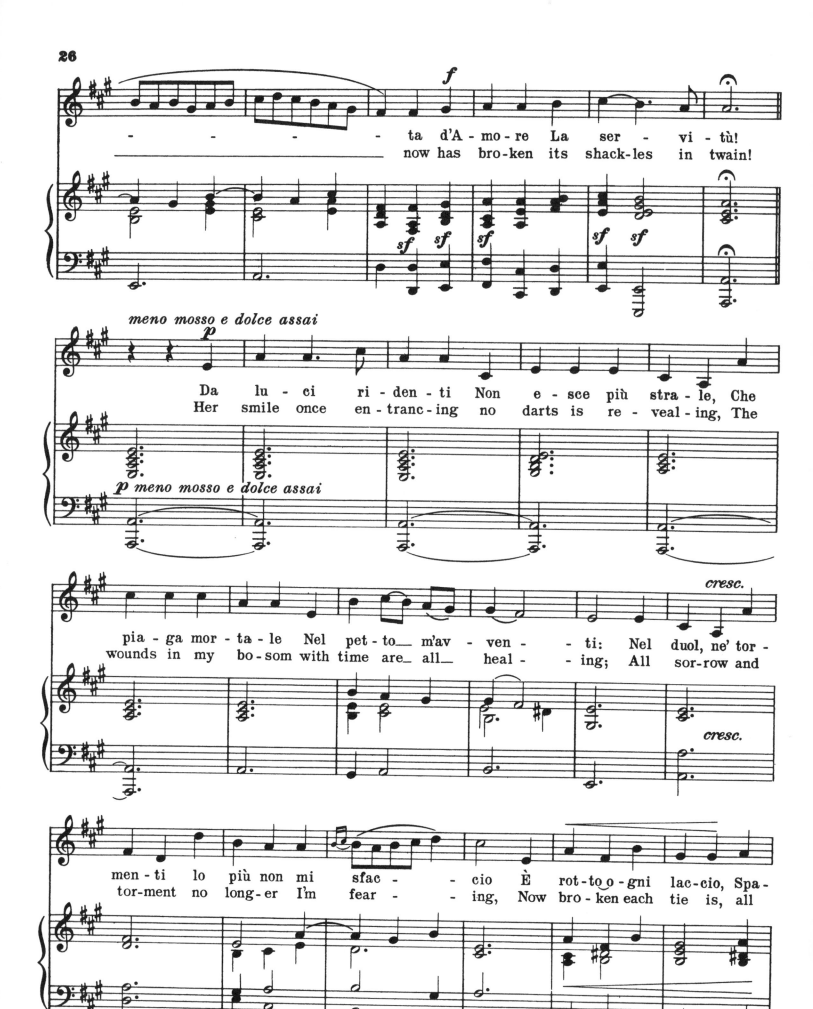

- ta d'A - mo - re La ser - vi - tù!
now has bro-ken its shack-les in twain!

meno mosso e dolce assai

Da lu - ci ri - den - ti Non e - sce più stra - le, Che
Her smile once en - tranc-ing no darts is re - veal - ing, The

pia - ga mor - ta - le Nel pet - to m'av - ven - ti: Nel duol, ne' tor -
wounds in my bo-som with time are all heal - ing; All sor-row and

men - ti Io più non mi sfac - cio È rot-to o-gni lac-cio, Spa -
tor-ment no long-er I'm fear - ing, Now bro-ken each tie is, all

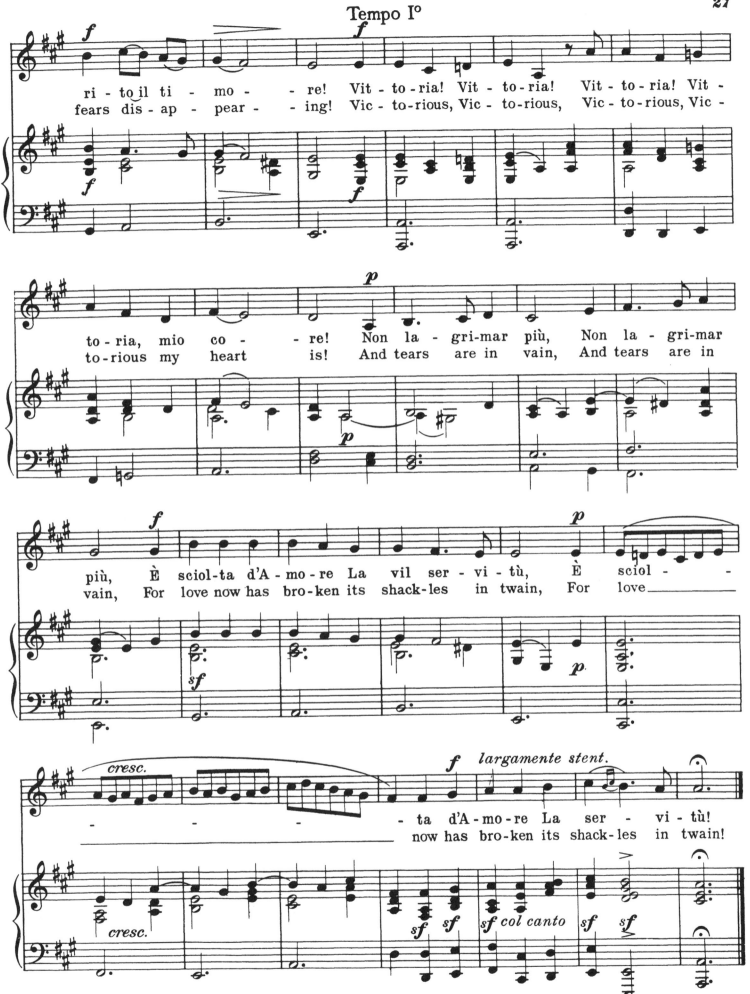

Danza, danza, fanciulla gentile
Dance, O dance, maiden gay
Arietta

English version by
Dr. Theodore Baker

Francesco Durante
(1684-1755)

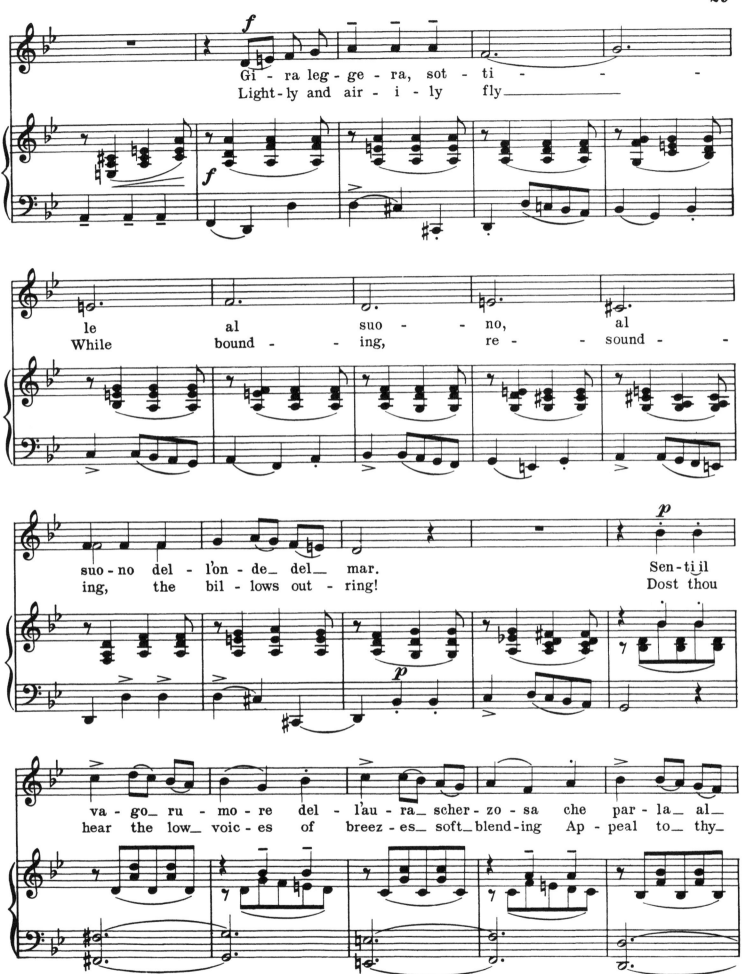

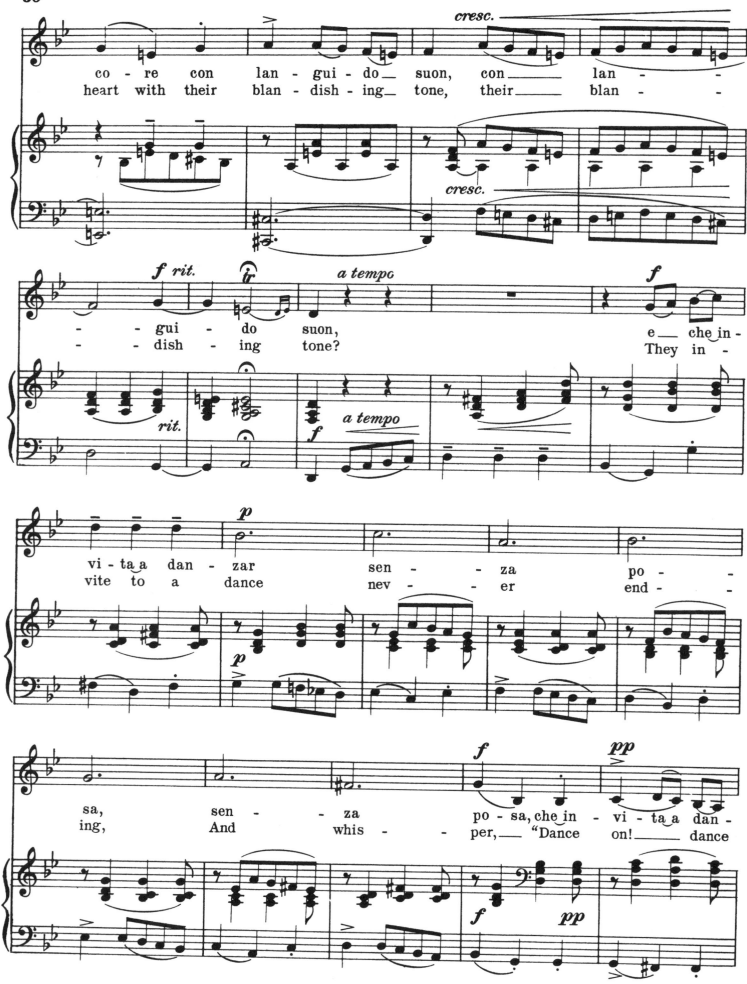

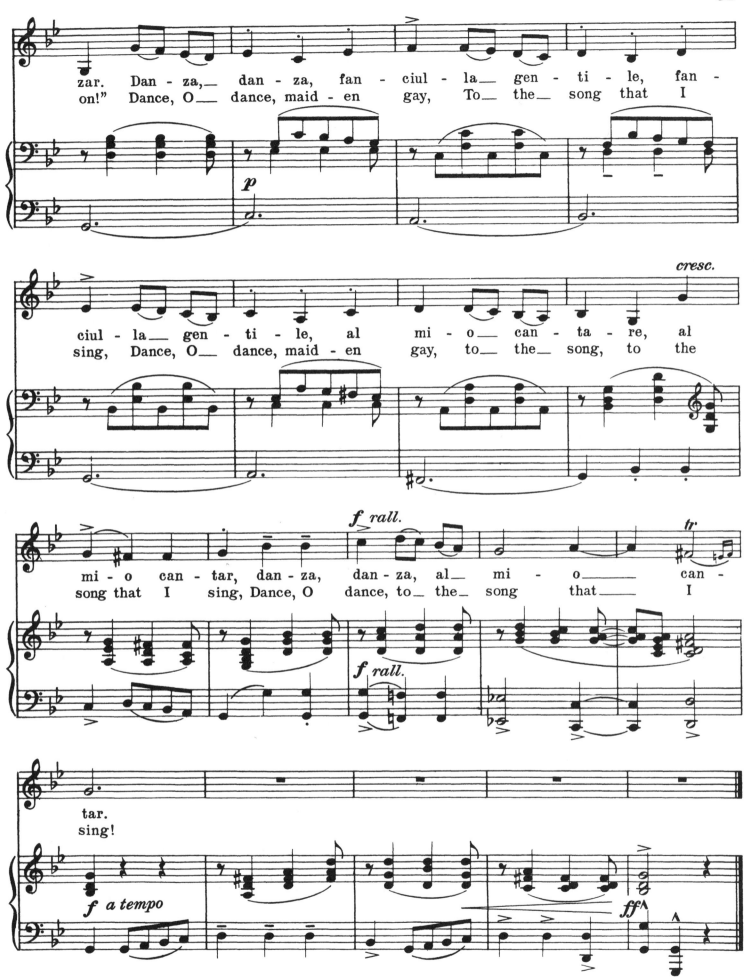

Vergin, tutto amor
Virgin, fount of love
Preghiera
Prayer

English version by
Dr. Theodore Baker

Francesco Durante
(1684-1755)

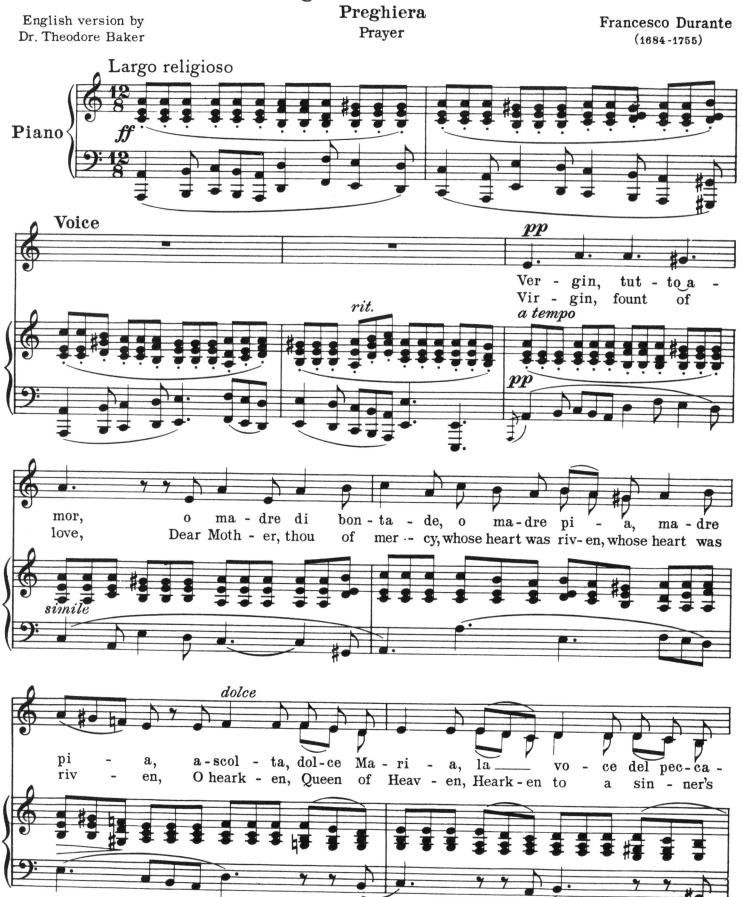

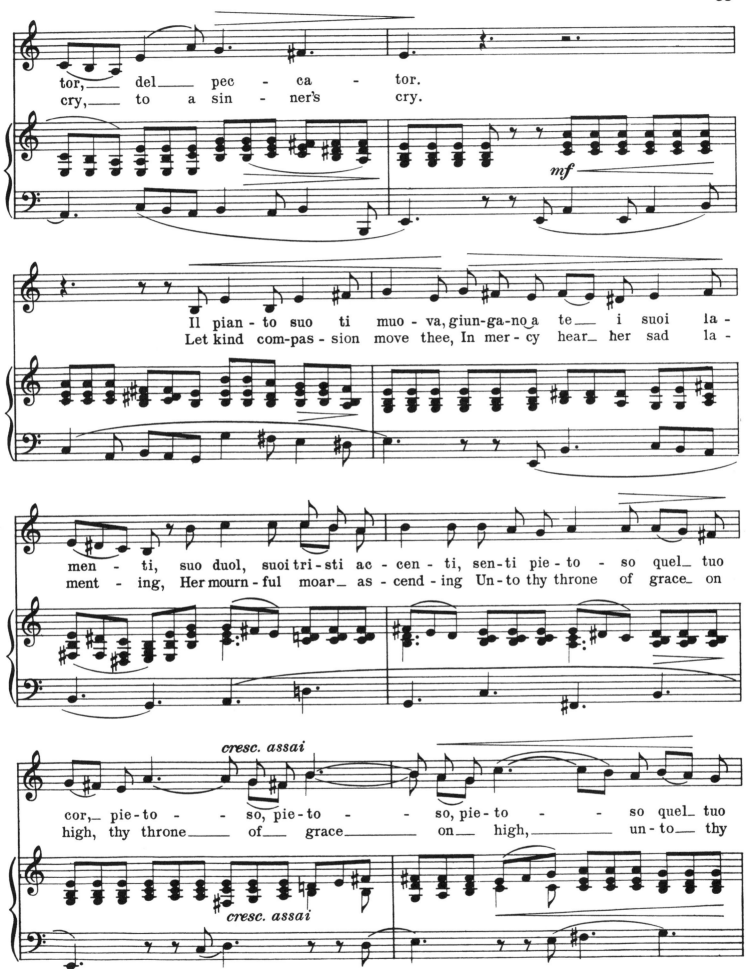

tor,___ del___ pec - ca - tor.
cry,___ to a sin - ner's cry.

Il pian - to suo ti muo - va, giun-ga-no_a te i suoi la -
Let kind com-pas - sion move thee, In mer - cy hear_ her sad la -

mf

men - ti, suo duol, suoi tri-sti ac - cen - ti, sen-ti pie-to - so quel_ tuo
ment - ing, Her mourn-ful moar_ as-cend-ing Un-to thy throne of grace_ on

cresc. assai

cor,_ pie-to - - so, pie-to - - so, pie-to - - so quel_ tuo
high, thy throne___ of_ grace_____ on_ high,_____ un-to_ thy

cresc. assai

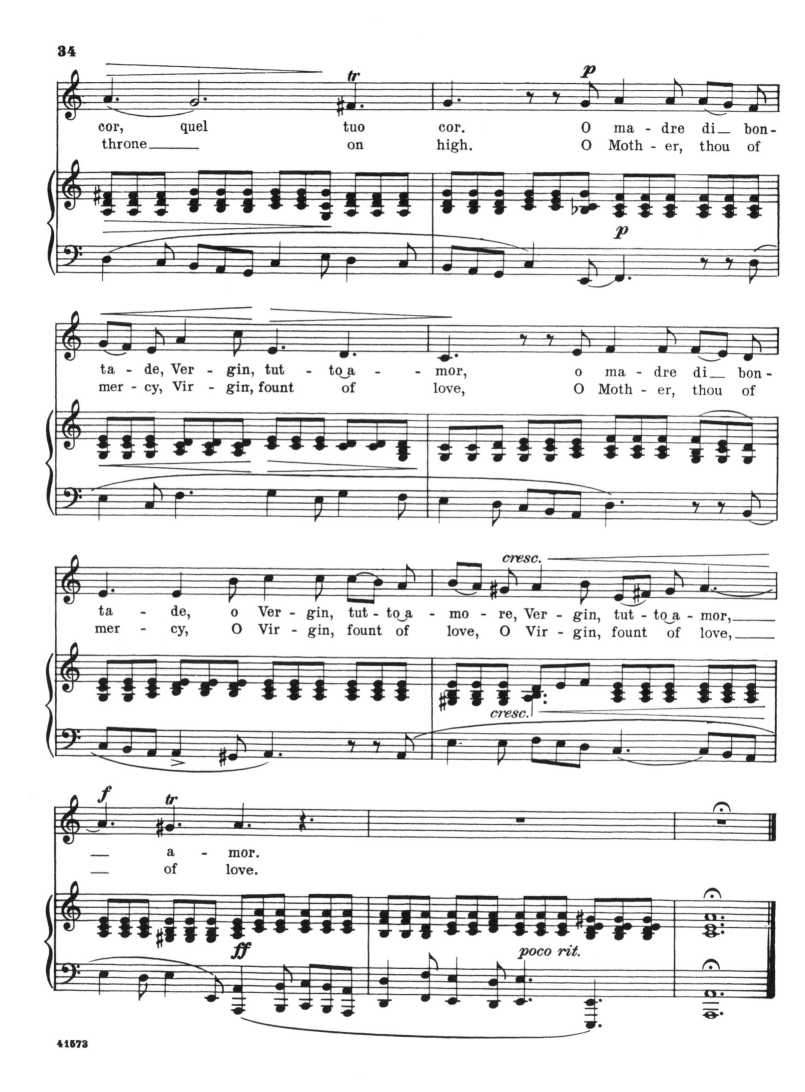

Caro mio ben
Thou, all my bliss
Arietta

English version by
Dr. Theodore Baker

Giuseppe Giordani (Giordanello)
(1744-1798)

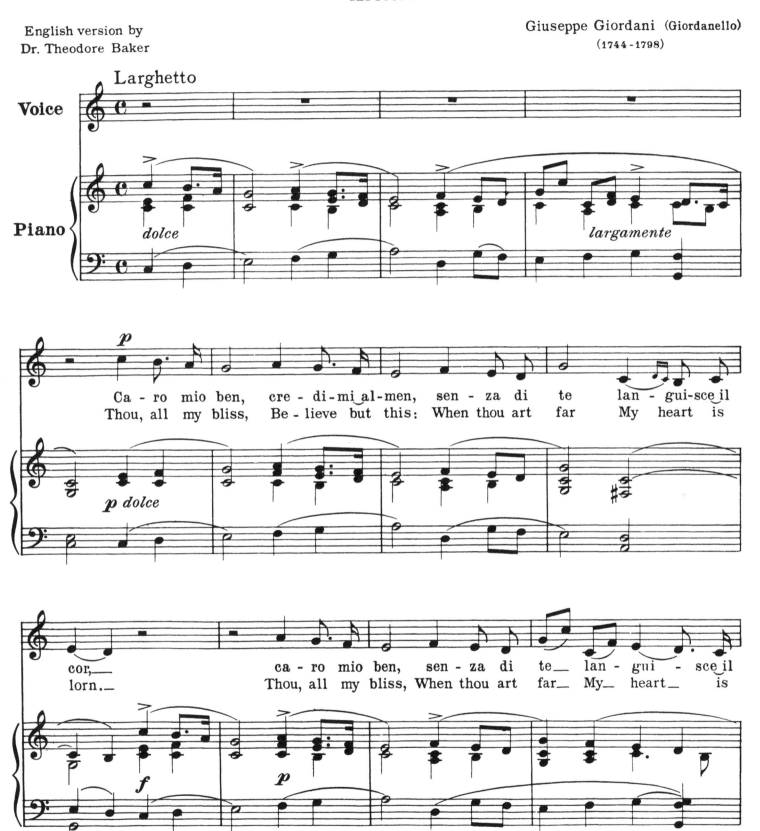

Ca - ro mio ben, cre - di - mi al-men, sen - za di te lan - gui-sce il
Thou, all my bliss, Be - lieve but this: When thou art far My heart is

cor,— ca - ro mio ben, sen - za di te lan - gui - sce il
lorn.— Thou, all my bliss, When thou art far— My— heart— is

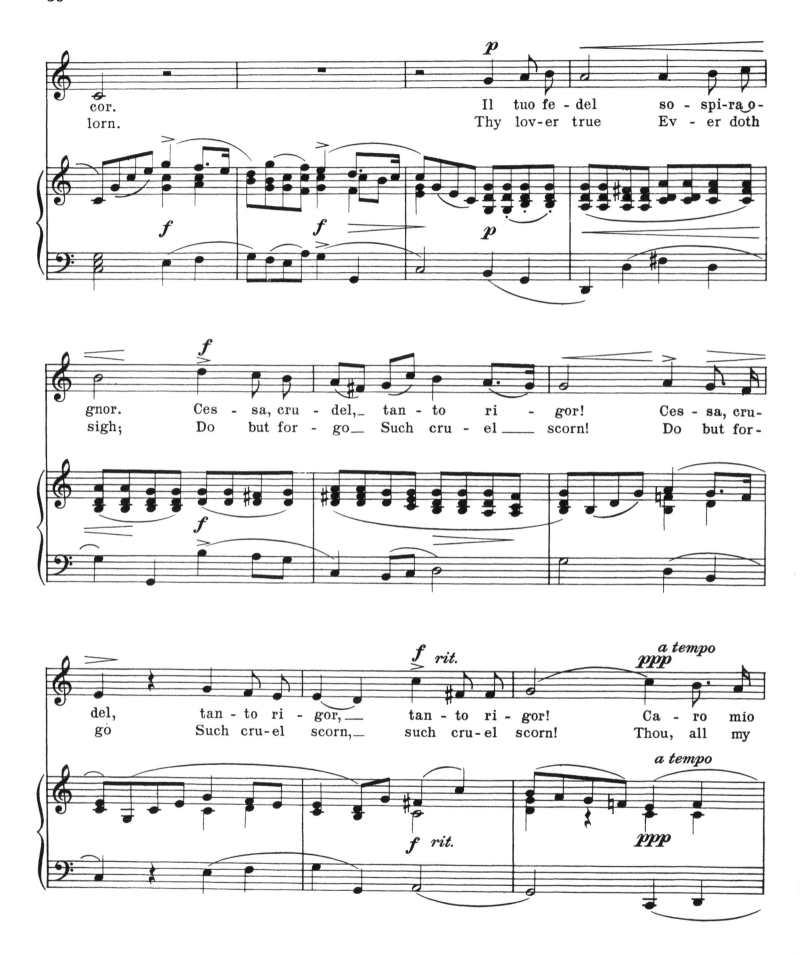

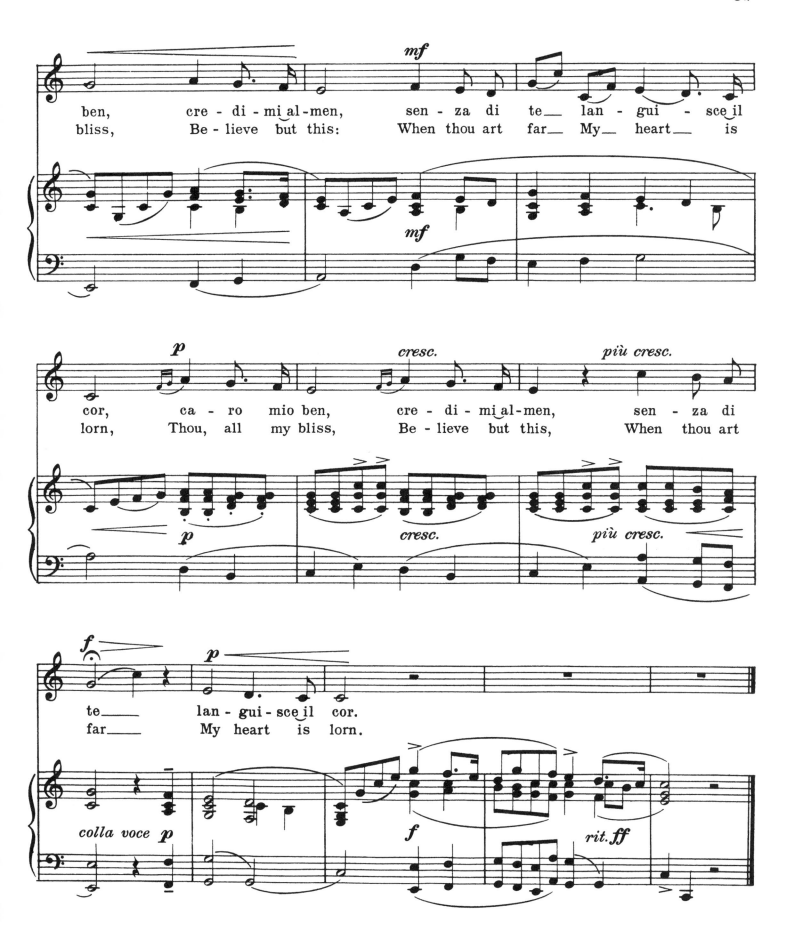

O del mio dolce ardor

O thou belov'd

Aria

English version by
Dr. Theodore Baker

Christoph Willibald von Gluck
(1714 - 1787)

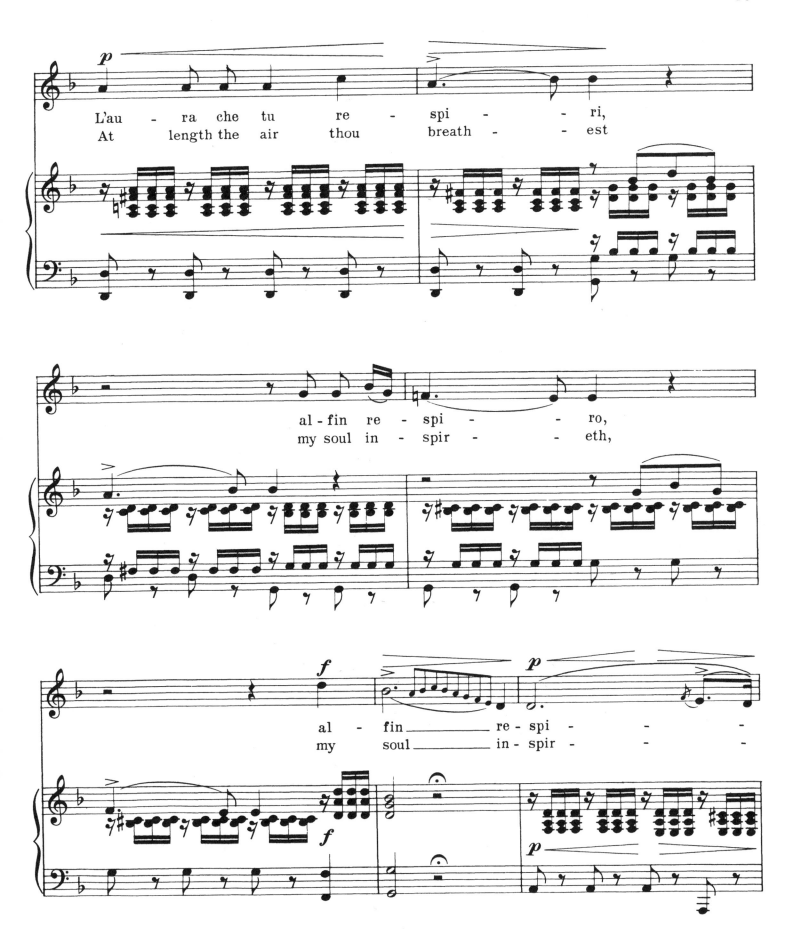

L'au - ra che tu re - spi - - ri,
At length the air thou breath - - est

al - fin re - spi - - ro,
my soul in - spir - - eth,

al - fin re - spi - -
my soul in - spir - -

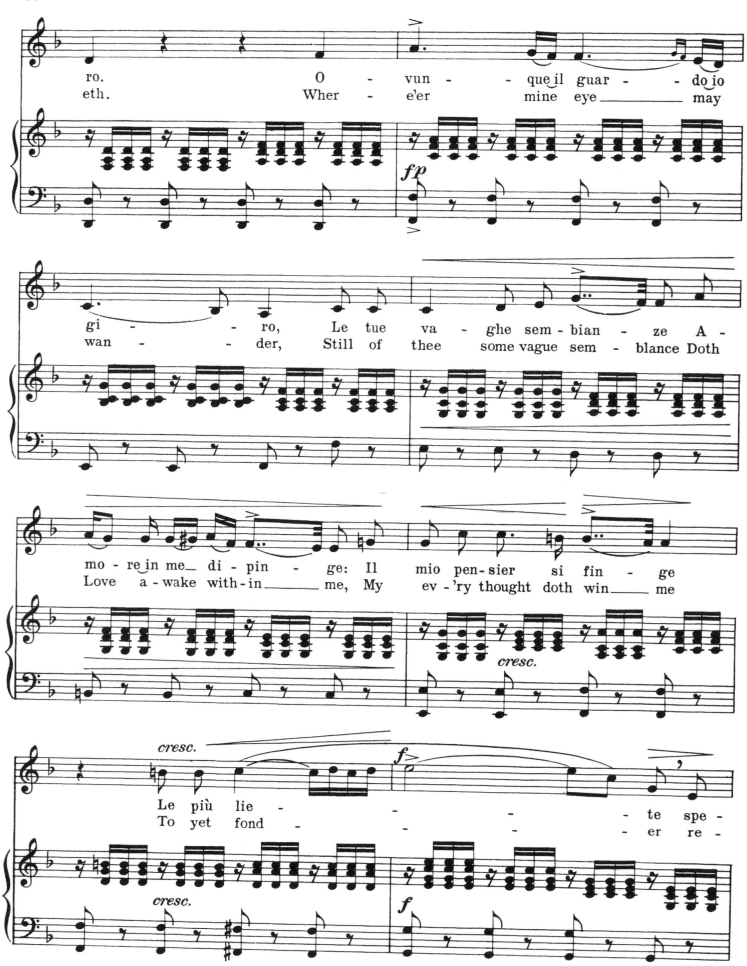

ro.
eth.

O - vun - - que il guar - - do io
Wher - e'er mine eye_____ may

fp

gi - - ro, Le tue va - ghe sem - bian - ze A -
wan - - der, Still of thee some vague sem - blance Doth

mo - re in me di - pin - ge: Il mio pen - sier si fin - ge
Love a - wake with - in_____ me, My ev - 'ry thought doth win_____ me

cresc.

cresc.

Le più lie - - - te spe -
To yet fond - - - er re -

cresc.

f

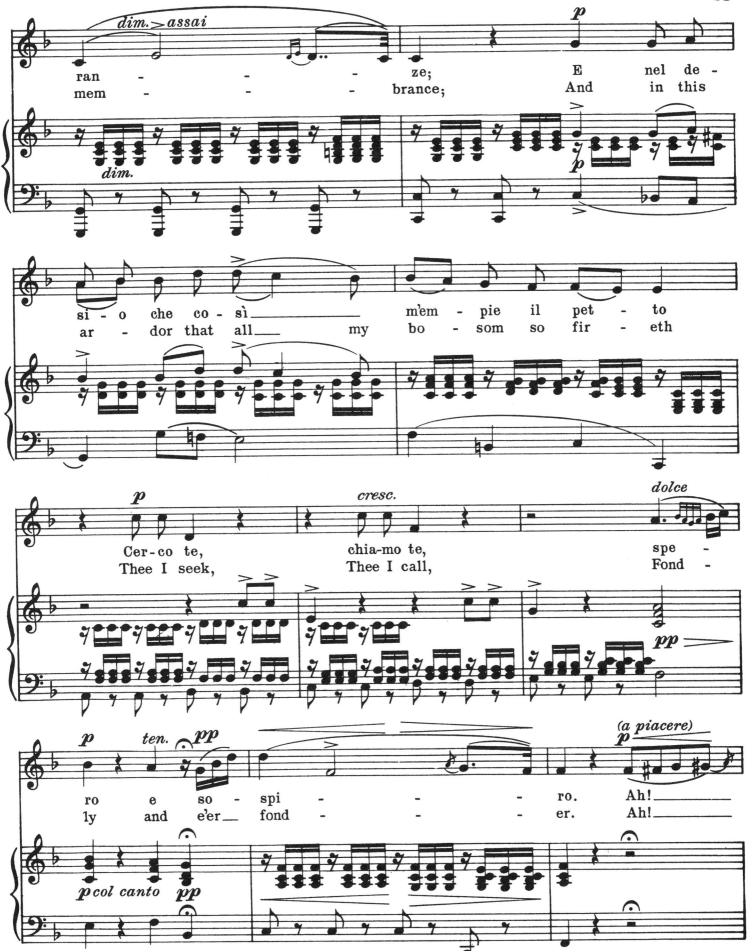

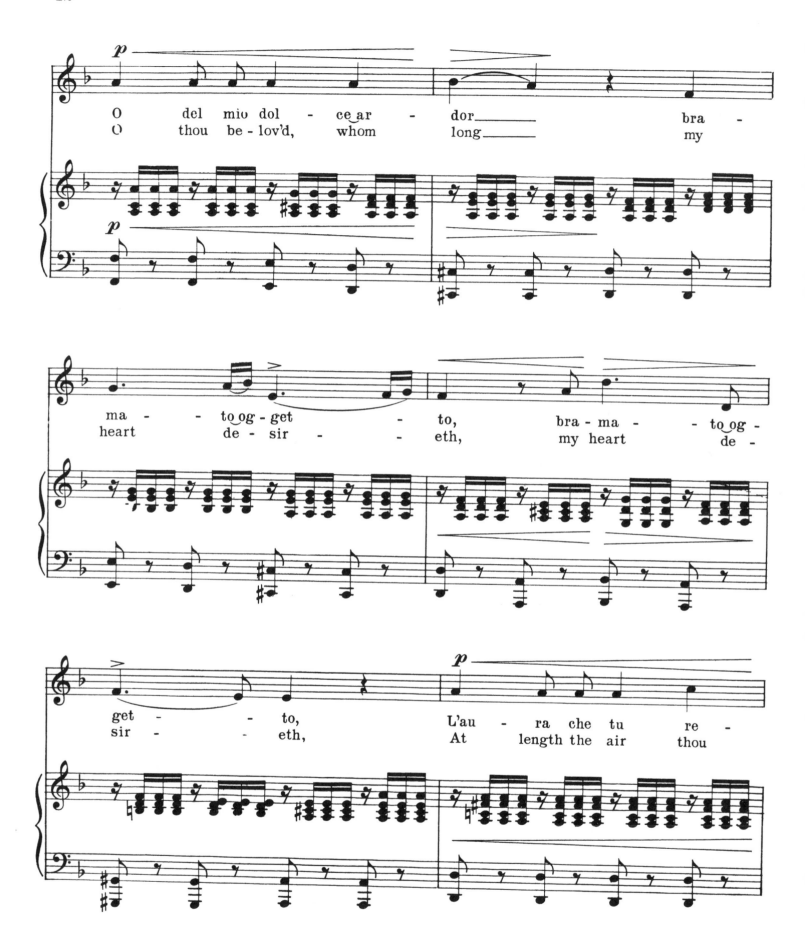

O del mio dol - ce ar - dor_____ bra - ma -
O thou be - lov'd, whom long_____ my

ma - to og - get - to, bra - ma - - to og -
heart de - sir - - eth, my heart de -

get - - to, L'au - ra che tu re -
sir - - eth, At length the air thou

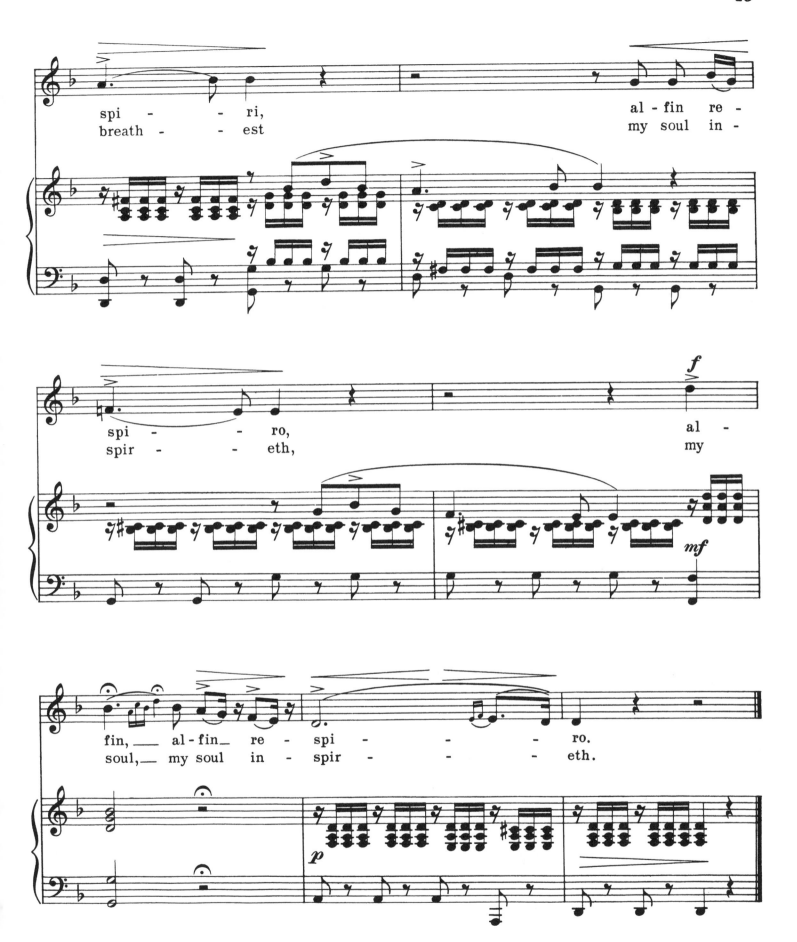

Che fiero costume

How void of compassion
Arietta

English version by
Dr. Theodore Baker

Giovanni Legrenzi
(1626-1690)

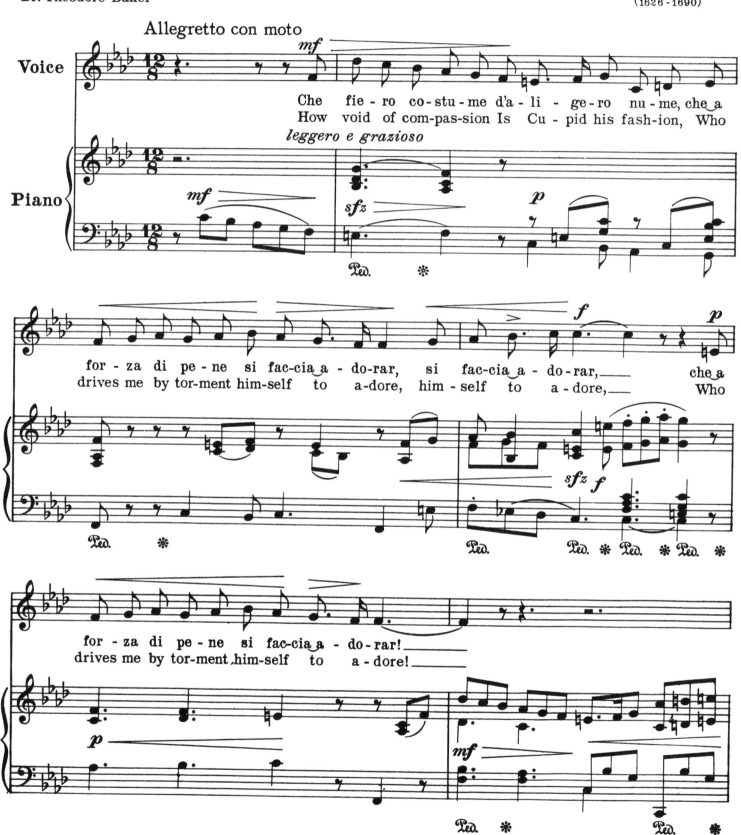

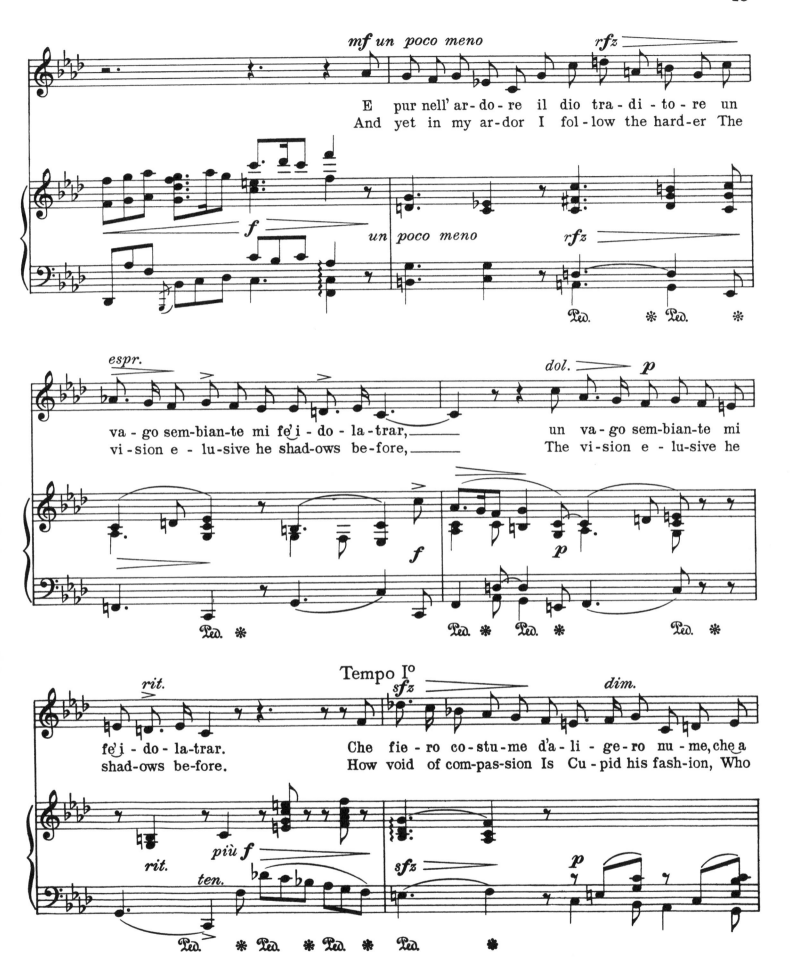

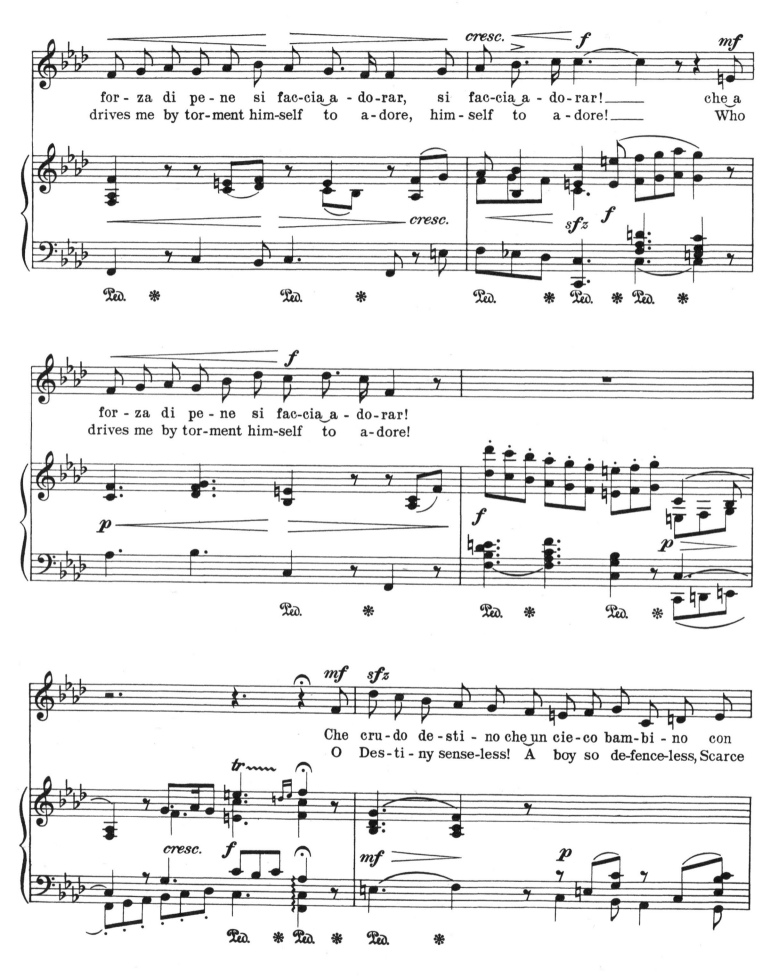

forza di pene si faccia a-do-rar, si faccia a-do-rar!___ che a
drives me by tor-ment him-self to a-dore, him-self to a-dore!___ Who

for-za di pe-ne si fac-cia a-do-rar!
drives me by tor-ment him-self to a-dore!

Che cru-do de-sti-no che un cie-co bam-bi-no con
O Des-ti-ny sense-less! A boy so de-fence-less, Scarce

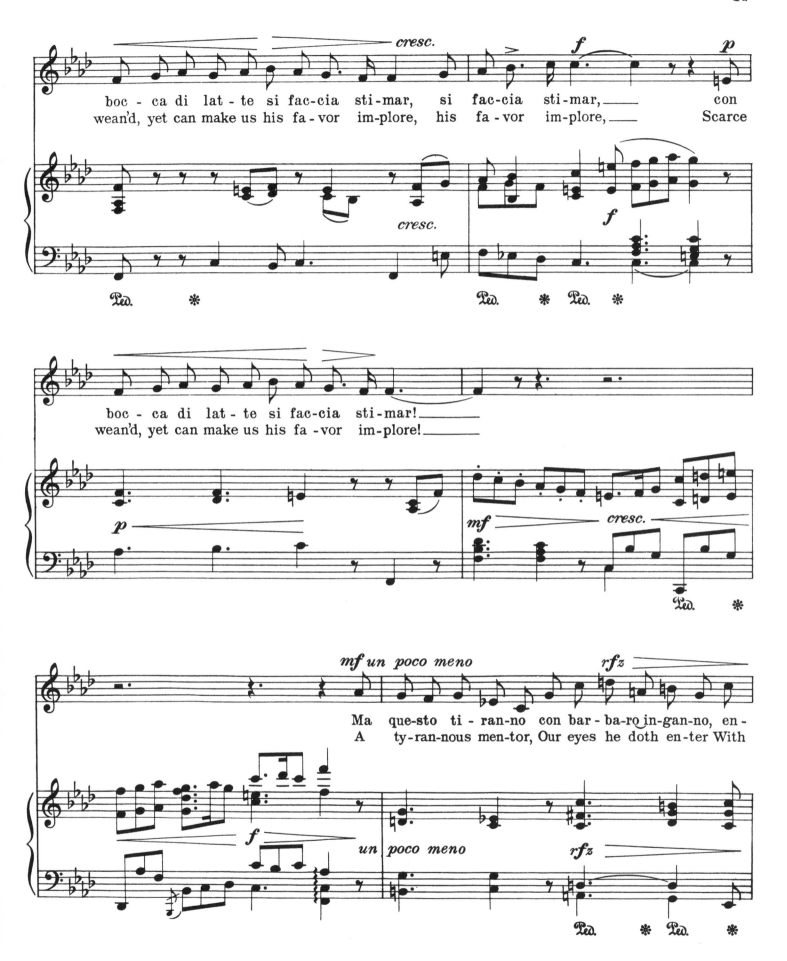

boc - ca di lat - te si fac-cia sti-mar, si fac-cia sti-mar,_____ con
wean'd, yet can make us his fa - vor im-plore, his fa - vor im-plore,_____ Scarce

boc - ca di lat - te si fac-cia sti-mar!_____
wean'd, yet can make us his fa - vor im-plore!_____

Ma que-sto ti - ran-no con bar - ba-ro in-gan-no, en -
A ty-ran-nous men-tor, Our eyes he doth en-ter With

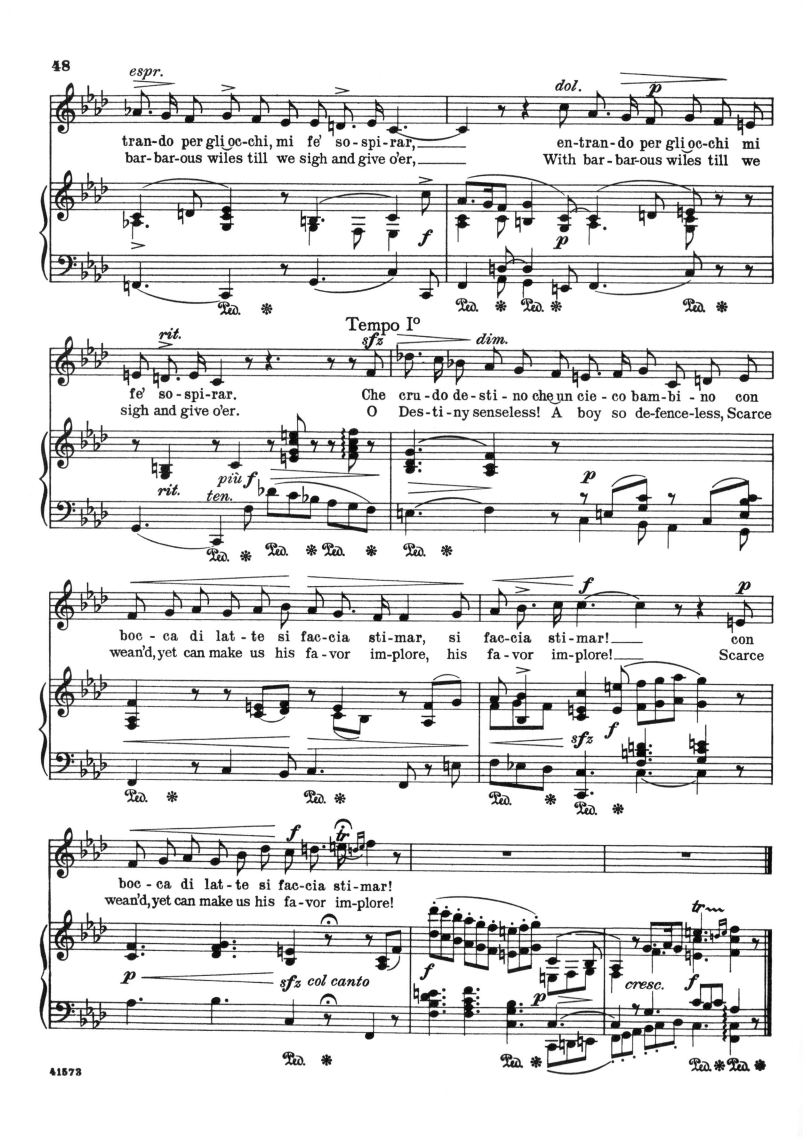

espr.

tran-do per gli oc-chi, mi fe' so-spi-rar,_____ en-tran-do per gli oc-chi mi
bar-bar-ous wiles till we sigh and give o'er,_____ With bar-bar-ous wiles till we

dol.

rit. **Tempo I°** *sfz dim.*

fe' so-spi-rar. Che cru-do de-sti-no che un cie-co bam-bi-no con
sigh and give o'er. O Des-ti-ny senseless! A boy so de-fence-less, Scarce

più f ten. *rit.*

boc-ca di lat-te si fac-cia sti-mar, si fac-cia sti-mar!_____ con
wean'd, yet can make us his fa-vor im-plore, his fa-vor im-plore!_____ Scarce

boc-ca di lat-te si fac-cia sti-mar! Scarce
wean'd, yet can make us his fa-vor im-plore!

sfz col canto *cresc.*

Pur dicesti, o bocca bella

Mouth so charmful

Arietta

English version by
Dr. Theodore Baker

Antonio Lotti
(1667-1740)

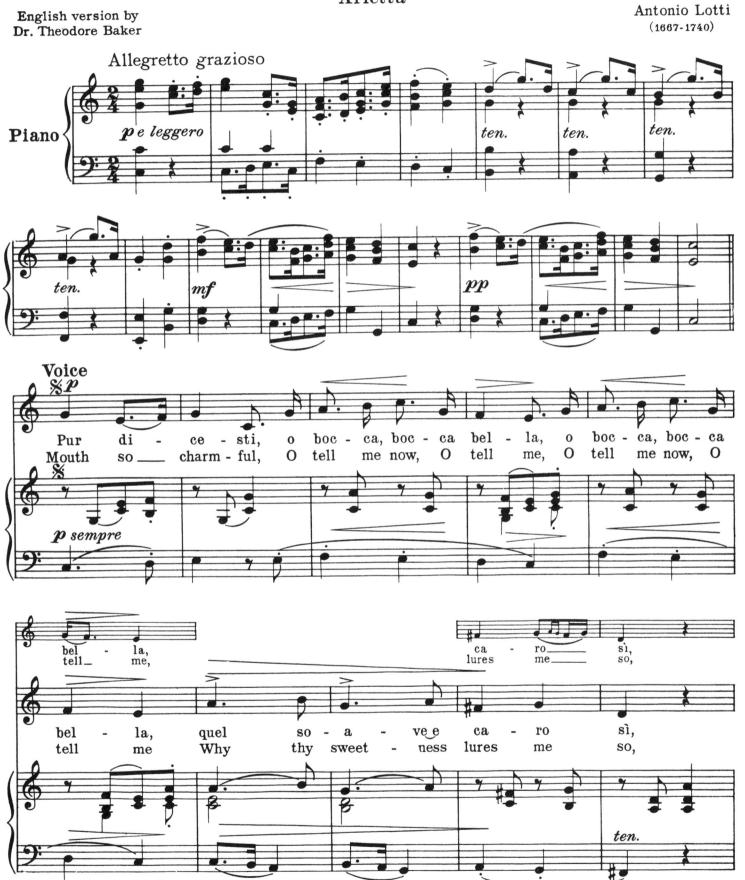

Allegretto grazioso

Piano

Voice

Pur di - ce - sti, o boc - ca, boc - ca bel - la, o boc - ca, boc - ca
Mouth so___ charm - ful, O tell me now, O tell me, O tell me now, O

bel - la, ca - ro___ sì,
tell___ me, lures me___ so,

bel - la, quel so - a - ve e ca - ro sì,
tell me Why thy sweet - ness lures me so,

41572

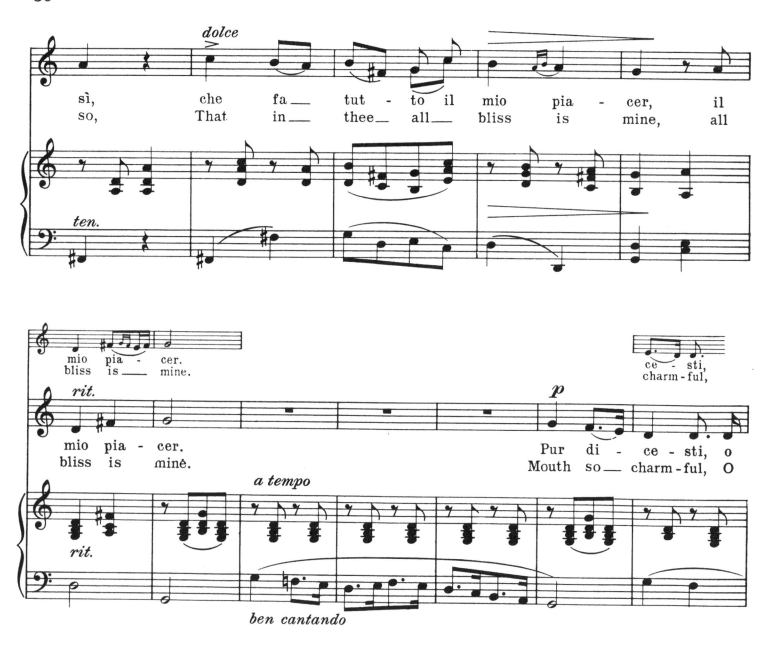

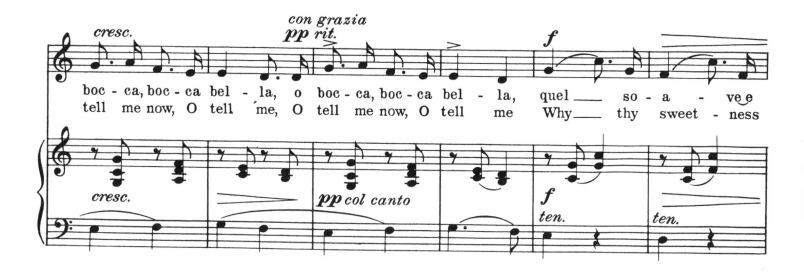

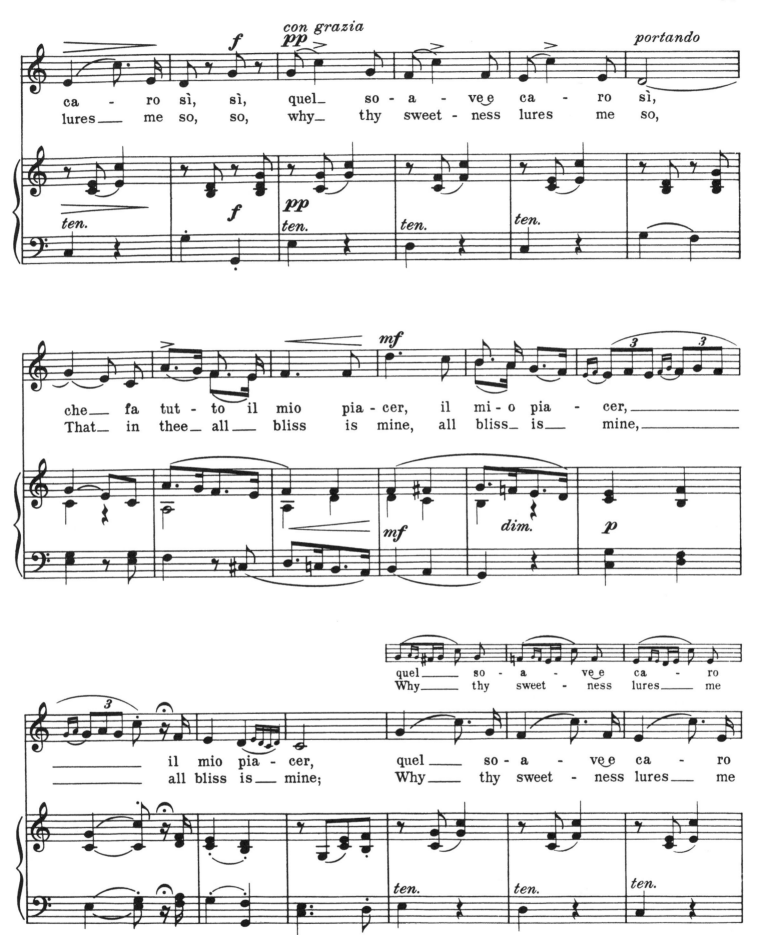

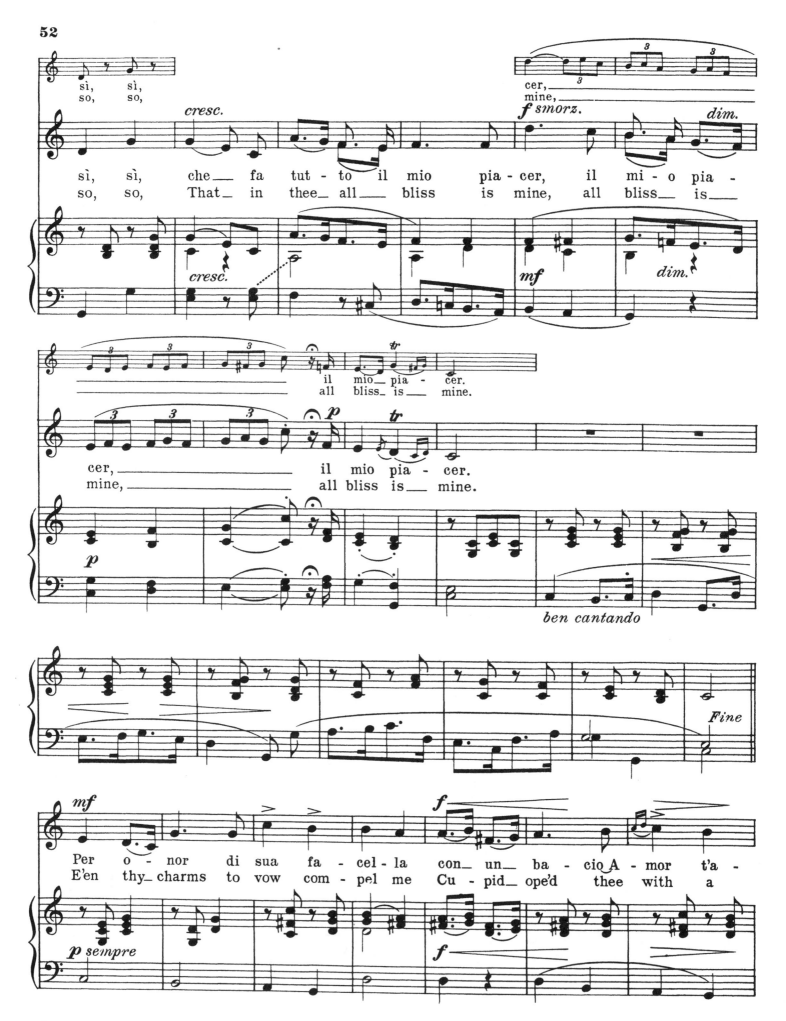

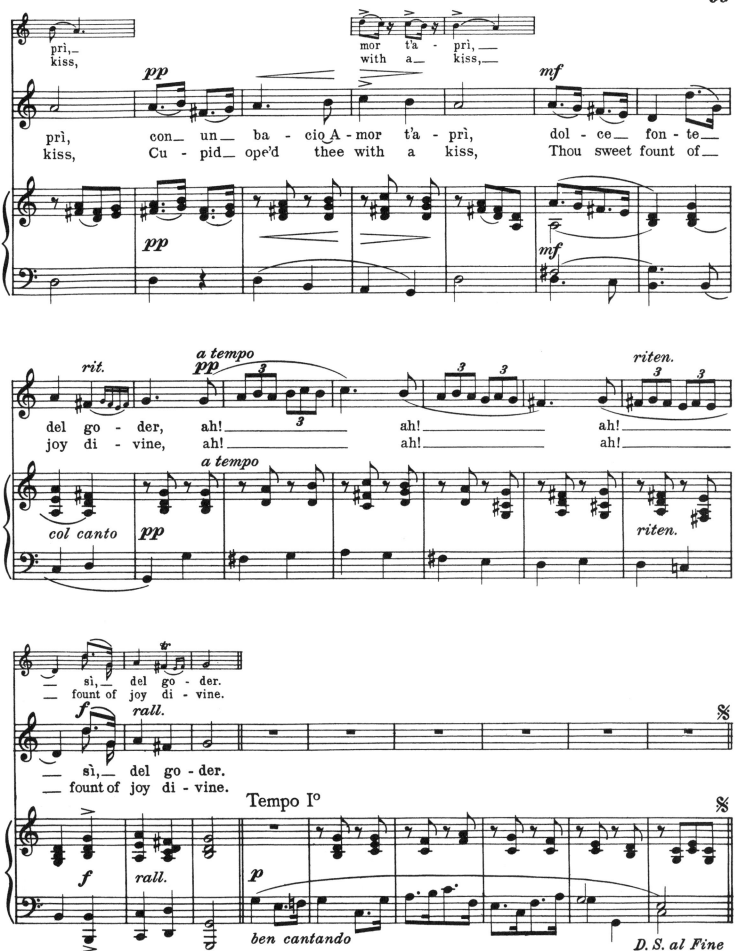

Il mio bel foco
My joyful ardor
Recitativo ed Aria

English version by
Dr. Theodore Baker

Benedetto Marcello
(1686-1739)

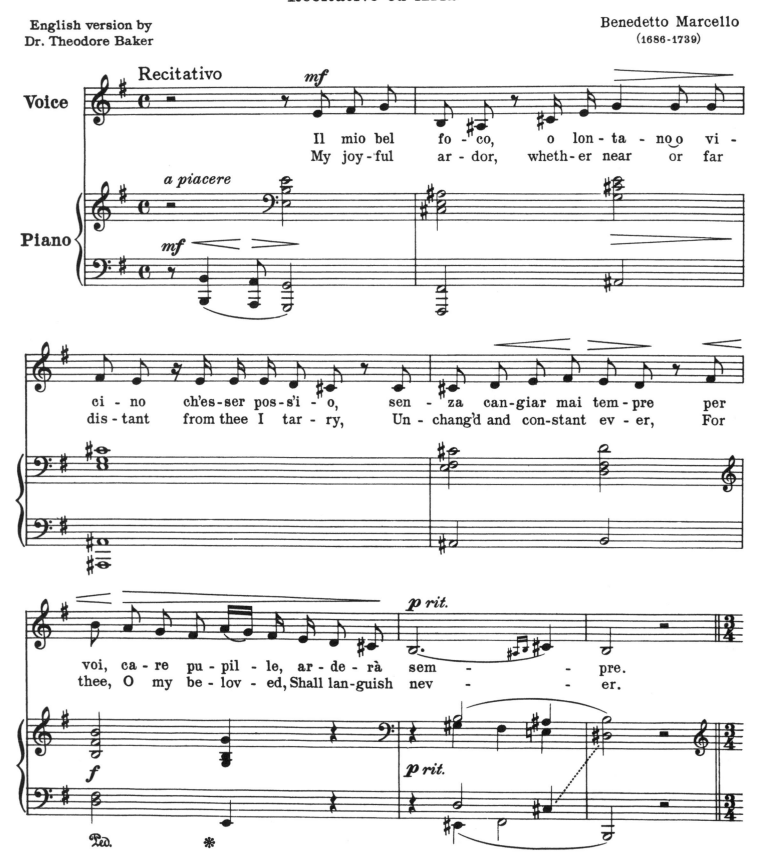

41573

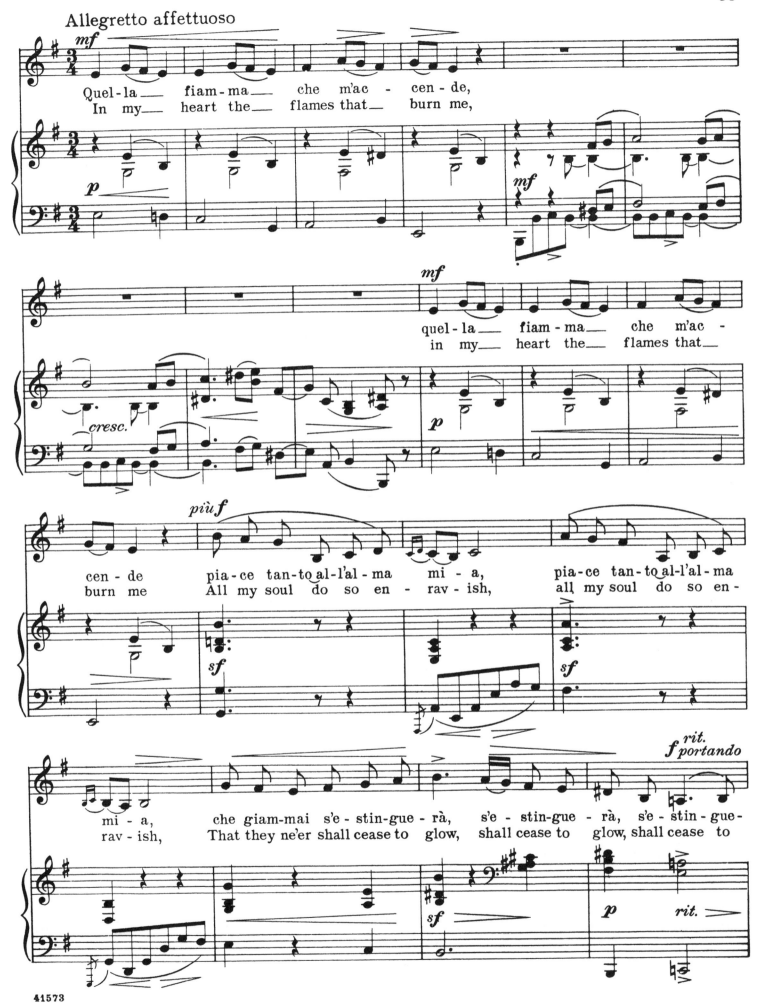

Allegretto affettuoso

Quel-la___ fiam-ma___ che m'ac - cen-de,
In my___ heart the___ flames that___ burn me,

quel - la___ fiam - ma___ che m'ac -
in my___ heart the___ flames that___

cen - de pia - ce tan-to al-l'al - ma mi - a, pia - ce tan-to al-l'al - ma
burn me All my soul do so en - rav - ish, all my soul do so en -

mi - a, che giam-mai s'e-stin-gue - rà, s'e - stin-gue - rà, s'e - stin - gue-
rav - ish, That they ne'er shall cease to glow, shall cease to glow, shall cease to

41573

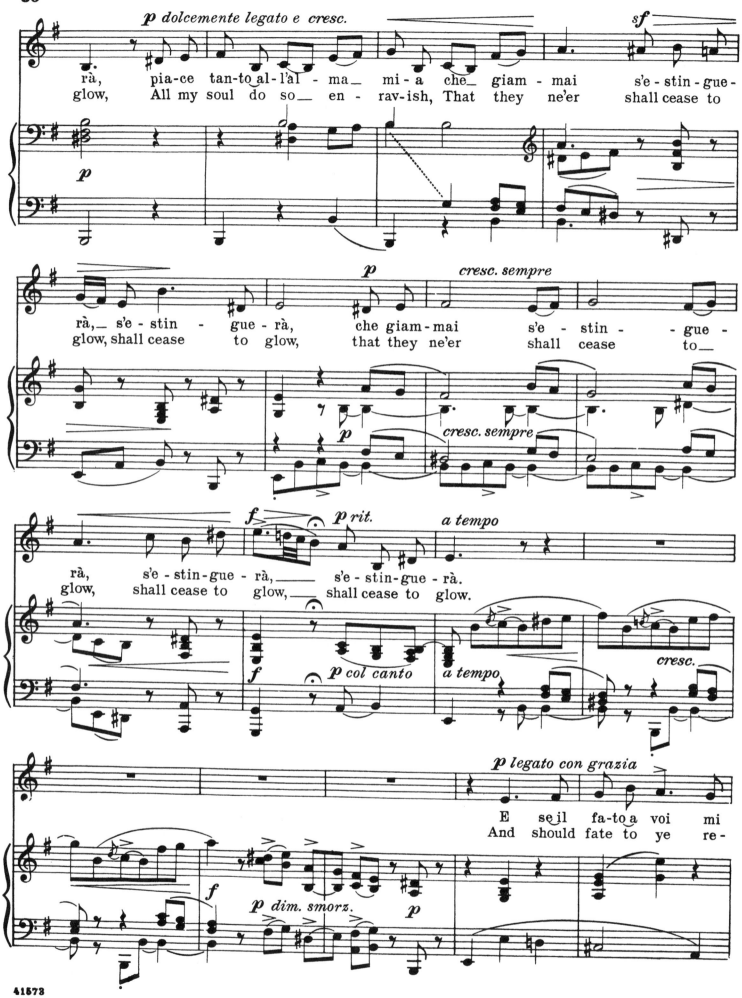

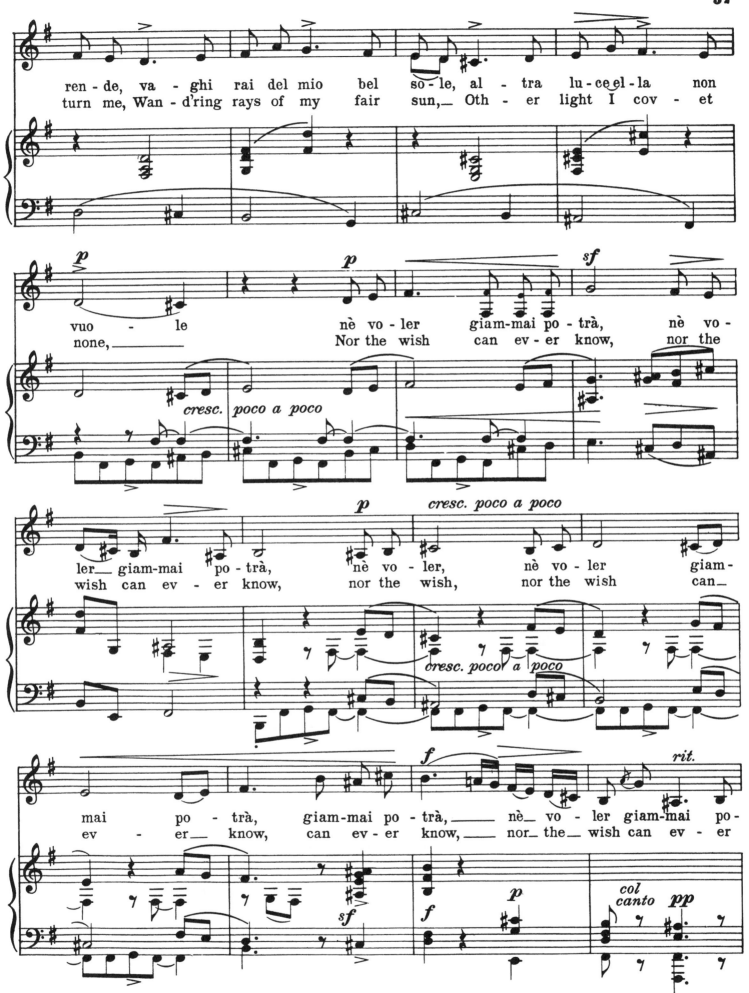

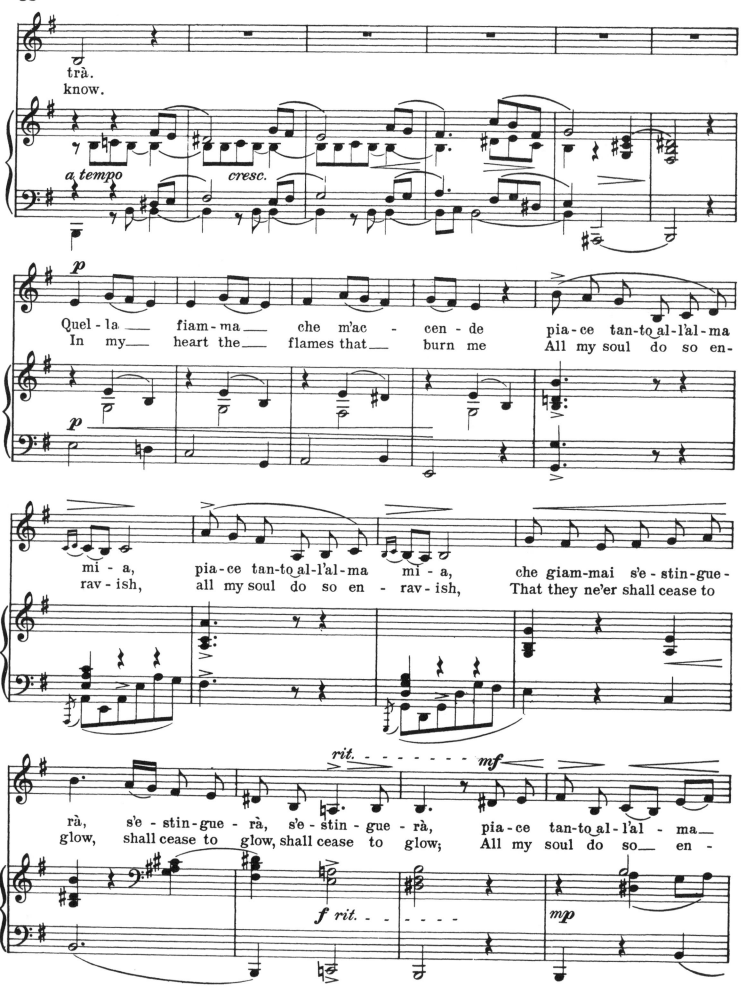

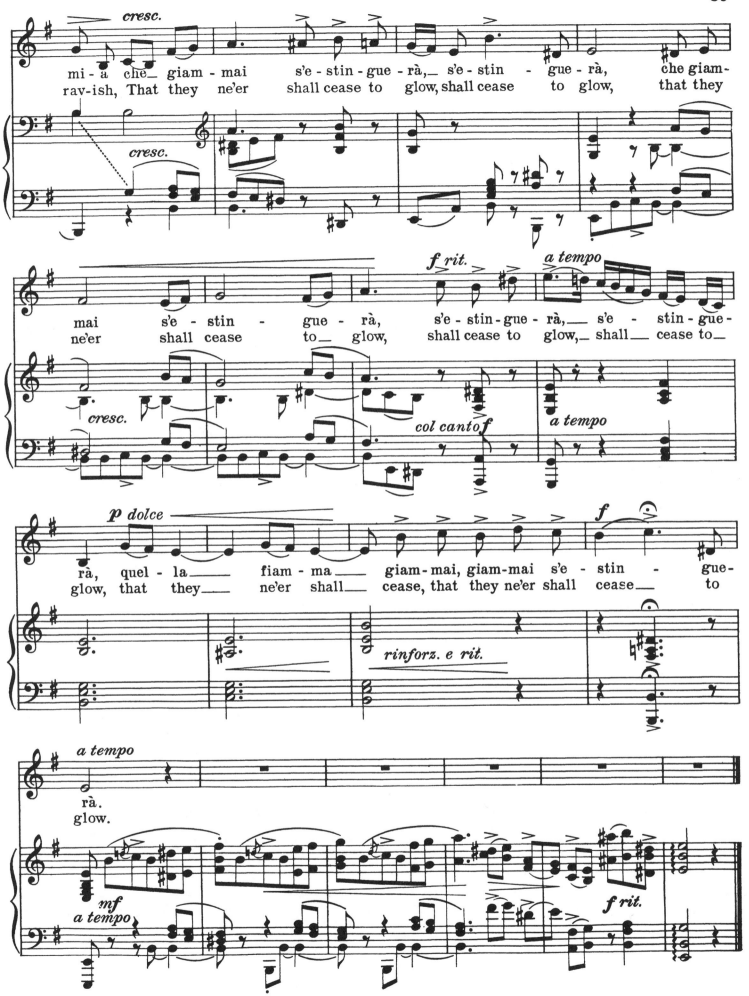

Non posso disperar
I do not dare despond
Arietta

English version by
Dr. Theodore Baker

S. De Luca
(15... - 16...)

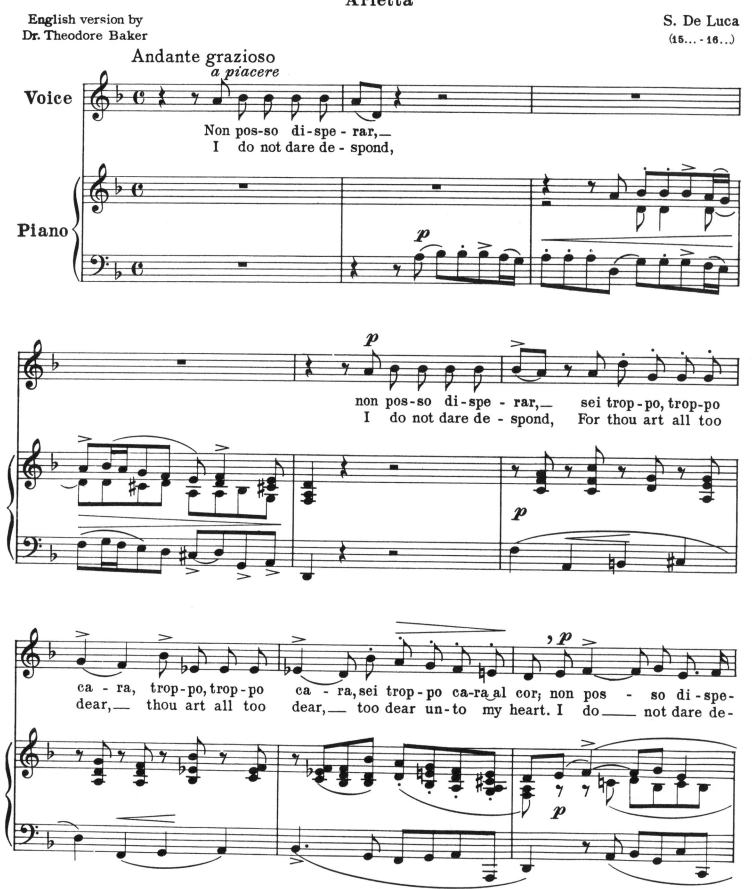

41573

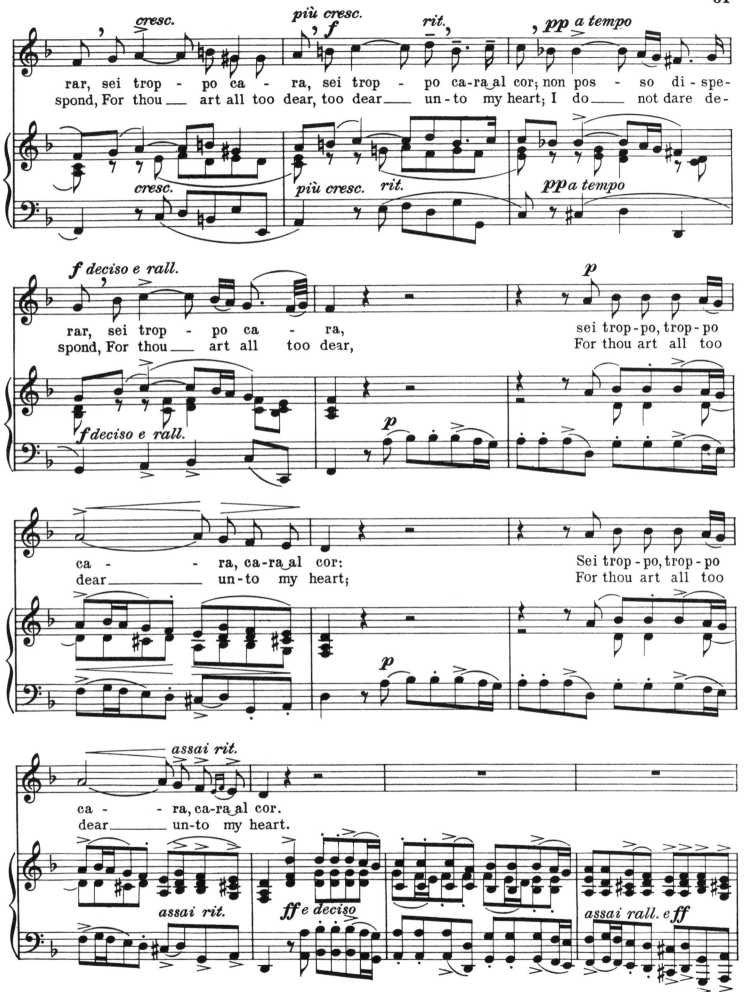

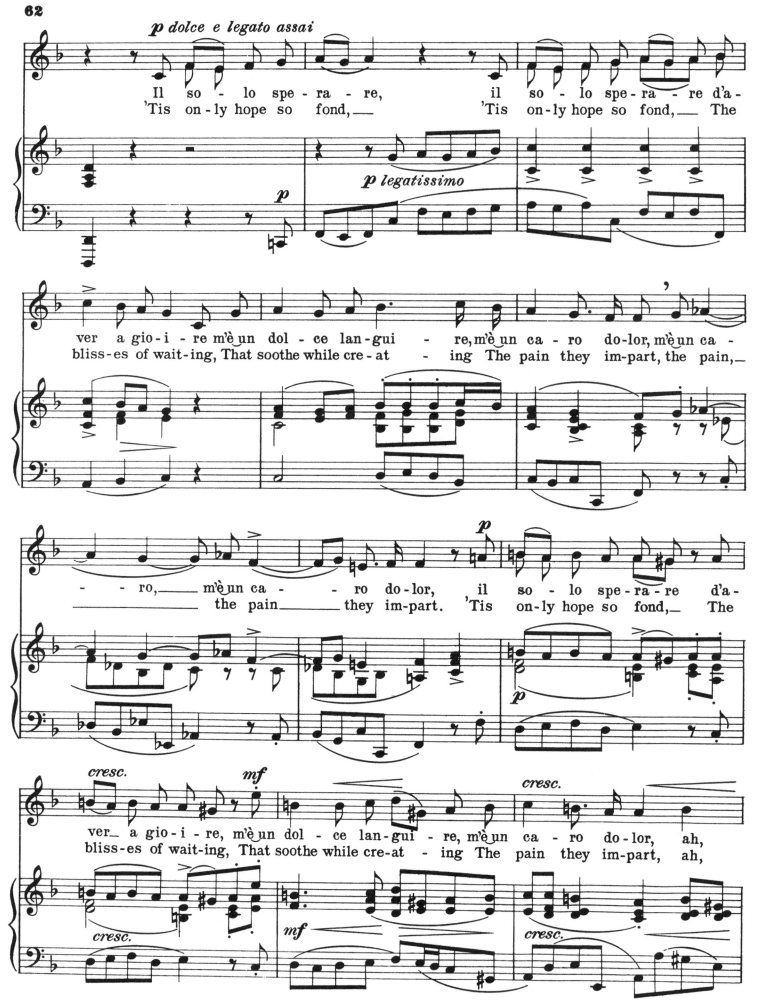

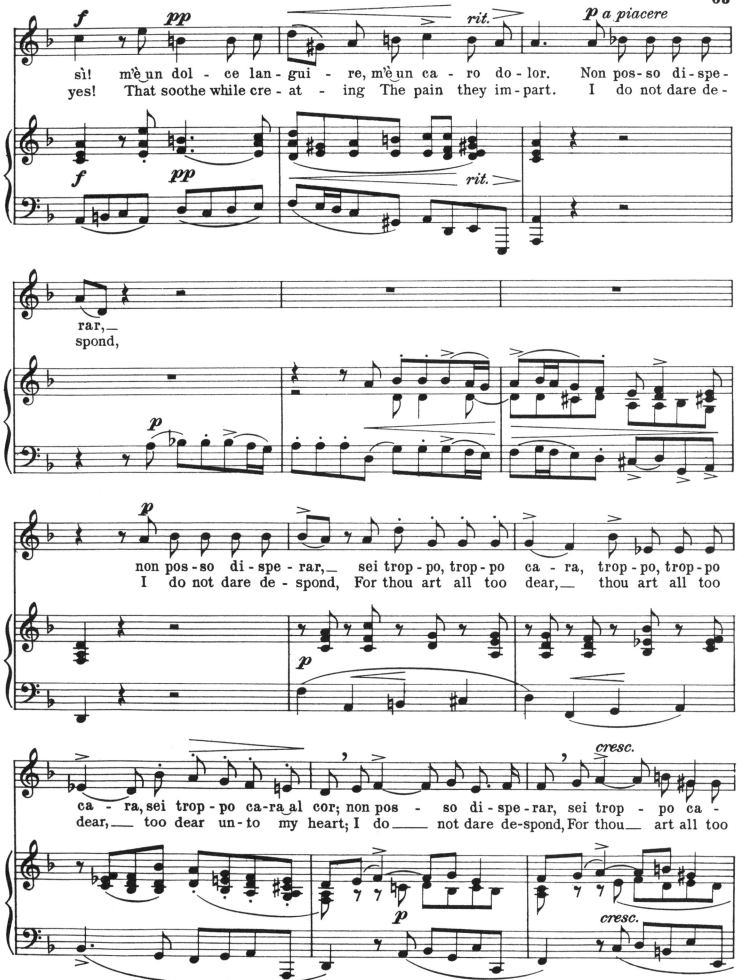

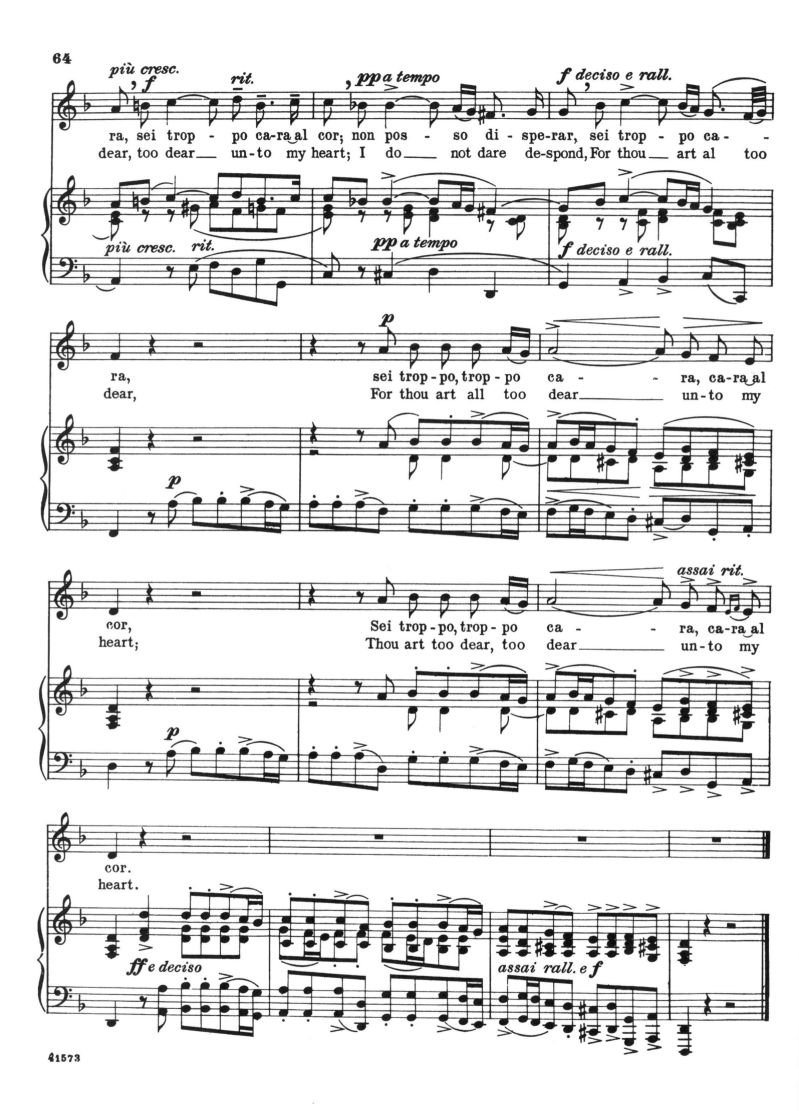

Lasciatemi morire!
No longer let me languish
Canto from the opera "Ariana"

English version by
Dr. Theodore Baker

Claudio Monteverdi
(1567-1643)

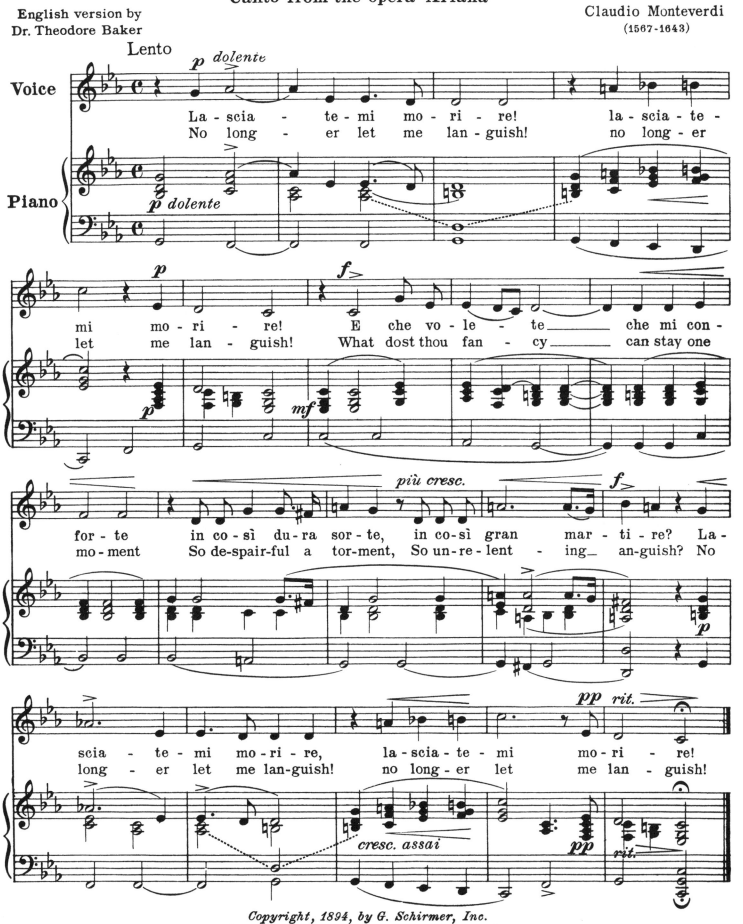

11573

Nel cor più non mi sento

Why feels my heart so dormant

Arietta

English version by
Dr. Theodore Baker

Giovanni Paisiello
(1740-1816)

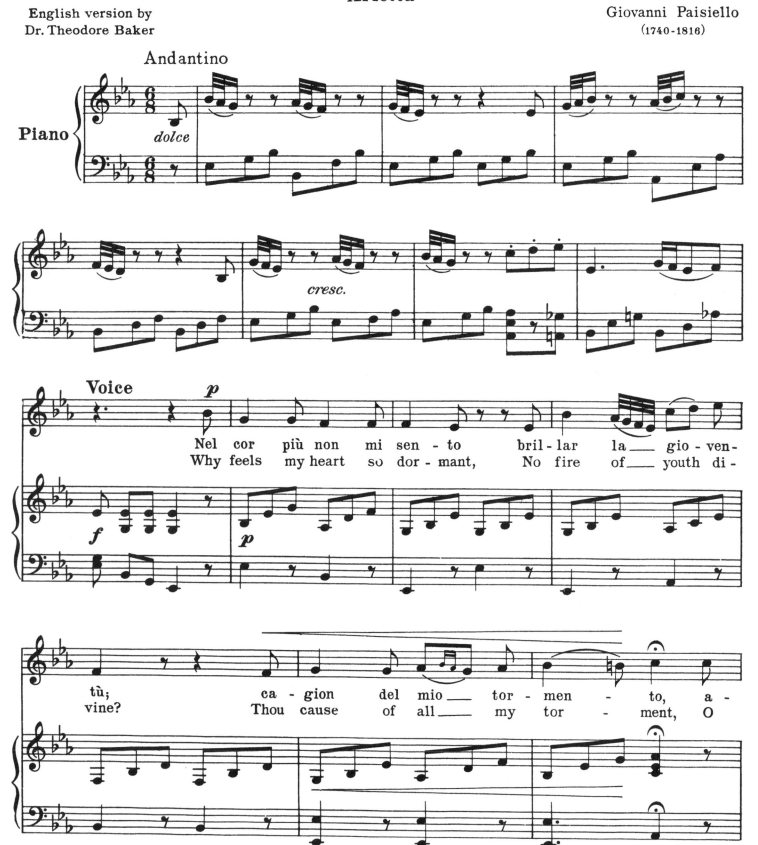

Nel cor più non mi sen - to bril - lar la___ gio - ven -
Why feels my heart so dor - mant, No fire of___ youth di -

tù; ca - gion del mio___ tor - men - to, a -
vine? Thou cause of all___ my tor - ment, O

41573

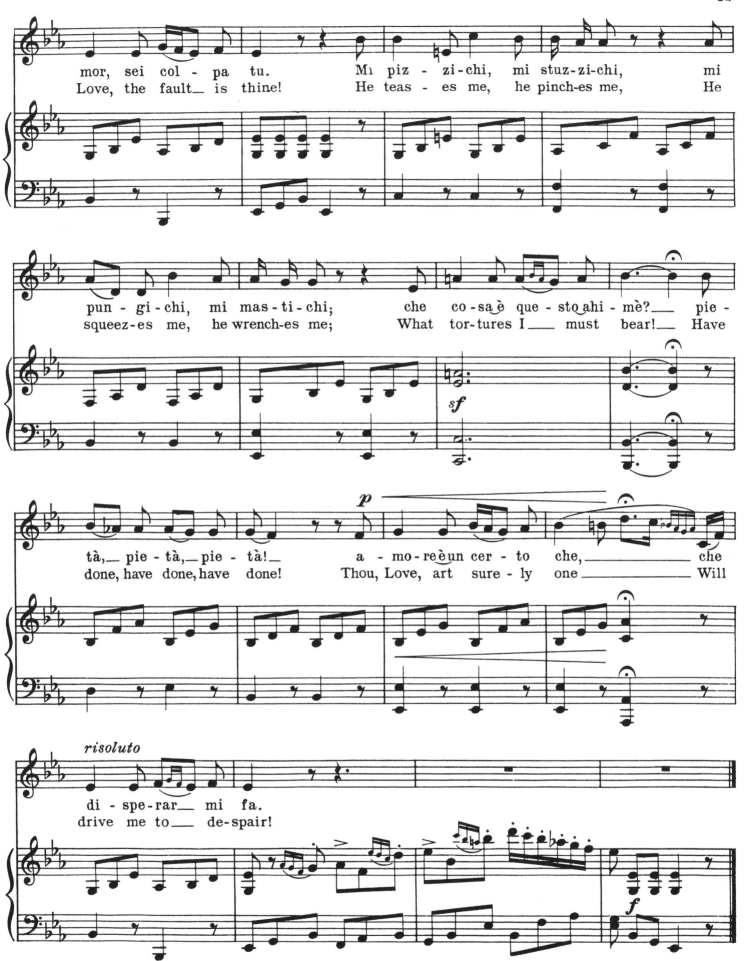

mor, sei col - pa tu.
Love, the fault __ is thine!

Mi piz - zi - chi, mi stuz-zi-chi,
He teas - es me, he pinch-es me,

mi
He

pun - gi - chi, mi mas-ti-chi;
squeez-es me, he wrench-es me;

che co - sa è que - sto ahi - mè? __ pie -
What tor-tures I __ must bear! __ Have

tà, __ pie - tà, __ pie - tà! __
done, have done, have done!

a - mo - re è un cer - to che, __ che
Thou, Love, art sure - ly one __ Will

risoluto

di - spe - rar __ mi fa.
drive me to __ de-spair!

Se tu m'ami, se sospiri

If thou lov'st me

Arietta

English version by
Dr. Theodore Baker

Giovanni Battista Pergolesi
(1710-1736)

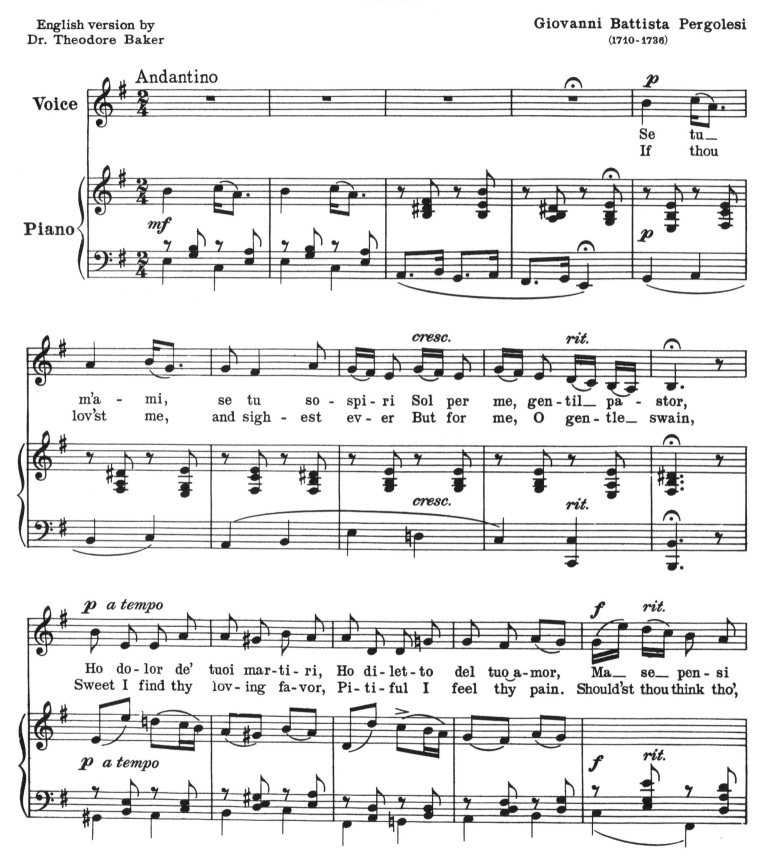

41573

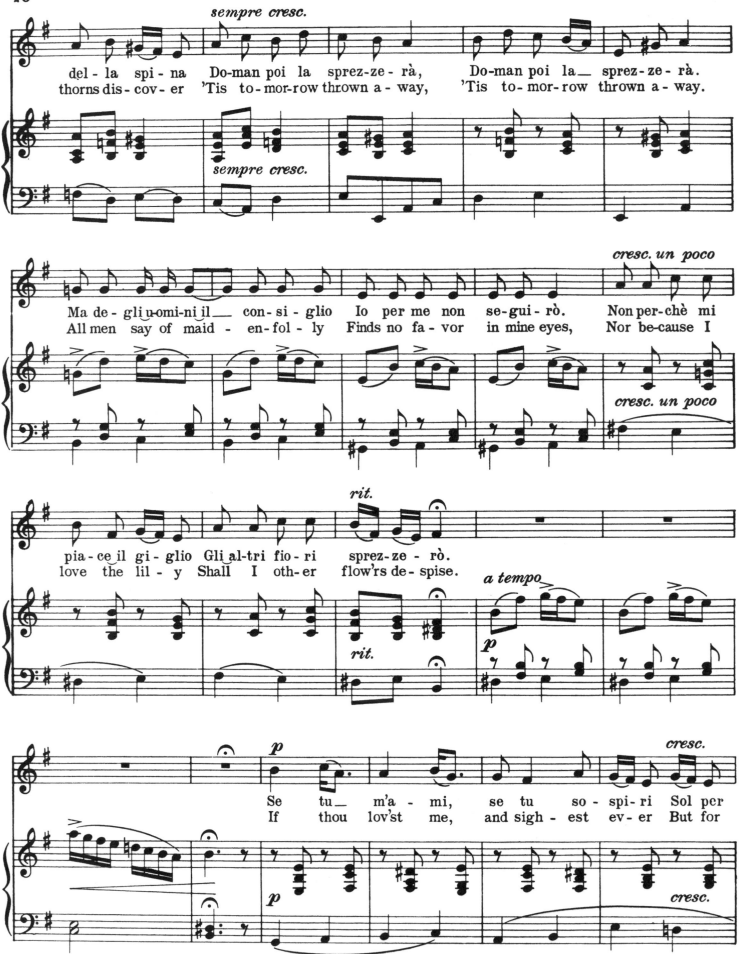

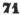

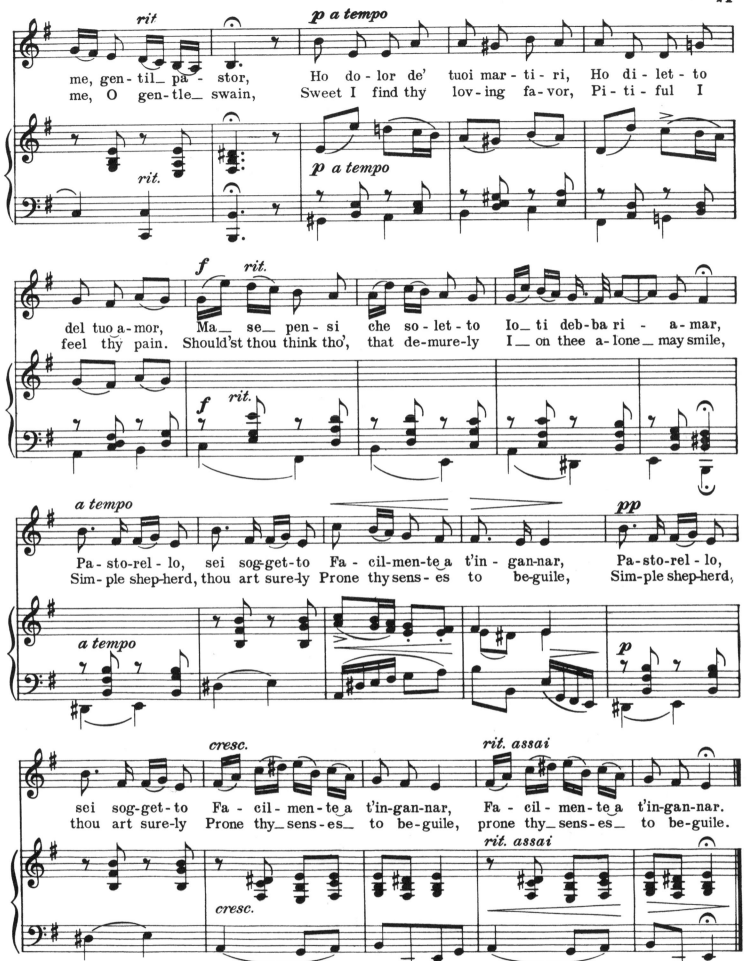

me, gen-til_ pa - stor, Ho do-lor de' tuoi mar-ti-ri, Ho di-let-to
me, O gen-tle_ swain, Sweet I find thy lov-ing fa-vor, Pi-ti-ful I

del tuo a-mor, Ma_ se pen-si che so-let-to Io_ ti deb-ba ri - a-mar,
feel thy pain. Should'st thou think tho', that de-mure-ly I_ on thee a-lone_ may smile,

Pa - sto-rel - lo, sei sog-get-to Fa - cil-men-te a t'in - gan-nar, Pa-sto-rel - lo,
Sim - ple shep-herd, thou art sure-ly Prone thy sens-es to be-guile, Sim-ple shep-herd,

sei sog-get-to Fa - cil - men-te a t'in-gan-nar, Fa - cil - men-te a t'in-gan-nar.
thou art sure-ly Prone thy_ sens-es_ to be-guile, prone thy_ sens-es_ to be-guile.

Nina

Canzonetta

English version by
Dr. Theodore Baker

Attributed to
Giovanni Battista Pergolesi*
(1710-1736)

*Although this song was long attributed to Pergolesi, it was composed by Legrenzio Vincenzo Ciampi (1719 - ?)

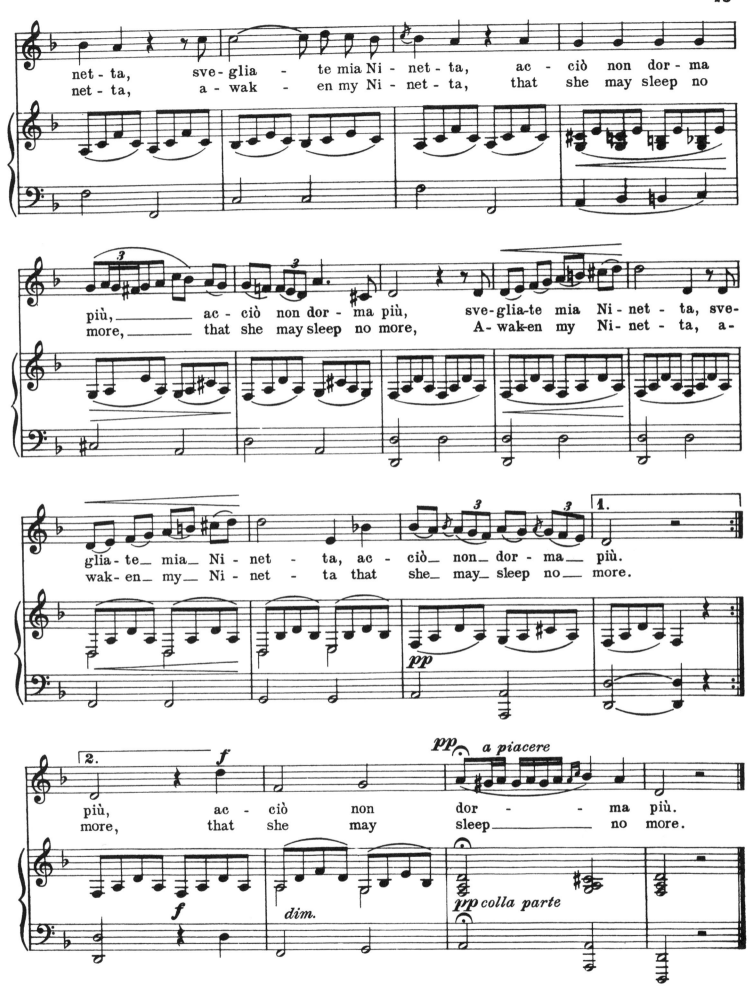

net - ta, sve - glia - te mia Ni - net - ta, ac - ciò non dor - ma
net - ta, a - wak - en my Ni - net - ta, that she may sleep no

più,_____ ac - ciò non dor - ma più, sve - glia-te mia Ni - net - ta, sve -
more,_____ that she may sleep no more, A - wak-en my Ni - net - ta, a -

glia-te mia Ni - net - ta, ac - ciò non dor - ma_ più.
wak-en my Ni - net - ta that she may_ sleep no_ more.

più, ac - ciò non dor - ma più.
more, that she may sleep_____ no more.

Già il sole dal Gange
O'er Ganges now launches
Canzonetta

English version by
Dr. Theodore Baker

Alessandro Scarlatti
(1659 - 1725)

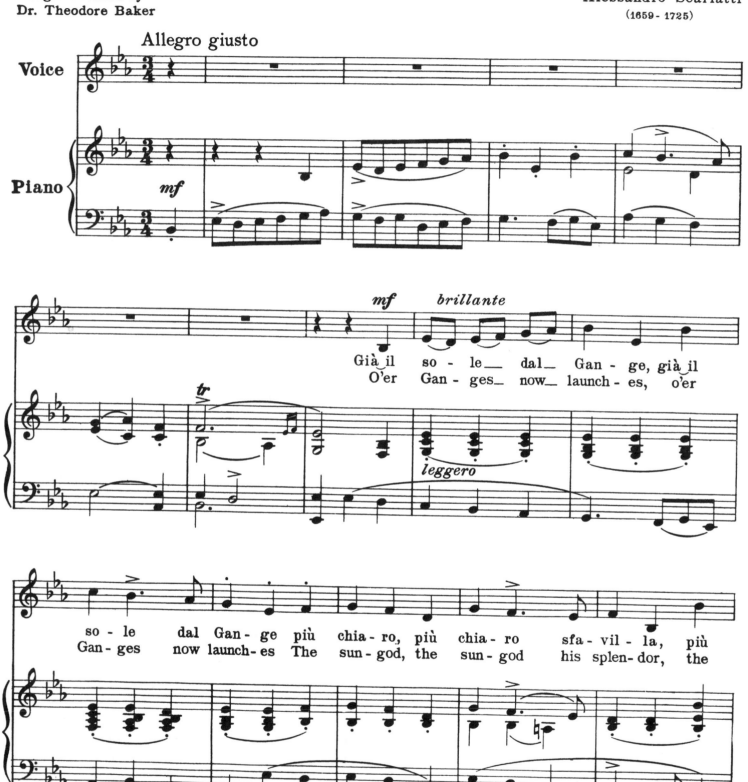

Già il so - le dal Gan - ge, già il
O'er Gan - ges now launch - es, o'er

so - le dal Gan - ge più chia - ro, più chia - ro sfa - vil - la, più
Gan - ges now launch - es The sun - god, the sun - god his splen - dor, the

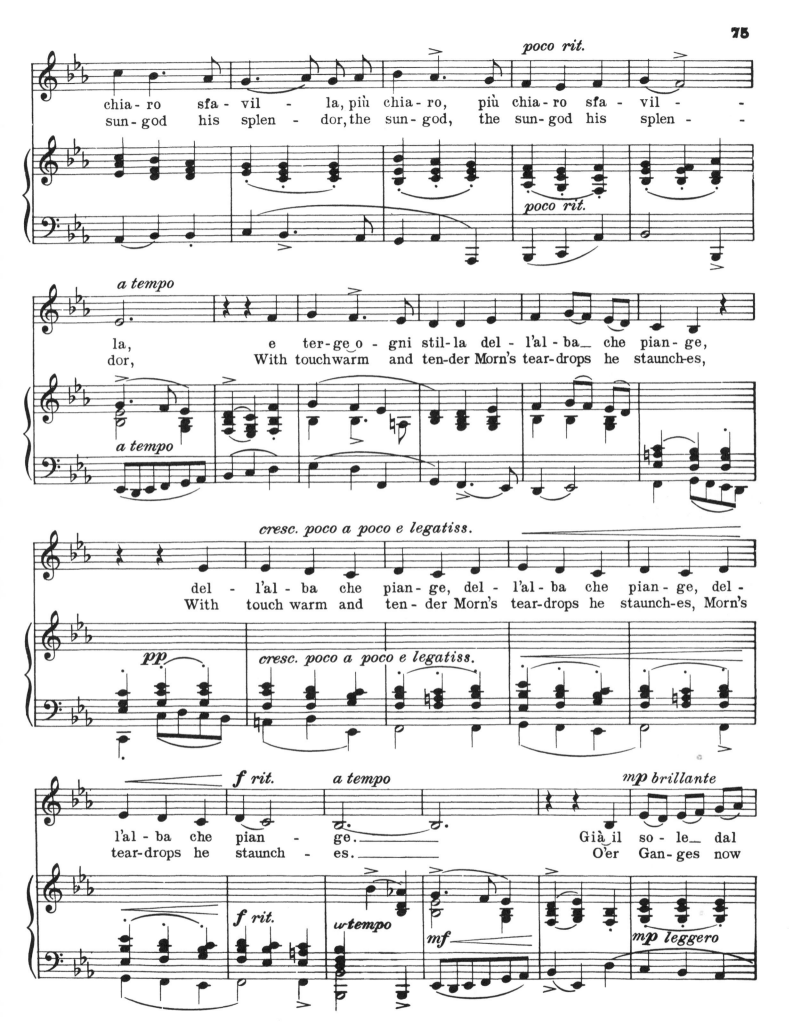

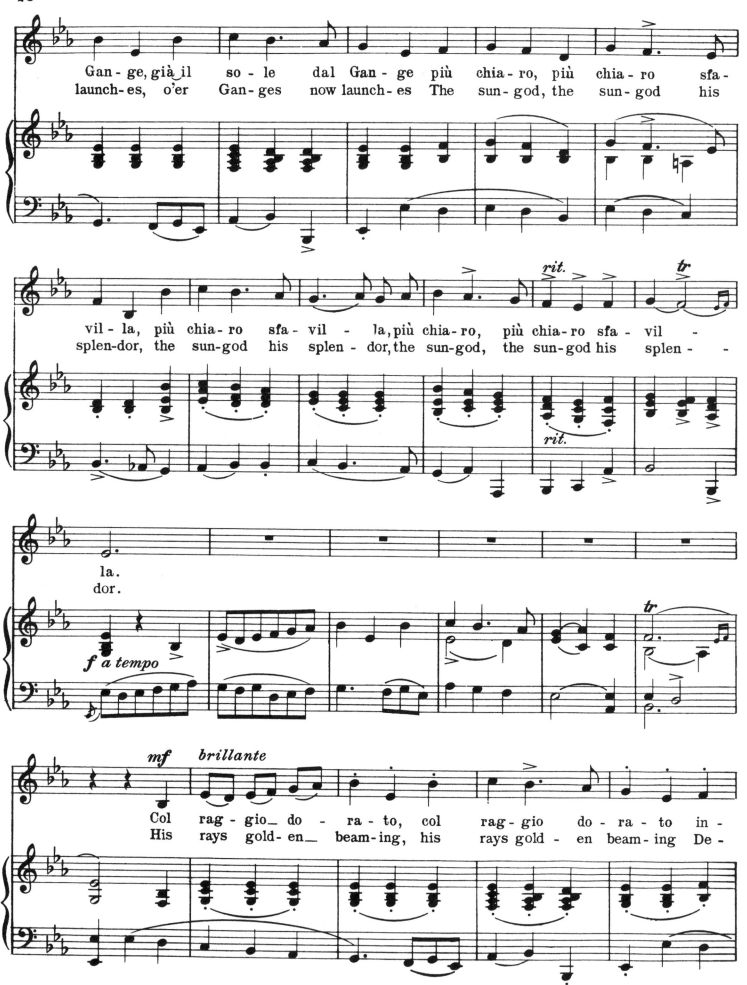

Le Violette
The Violets
Canzone

Alessandro Scarlatti
(1659 - 1725)

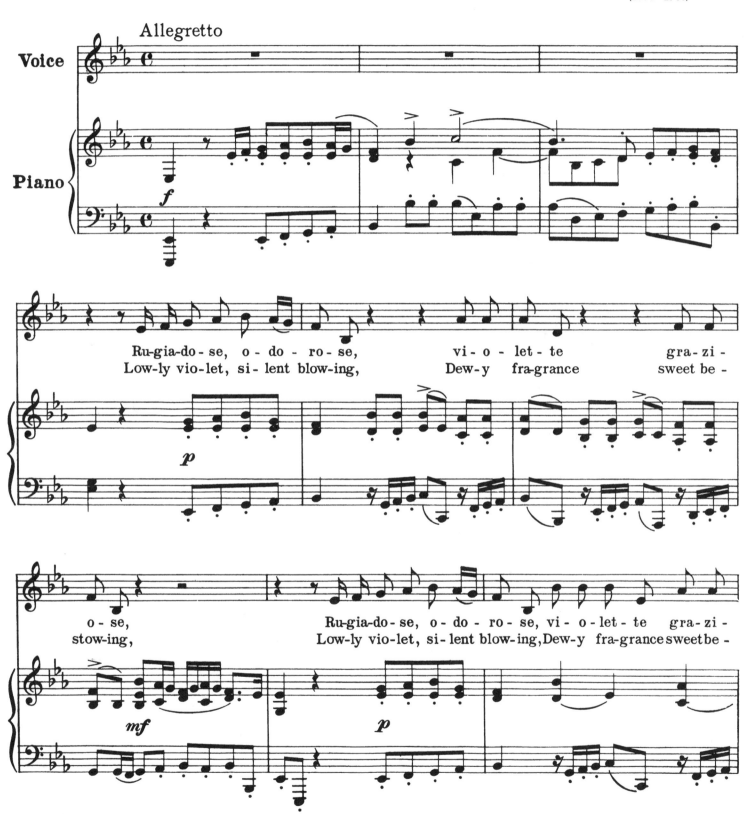

Ru-gia-do-se, o-do-ro-se, vi-o-let-te gra-zi-
Low-ly vio-let, si-lent blow-ing, Dew-y fra-grance sweet be-

o-se, Ru-gia-do-se, o-do-ro-se, vi-o-let-te gra-zi-
stow-ing, Low-ly vio-let, si-lent blow-ing, Dew-y fra-grance sweet be-

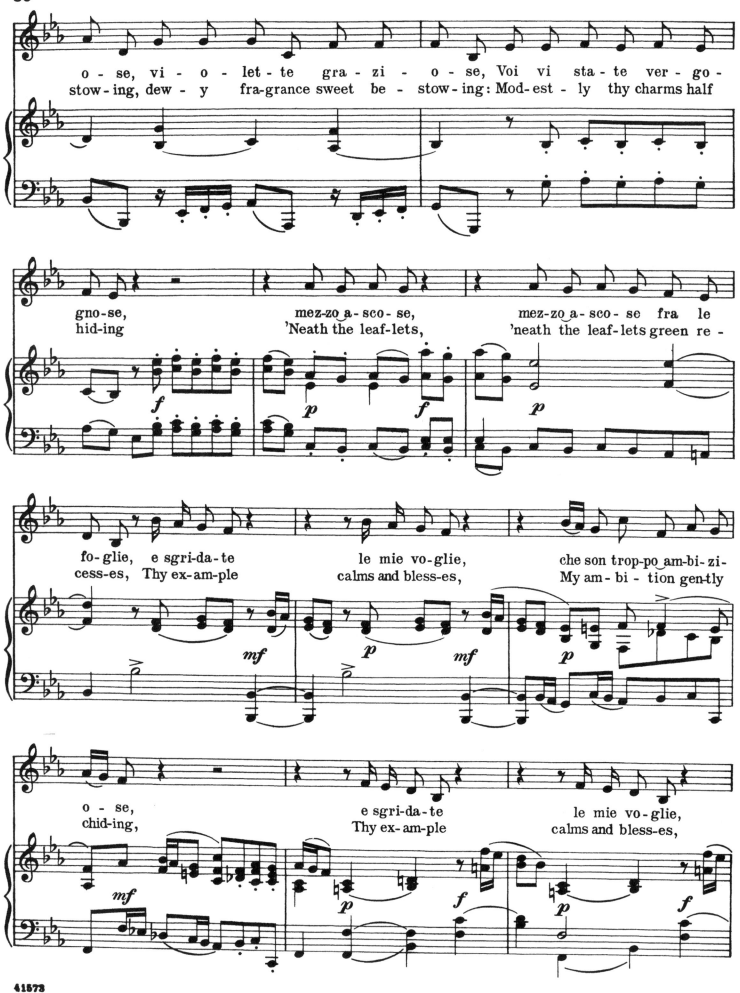

o - se, vi - o - let - te gra - zi - o - se, Voi vi sta - te ver - go -
stow - ing, dew - y fra-grance sweet be - stow - ing: Mod-est - ly thy charms half

gno - se, mez-zo a-sco - se, mez-zo a-sco - se fra le
hid - ing 'Neath the leaf-lets, 'neath the leaf-lets green re -

fo - glie, e sgri-da-te le mie vo-glie, che son trop-po am-bi-zi-
cess - es, Thy ex-am-ple calms and bless-es, My am - bi - tion gen-tly

o - se, e sgri-da-te le mie vo-glie,
chid-ing, Thy ex-am-ple calms and bless-es,

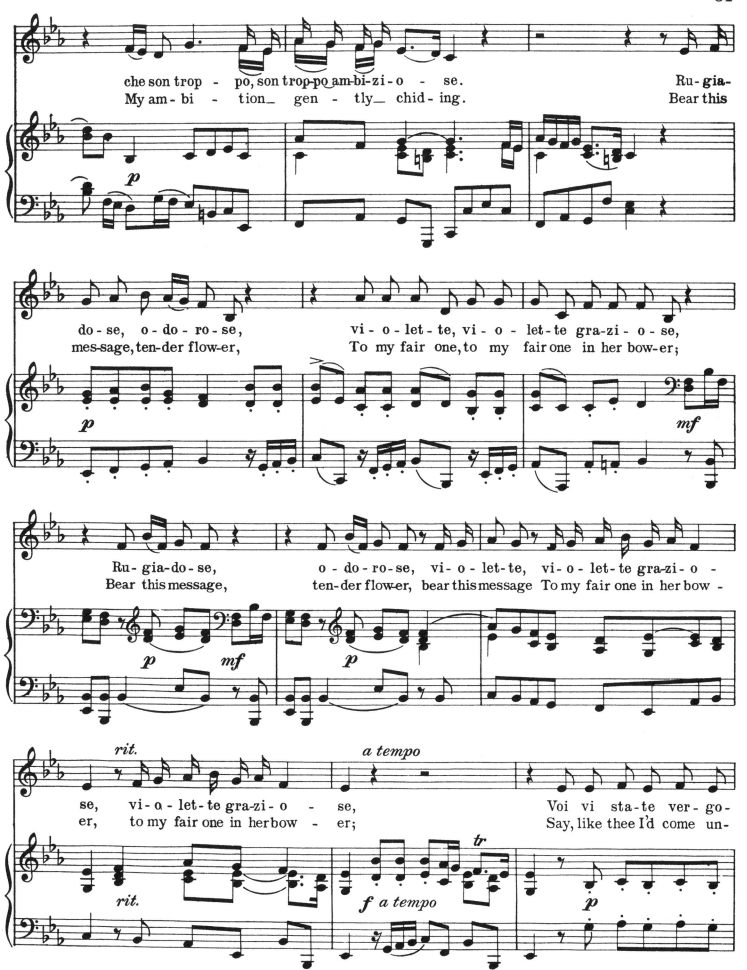

che son trop - po, son trop-po am-bi-zi-o - se. Ru-gia-
My am - bi - tion gen - tly chid - ing. Bear this

do - se, o - do - ro - se, vi - o - let - te, vi - o - let - te gra-zi-o - se,
mes-sage, ten-der flow-er, To my fair one, to my fair one in her bow-er;

Ru - gia-do - se, o - do - ro - se, vi - o - let - te, vi - o - let - te gra-zi-o -
Bear this message, ten-der flow-er, bear this message To my fair one in her bow -

se, vi - o - let - te gra-zi-o - se, Voi vi sta - te ver-go-
er, to my fair one in her bow - er; Say, like thee I'd come un-

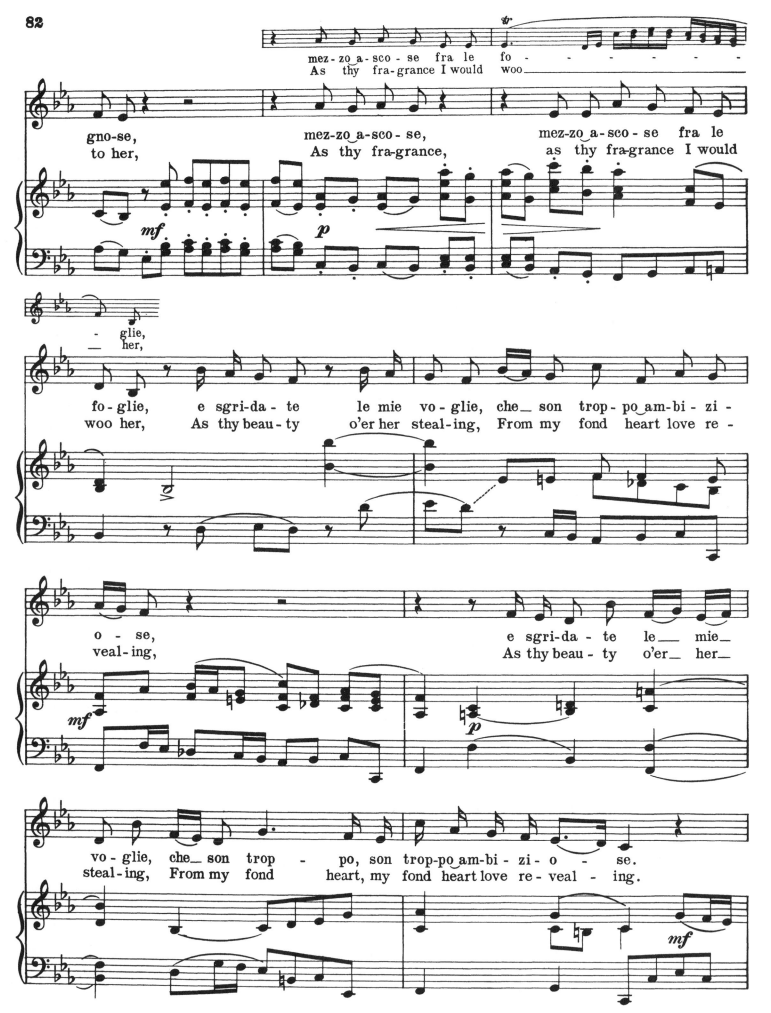

mez-zo a-sco-se fra le fo - - - - - -
As thy fra-grance I would woo _____

gno-se, mez-zo a-sco-se, mez-zo a-sco-se fra le
to her, As thy fra-grance, as thy fra-grance I would

- glie, e sgri-da - te le mie vo-glie, che_ son trop-po am-bi-zi-o
her, As thy beau-ty o'er her steal-ing, From my fond heart love re-

o-se, e sgri-da-te le_ mie
veal-ing, As thy beau-ty o'er_ her_

vo-glie, che_ son trop - po, son trop-po am-bi-zi-o - se.
steal-ing, From my fond heart, my fond heart love re-veal-ing.

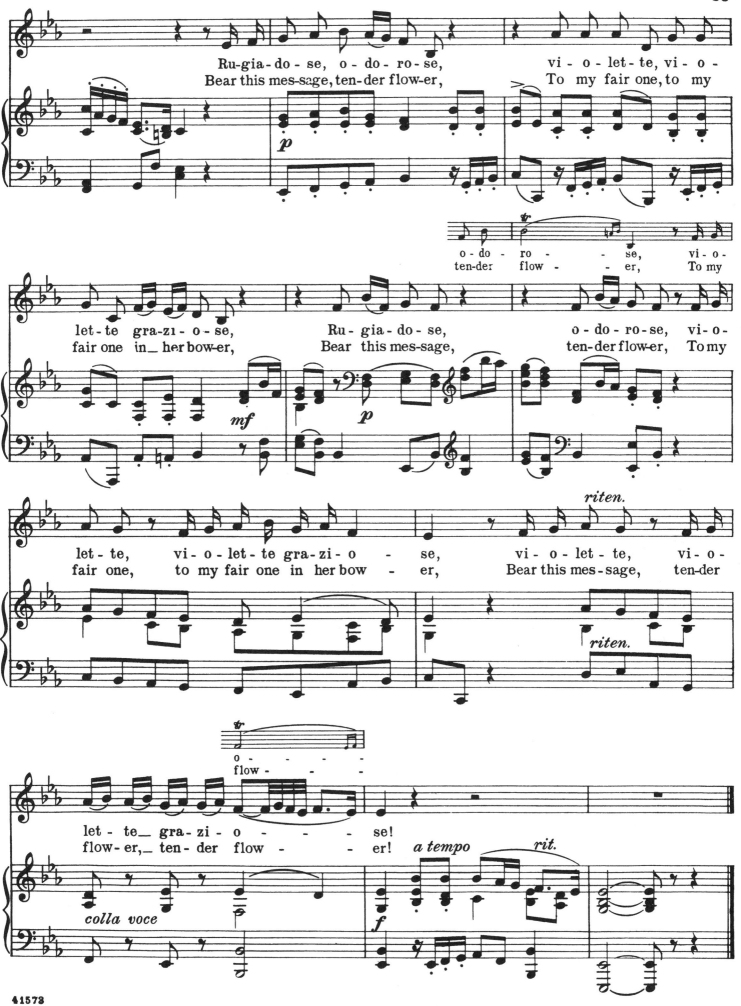

41573

O cessate di piagarmi
O no longer seek to pain me
Arietta

English version by
Dr. Theodore Baker

Alessandro Scarlatti
(1659-1725)

41573

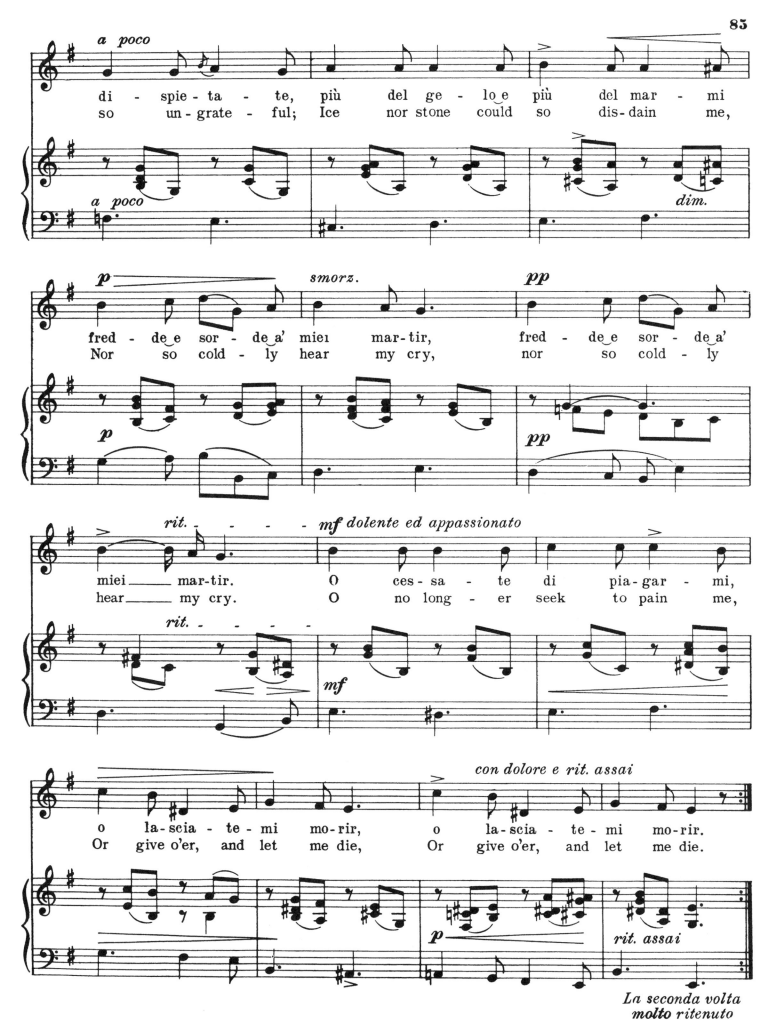

Se Florindo è fedele
Should Florindo be faithful
Arietta

English version by
Dr. Theodore Baker

Alessandro Scarlatti
(1659 - 1725)

Allegretto grazioso, moderato assai

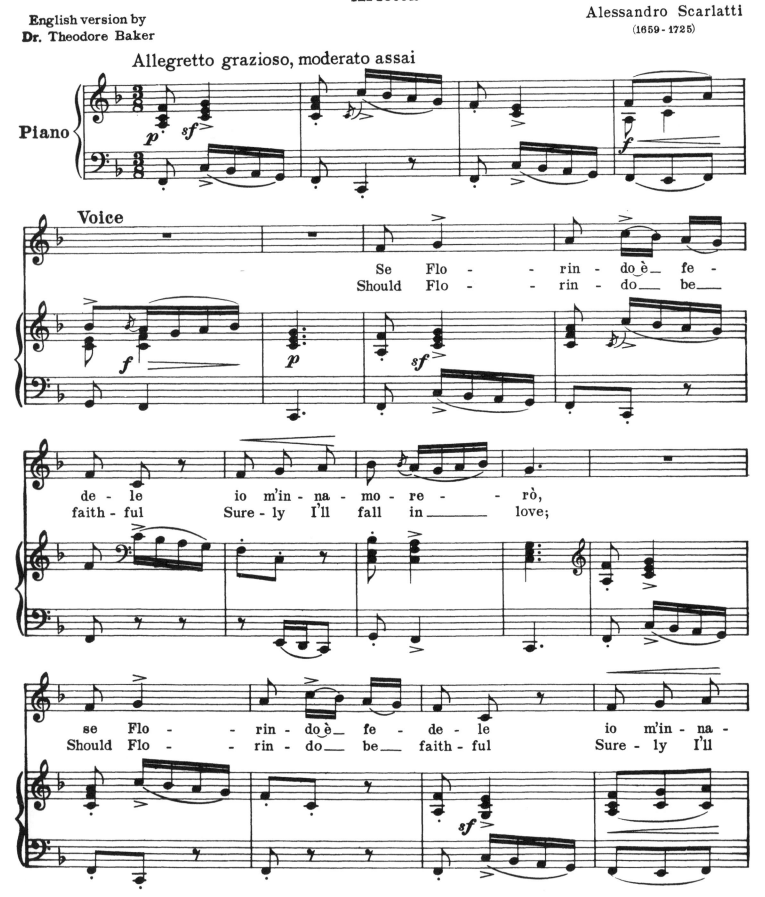

Se Flo - rin - do_è_ fe - de - le io m'in - na - mo - re - rò, se Flo - rin - do_è_ fe - de - le io m'in - na

Should Flo - rin - do_ be_ faith - ful Sure - ly I'll fall in _____ love; Should Flo - rin - do_ be_ faith - ful Sure - ly I'll

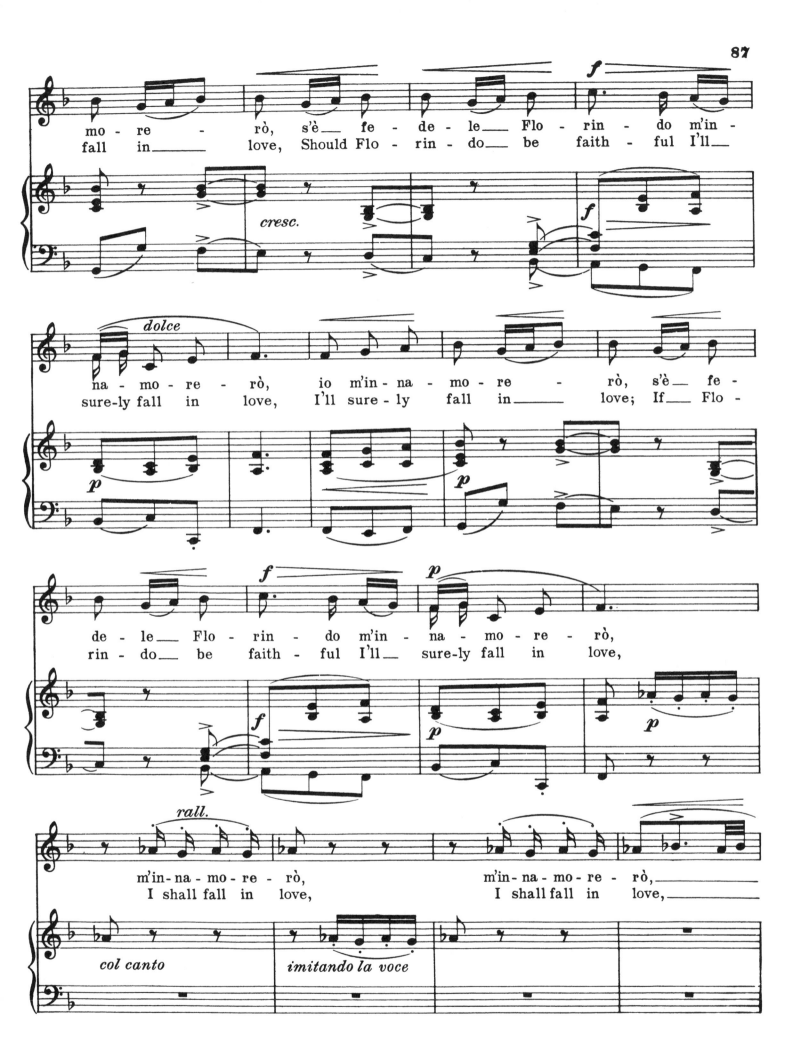

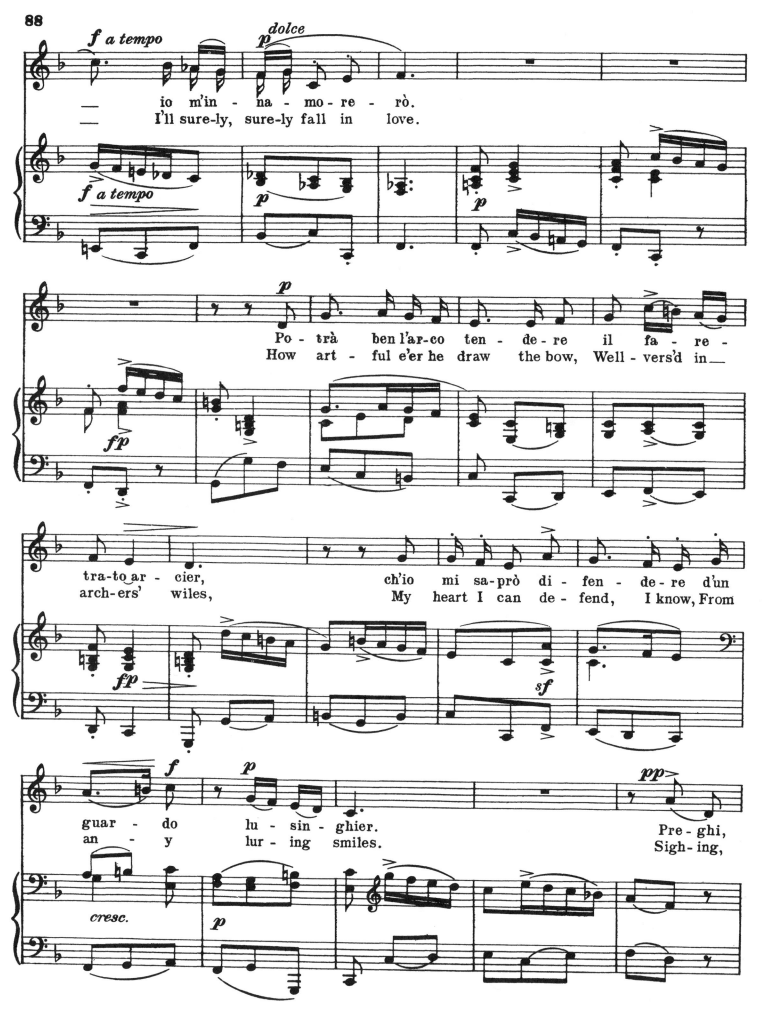

io m'in - na - mo - re - rò.
I'll sure-ly, sure-ly fall in love.

Po - trà ben l'ar-co ten - de - re il fa - re -
How art - ful e'er he draw the bow, Well - vers'd in

tra-to ar - cier, ch'io mi sa-prò di - fen - de - re d'un
arch-ers' wiles, My heart I can de - fend, I know, From

guar - do lu - sin - ghier. Pre - ghi,
an - y lur - ing smiles. Sigh-ing,

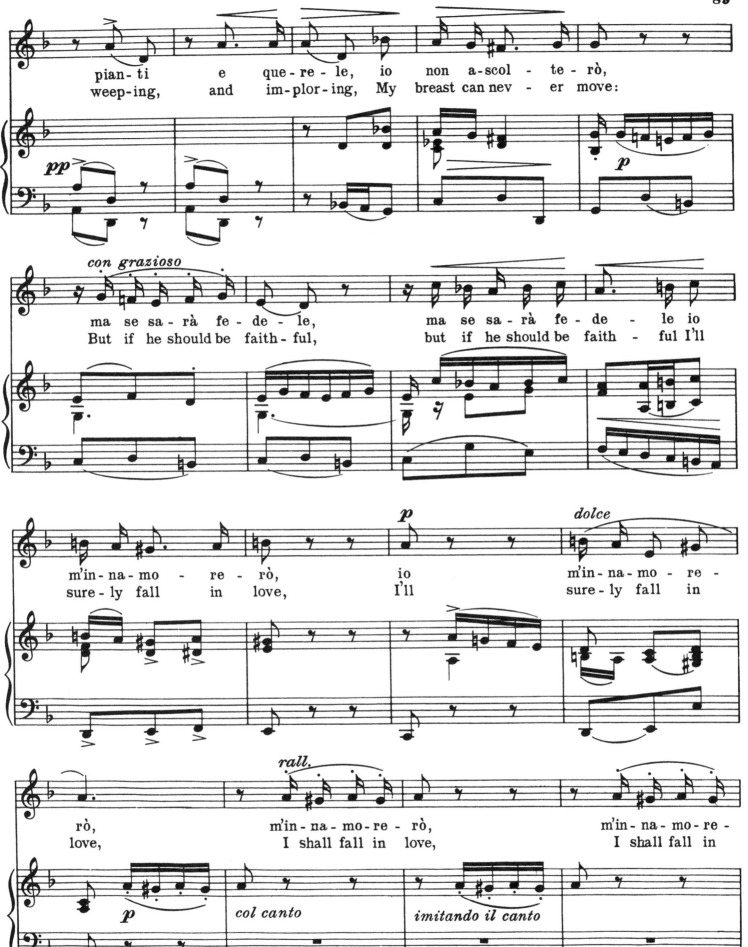

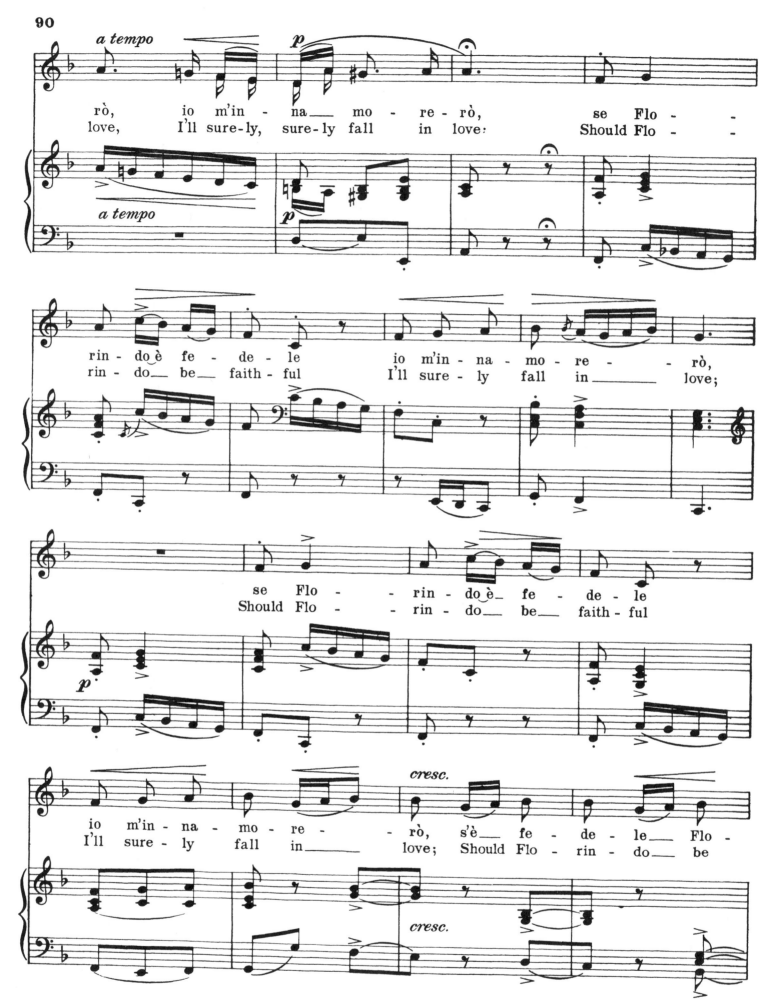

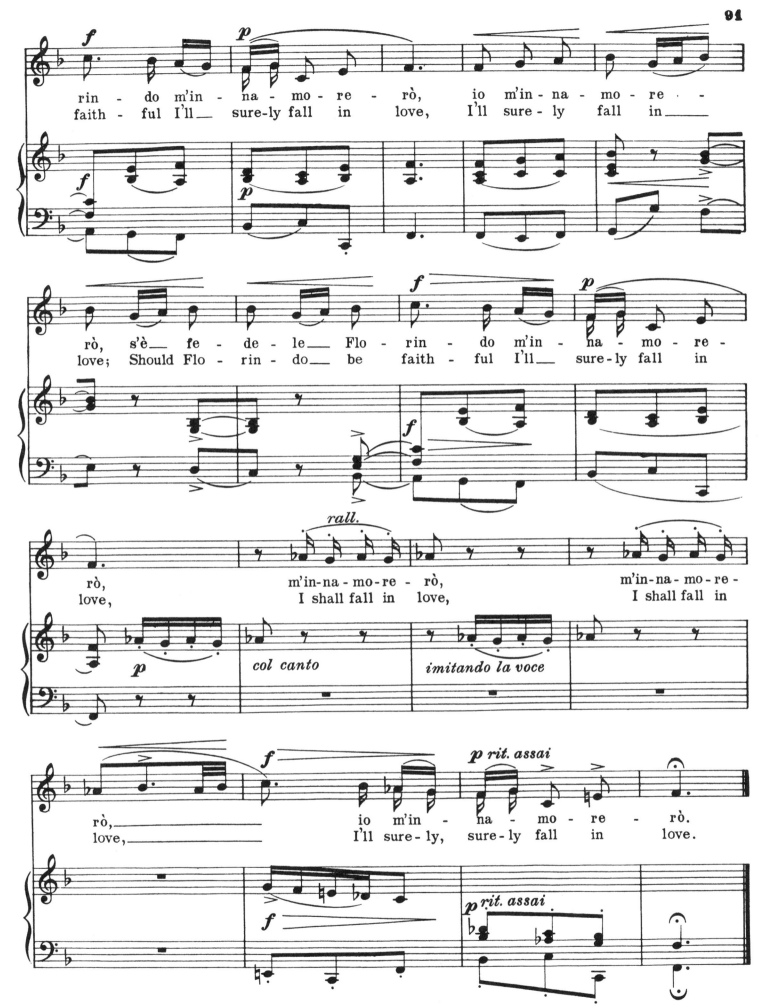

Pietà, Signore!
O Lord, have mercy

English version by
H. Millard

Alessandro Stradella
(1645?–1682?)

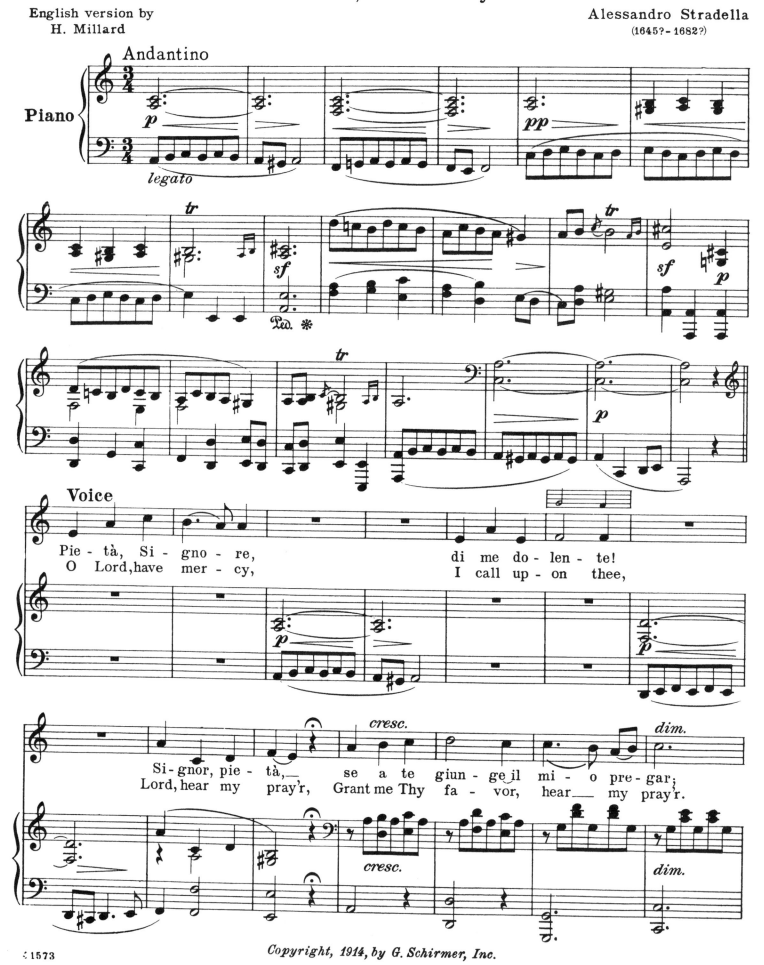

Pie - tà, Si - gno - re, di me do - len - te!
O Lord, have mer - cy, I call up - on thee,

Si - gnor, pie - tà,— se a te giun - ge il mi - o pre - gar;
Lord, hear my pray'r, Grant me Thy fa - vor, hear— my pray'r.

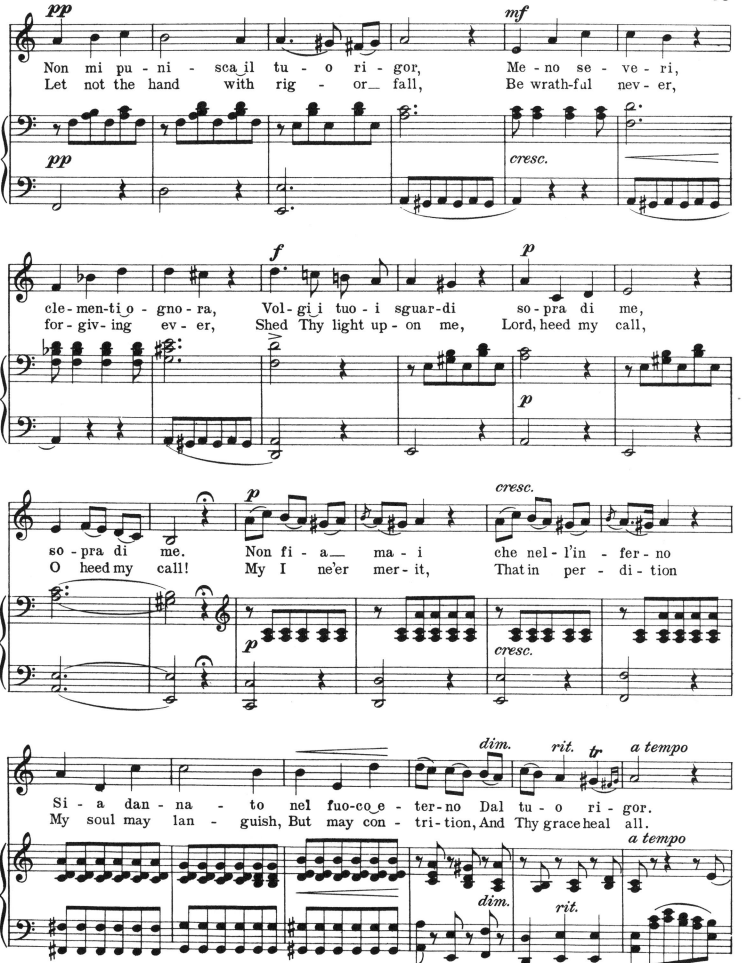

Non mi pu - ni - sca il tu - o ri - gor, Me - no se - ve - ri,
Let not the hand with rig - or fall, Be wrath - ful nev - er,

cle - men - ti o - gno - ra, Vol - gi i tuo - i sguar - di so - pra di me,
for - giv - ing ev - er, Shed Thy light up - on me, Lord, heed my call,

so - pra di me. Non fi - a mai che nel l'in - fer - no
O heed my call! My I ne'er mer - it, That in per - di - tion

Si - a dan - na - to nel fuo - co e - ter - no Dal tu - o ri - gor.
My soul may lan - guish, But may con - tri - tion, And Thy grace heal all.

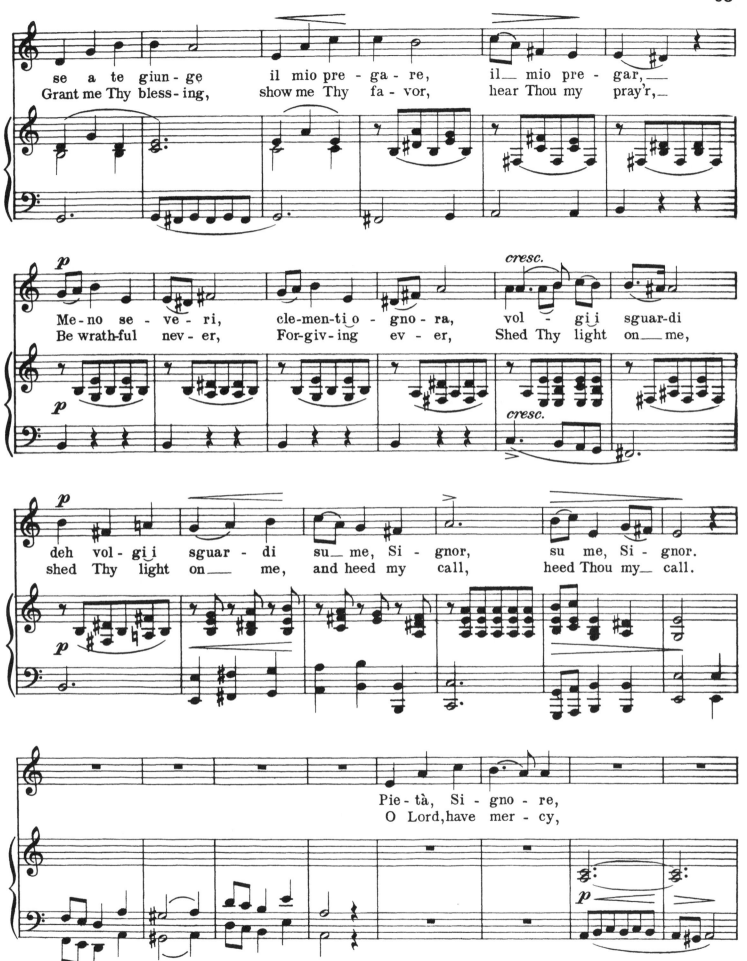

se a te giun - ge il mio pre - ga - re, il mio pre - gar, __
Grant me Thy bless - ing, show me Thy fa - vor, hear Thou my pray'r, __

Me - no se - ve - ri, cle - men - ti o gno - ra, vol - gi i sguar - di
Be wrath - ful nev - er, For - giv - ing ev - er, Shed Thy light on __ me,

deh vol - gi i sguar - di su __ me, Si - gnor, su me, Si - gnor.
shed Thy light on __ me, and heed my call, heed Thou my __ call.

Pie - tà, Si - gno - re,
O Lord, have mer - cy,

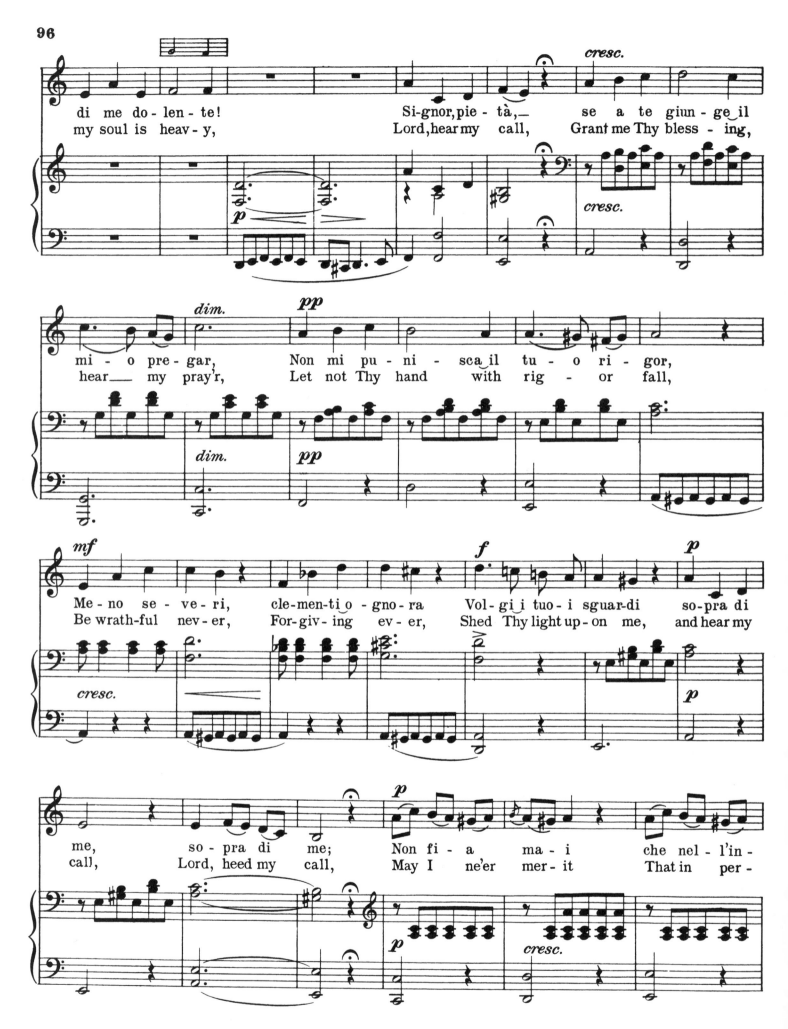

Tu lo sai
Ask thy heart

English version by
Everett Helm

Giuseppe **Torelli**
(1650-1703)

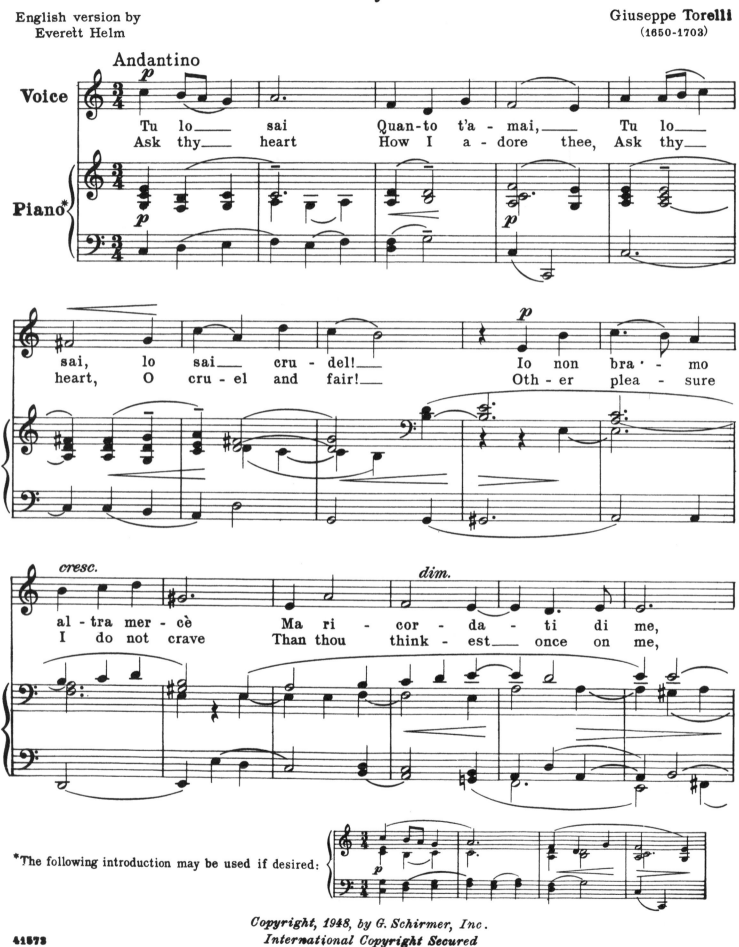

*The following introduction may be used if desired:

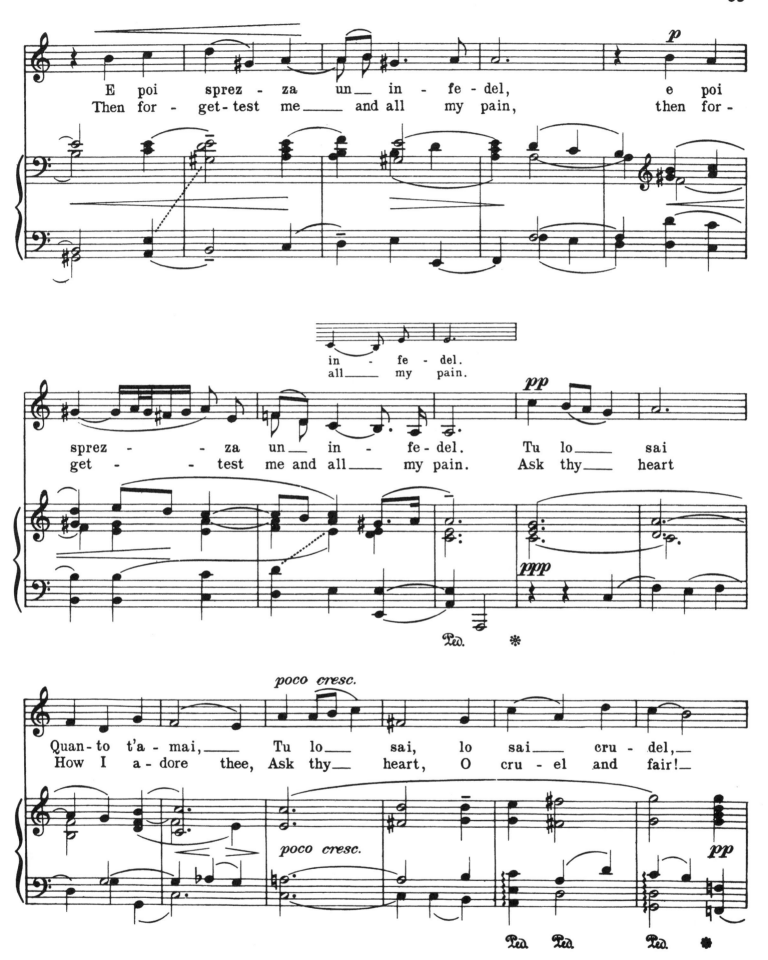

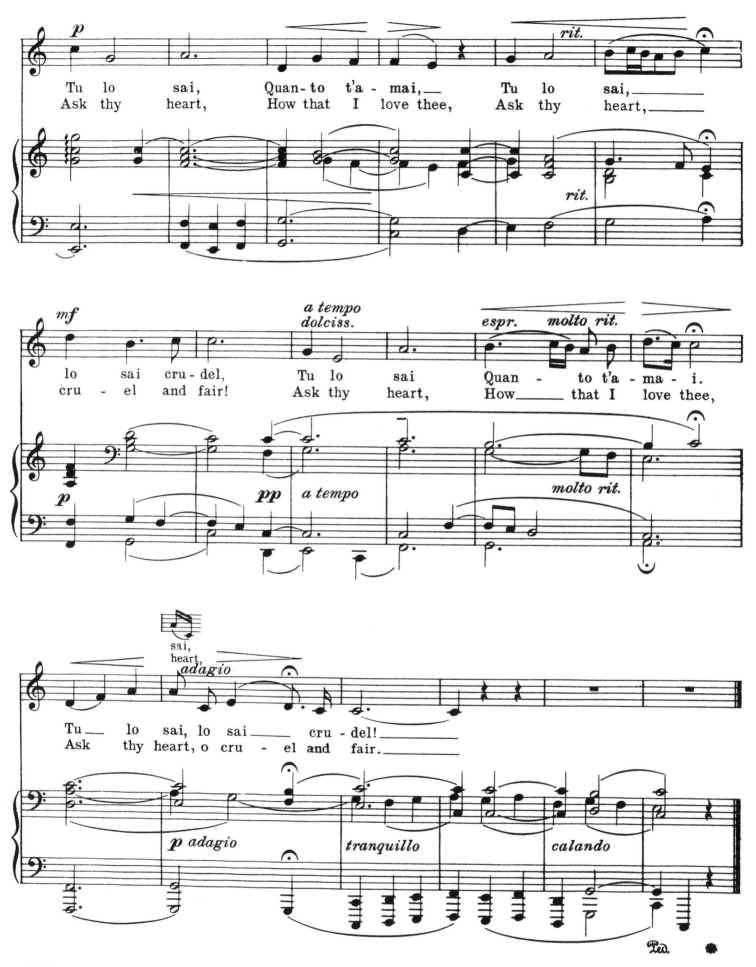

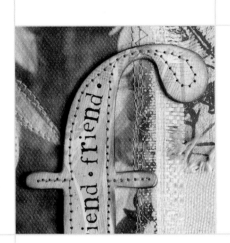

Art from the Heart

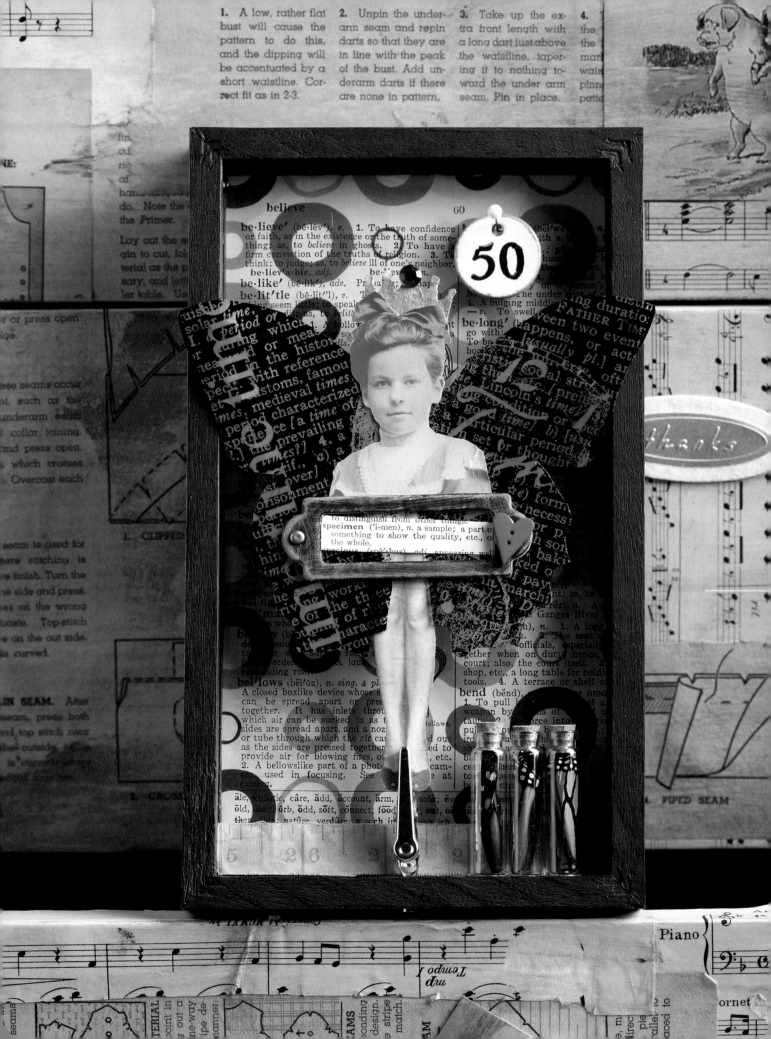

Art from the Heart

Mixed-Media Collage

Catherine Matthews-Scanlon

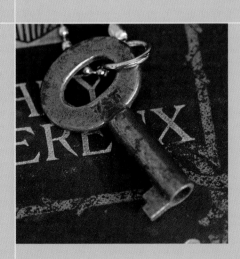

Martingale®
& COMPANY

If you have any questions or comments, please contact:

Kidara

Jo Packham

215 Historic 25th Street

Ogden, Utah 84401

Art from the Heart: Mixed-Media Collage
© 2007 by Catherine Matthews-Scanlon

Martingale & Company

20205 144th Ave. NE

Woodinville, WA 98072-8478 USA

www.martingale-pub.com

Credits

President & CEO	Tom Wierzbicki
Publisher	Jane Hamada
Editorial Director	Mary V. Green
Managing Editor	Tina Cook
Designer	Matt Shay
Photographer	Zac Williams
Copy Editor	Ana Maria Ventura

Printed in China

12 11 10 09 08 07 8 7 6 5 4 3 2 1

Library of Congress Cataloging-in-Publication Data

Library of Congress Control Number: 2007017335

ISBN: 978-1-56477-807-9

Mission Statement
Dedicated to providing quality products and service to inspire creativity.

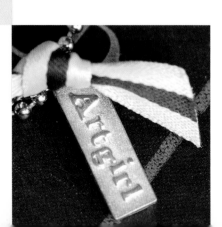

Foreword

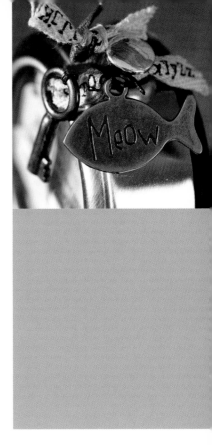

I have been intrigued with altered art projects for quite a long time. However, I initially didn't know where to start or even how to do many of the techniques used in this book. When I started teaching classes at a wonderful scrapbook store in Massachusetts, I was exposed to so many more unique products than my local craft store had to offer. My eyes were opened for the first time! I felt like a kid in a candy store—so many things to try and so much time to try them. I couldn't learn fast enough!

When my aunt gave me a funky quilt magazine with pictures of stitched photo quilts, my eyes opened even wider and I began experimenting. After reading new books and magazines, I became inspired to try new things. I had some time on my hands as well as a room all my own in which to create, which was just the recipe I needed in order to focus on teaching myself to make cool stuff with photographs. I believe it all happened because it was supposed to—I am meant to make great projects, but also to teach others!

The title of this book is a play on words—as if by working with our art supplies and photographs, heartfelt memories can be transformed into art. I love delving deep inside my mind, where there are images, thoughts, words, and possibly even music, all jumbled together and confused. Things that only I remember: the way my grandmother and I wrote to each other when I was a child, how I felt when my mom taught me how to sew, or the way I have always loved the history of my family and old photographs. By putting these private memories down on canvas or paper, my friends and family can take an active part in my memory. It's as if the materials and the time spent creating the art alters my memory, transforming it into a tangible piece. It's right there to be touched, glanced at, and shared with the world.

Your altered memories can be touched or opened, worn as an adornment, or bless the walls of your home. Encase them in paint, paper, fabric, glass, or metal—each memory will be creatively showcased and protected for the world to see. Projects in this book range from jewelry and wall hangings to tins and boxes, shrines, and more!

All the memories you have created in your lifetime don't have to remain hidden away inside your head—turn them into masterpieces to be shared! Let's get started.

CHAPTER 1 instructions, tools, and supplies

CHAPTER 2 jewelry and other little gems

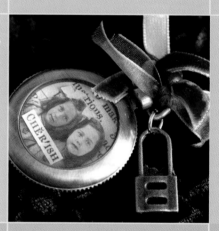

CHAPTER 3 adorning the walls

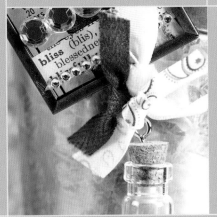

CHAPTER 4 glass ornaments

CHAPTER 5 clock shrines

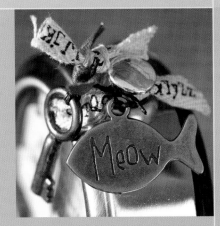

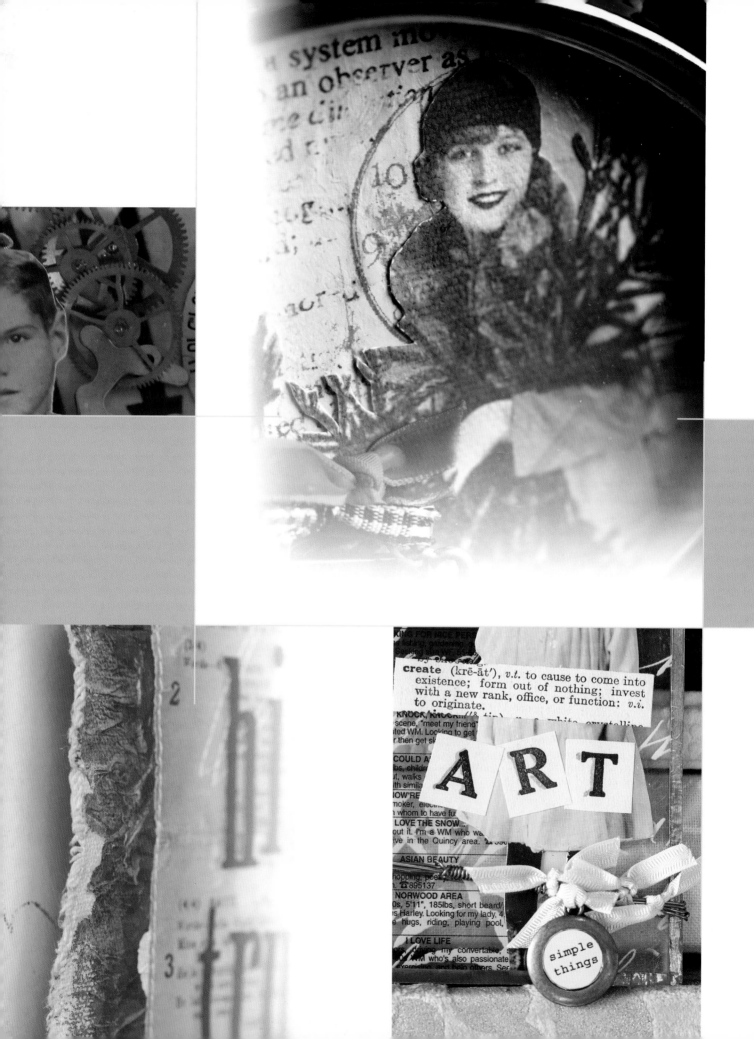

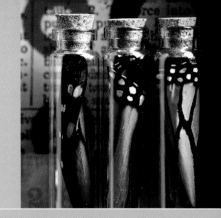

CHAPTER 1

instructions, tools, and supplies

Sometimes our memories invoke wonderful project ideas that we're not quite sure how to make into reality, while sometimes project supplies provide vast amounts of inspiration! Either way, this chapter will help you figure out what basic supplies you'll need to complete the projects in this book.

Decoupage

The word "decoupage" actually means "to cut out," while the person doing the cutting is called a *decouper*. This ancient technique goes back as far as the 12th century, when Chinese peasants used basic decoupage techniques to secure revered objects to make their own original art.

Wikipedia (www.wikipedia.org) defines decoupage as "the art of decorating an object by gluing colored paper cut-outs onto it in combination with special paint effects, gold leaf, etc. Commonly an object like a small box or an item of furniture is covered by cutouts from magazines or from purpose-manufactured papers. Each layer is sealed with varnishes (often multiple coats) until the 'stuck on' appearance disappears and the result looks like painting or inlay work."

I've used some decoupage techniques throughout this book, primarily using white glue or decoupage medium as the adhesive. The best adhesive products for decoupage techniques will spread easily and not dry too quickly to allow you to reposition pieces if necessary. This slow-drying characteristic will also allow you to place additional pieces before applying more glue.

Basic Glass Cutting

Cutting glass can be tricky, not to mention dangerous. You can never be too careful. Make sure your glass cutter is sharp, wear safety glasses, and protect your work surface with newspapers. A well-oiled glass cutter will produce the best results. In order to cut glass, you will need a general-purpose glass cutter, a metal ruler, and a permanent marker.

Note: This process works best for straight lines. Round or curved pieces require additional tools.

First, mark the desired size on the glass using the ruler and marker. If you are not experienced in glass cutting and the cut is to be made within 1" of the edge of the glass, running pliers should be used.

After thoroughly reading the package instructions that accompanied your cutting tool, place the ruler's edge along the marker line and, slowly but firmly, run the glass cutter down the length of the glass. Make sure you do not stop in the middle or try to repeat the score from the top to the bottom. You are committed to this cut now, and rescoring the glass can yield less-than-satisfactory results.

Gently tap the ball end of the tool along the scored line in several places. Sometimes you will be able to see tiny hairline cracks emerge from the scored line, although this is not always the case.

Finally, place the glass face up on a flat, hard surface with the score line at the edge. Apply gentle but even pressure to force the glass to break along the scored line. *Note: Sometimes, if I am feeling uncomfortable with my glass-cutting abilities, I will wear gloves during this process for peace of mind.*

Of course, if you prefer not to cut your own glass, your local frame shop can cut your glass to size for a nominal fee.

Crackle Process Medium

This antiquing process, which is easily one of my favorites, can make a piece of wood or paper look as though you have added 100 years to it. All in an instant! It's very easy, and the results can be so unexpected.

Two-step crackle process medium will create a good crackle—any brand will do as they all work equally well. Following the manufacturer's directions, apply Step 1 over tissue paper, acrylic paint, or any other surface. Allow Step 1 to thoroughly dry, then apply Step 2. *Note: If you do not allow the crackle medium to dry between applications, and the two steps are mixed, you'll get mixed results.*

Play around with crackle medium to achieve the effect that you want—thick, deep cracks will result from applying a really thick coat of each step, while tiny cracks can be achieved by layering the steps two to five times each. It's an amazing look when the cracks turn out just right.

After the final layer of crackle is dry, seal your surface with a clear, matte varnish before applying any other medium to the project.

Ultra-Thick Embossing Powder

This magical powder can be used in a number of ways, simply by applying a little heat to the powder until it melts. While many people like to use it for creating a watermark on their paper, I use it to make a hard, shiny coating on metal or photographs, or to embalm objects. To use this embossing powder to create a watermark, simply follow the manufacturer's instructions.

Ultra-thick embossing powder is great for sealing pendants and other jewelry-type projects. First off, if the end project ever cracks, simply applying a little heat results in a brand new finish. Secondly, it doesn't require mixing and working before the epoxy sets up. It's very easy to re-melt the embossing

powder to remove bubbles or other imperfections, and adding watch parts, charms, or other metal pieces to the powder before it is melted will permanently secure the piece inside the final project. *Note: Make sure not to use plastic, as it will melt in the heating process described on page 18 for Pendant and Keychain Set.*

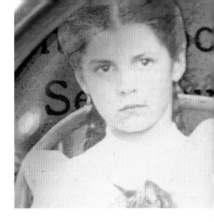

Triple-Thick Clear Glaze

This great spray adds a very shiny, clear glaze. It doesn't yellow, and just one application will seal and protect your beautiful art. One application is like two or three applications of a standard glaze because it's very thick. Be sure to have adequate ventilation when using this glaze, or spray outside, as the fumes are very toxic.

Acrylic Paint

There are so many brands and colors available, it can be hard to determine which acrylic paint is best to use. The higher-end two-ounce bottles spread more easily and dry more quickly; however, I generally find that the right color is more important than using any particular brand. After all, paint is paint!

Antique Pictures to Digital Images

Oftentimes, I don't want to use my original image because it has sentimental value or it is one-of-a-kind. To create a copy, I scan the image using my scanner, then remove any imperfections that may have happened during the years the photograph has been around. I then import the photographs into my photo editing program, and print them on various mediums. This way, I can work with the copies and save the originals.

Printing Mediums

There are so many choices to make when looking for unique products to print your scanned images on. Here are just a few ideas to get you started!

Ribbon or Twill: I have successfully printed on twill, muslin, and other mediums that I prepared myself. When printing on twill, it is best to design your words or art first, then print on a regular sheet of paper as a test run. Once you are satisfied with the output, apply strong double-stick tape over the printed text on the paper. Adhere the twill to the paper, making sure it is tightly secured from the top to the bottom of the paper. Run paper-and-twill through the printer. *Note: Taping the twill to the paper will help prevent the twill from jamming the printer, as well as the horrendous sound that accompanies a twill jam.*

Fabrics: You can purchase commercially prepared fabrics for use with your printer, which are much easier than preparing them yourself. I have found great 8$\frac{1}{2}$" x 11" sheets of muslin, cotton, and duck cloth, all of which work wonderfully with my printer. Just follow the manufacturer's instructions for perfect results. If you do choose to prepare your own fabric, cotton muslin can be a good choice. Soak it in fabric starch to stiffen, then allow to dry. Once dry, iron, trim to a size that will fit your printer's specifications, and print.

Canvas or Art Papers: A variety of art papers can be used with the techniques in this book. Prepared canvases, art papers specifically for reproducing artworks, and watercolor paper can all be useful. Watercolor paper can also be trimmed to size and used in your printer, as long as it is not one of the heavier weights. Check your printer specifications to see what weight you can successfully print on.

Photo Paper: Photo paper manufacturers are a dime a dozen—and in this case it's true that you pay for what you get! Oftentimes, spending a few extra dollars for the highest-quality paper is best, as it prevents fading. Several years ago, I purchased a wonderful weight and texture of paper at my local craft store. However, after using the paper for quite some time, I discovered that any photo printed on it that was exposed to light for several months began to fade very quickly. A black-and-white photo would disappear within six months. You can retard this process by using preservative sprays made specifically for inkjet-printed images. I highly recommend combining high-quality photo paper with a preservative spray for lasting results.

20 lb. Bond: I love using this paper when I am printing images that I plan to use with ultra-thick embossing powder. By printing on bond paper and following the Pendant and Keychain Set instructions on page 18, the watermark ink will cause the paper to become translucent and show off the patterned paper behind it. When printing large images and superimposing them over text or handwritten words, the words show through the photograph—yet the image can still be seen. It's just like magic and can yield beautiful and amazing results.

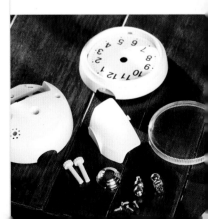

Transparencies: These clear plastic sheets are often used with overhead projectors. Some of the projects in this book use transparencies to create inexpensive, original backgrounds. Simply print or photocopy copyright-free images onto transparency sheets as you would print or photocopy on regular paper.

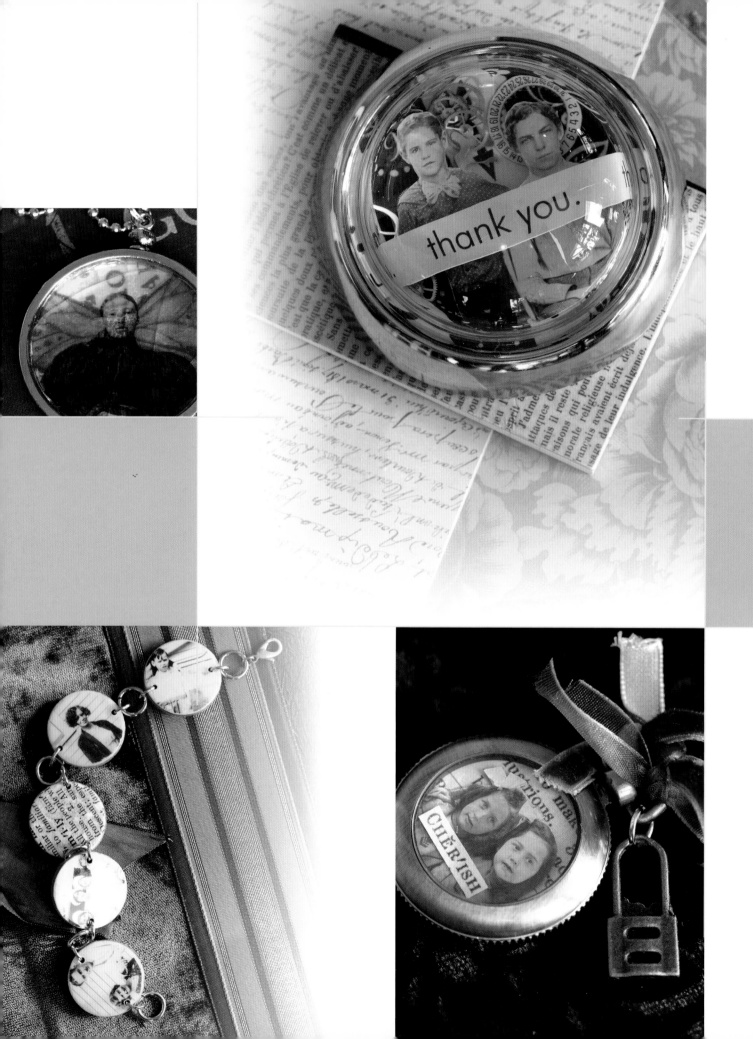

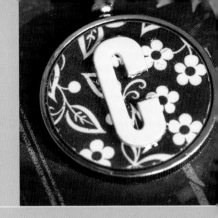

CHAPTER 2

jewelry and other little gems

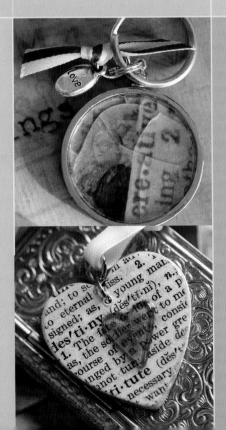

It never fails to impress me when I see artwork small enough to wear—the artist was able to work in miniature and create such a beautiful piece. I can't think of a better way to celebrate the memories of family, friends, and times gone by than a small piece of jewelry—custom made by you! Follow along and make these little bits of art that can be worn around your neck or wrist, decorate your desk, or even keep your keys safe. Although tiny, these diminutive works of art are perfect ways to celebrate all those important times and people in your life.

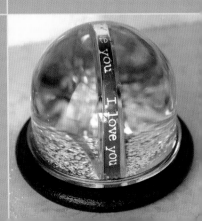

Cherish Pocket Watch Mini-Shadowbox

Materials:

1³/₈" pocket watch, charms, craft glue, dictionary page, foam dots, glue stick, jump rings (5mm), patterned paper, ribbon, ruler, scissors, small photograph

Instructions:

Remove the back of the pocket watch and measure the inside diameter of the back piece. Cut a circle from patterned paper to fit the inside of the back piece, then adhere to the back of the pocket watch using craft glue. Cut subjects from the photograph, and adhere to the patterned-paper circle using foam dots. Trim a descriptive word from dictionary page, and adhere to the bottom edge of the photograph with glue stick. Reassemble pocket watch. Embellish with ribbon and charms attached with jump rings. Give the pocket watch as a gift, or wear as jewelry on a length of ribbon.

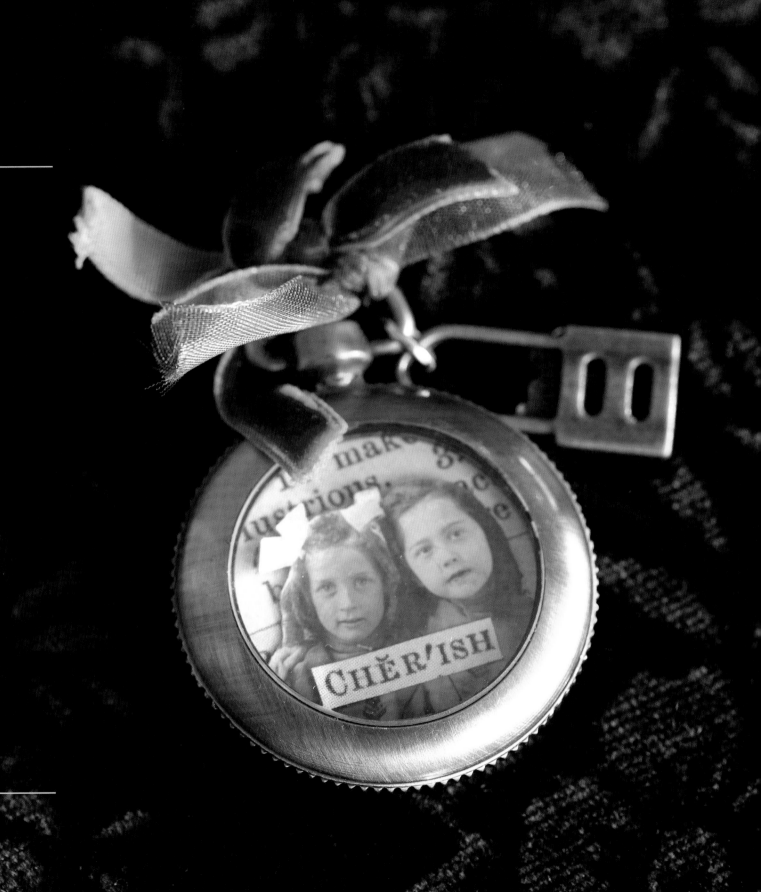

Blessings Wooden-Heart Necklace

Materials:

$1/16$"-bit drill, $1/4$"-wide velvet ribbon (1 yard), $1^1/2$" x $1/8$" wooden heart, clear protective nail polish, craft glue, dictionary page, heart-shaped button, image to fit wooden heart, jump rings (5mm and 10mm), sandpaper or nail file, scissors, three-dimensional gloss medium, word sticker

Instructions:

Drill a hole in the top of the wooden heart, making certain the 5mm jump ring will fit. Sand the heart until smooth, then wipe clean. Apply craft glue to one side of the heart and adhere photograph. Hold the heart up to the light to ensure image has been positioned as desired. Allow to dry.

Trim around the heart to remove any excess parts of the image. Sand the edges of the photo, and apply word sticker as desired. Apply several thick coats of clear nail polish to seal the heart and allow to dry overnight.

Following previously stated instructions, cover the back of the heart with the dictionary definition, but do not allow the nail polish to dry. Using three-dimensional gloss medium, adhere heart button in desired position. Apply another thick coat of nail polish and allow to dry.

To assemble, attach a 10mm jump ring to a 5mm jump ring, then slip the 5mm jump ring through the hole at the top of the wooden heart. Add velvet ribbon to hang the piece around your neck, and embellish as desired.

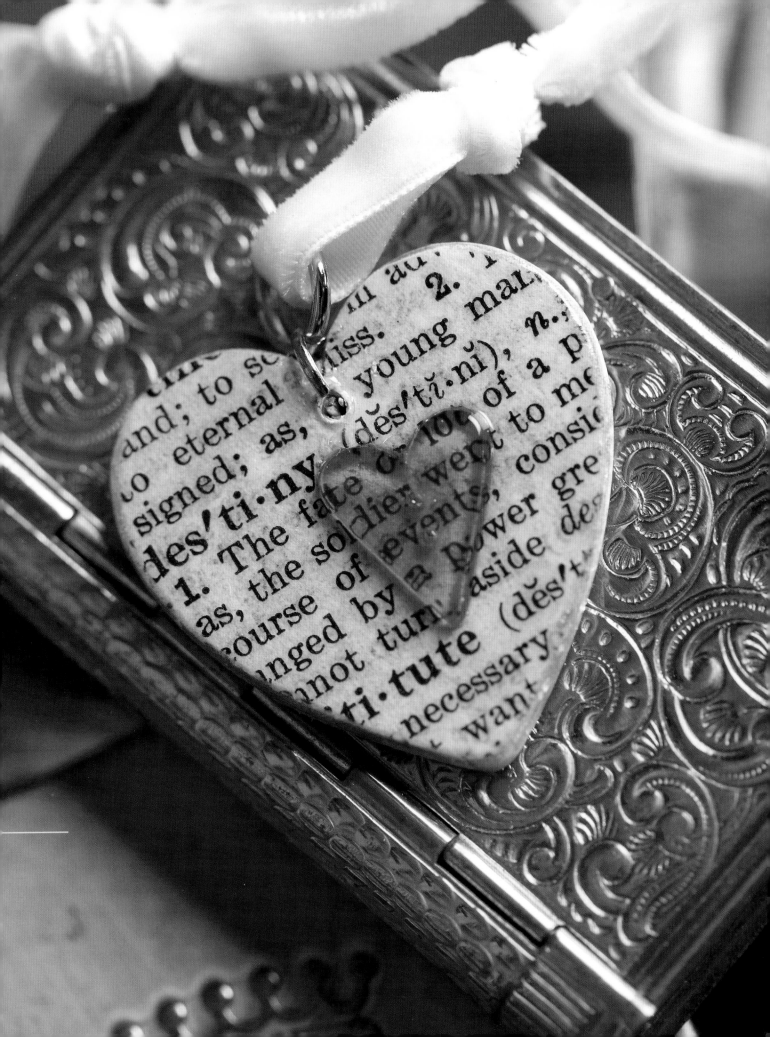

Pendant and Keychain Set

Materials:

1³/₈" circle punch, bead chain (24") or key ring, bond paper, chipboard letter (optional), computer and color printer, glue stick, heat gun (optional), image, jump rings (10mm), keepsake pendant, oven, patterned paper, ribbon, scissors, silver charms, three-dimensional gloss medium, ultra-thick embossing powder, watermark ink refill

Instructions:

Side 1: Preheat oven to 200° F (93° C). Punch circle from patterned paper and attach to pendant with glue stick. Print image on bond paper, trimming desired portion to size. Squeeze out a generous amount of watermark ink on the top of the mini-collage and spread with your finger. Measure ³/₄ teaspoon of ultra-thick embossing powder and place over the watermark ink.

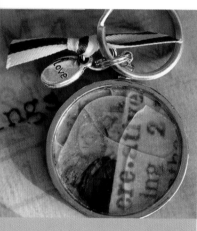

Heat pendant in preheated oven until embossing powder is melted, approximately seven minutes. *Note: Do not use the heat gun on the pendant before the embossing crystals have been melted as it will scatter the crystals. If bubbles appear after the crystals have melted, use a heat gun to re-melt the embossed crystals to allow the bubbles to escape.*

Side 2: Punch circle from patterned paper and attach to second side of pendant with glue stick. Place chipboard letter in the center, if desired. Cover the patterned-paper circle with three-dimensional gloss medium. *Note: The embossing powder technique cannot be done on this side, as Side 1 will melt off.* Allow to dry overnight.

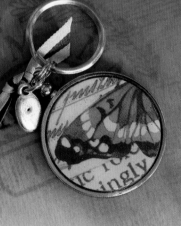

Attach the beaded chain or key ring to pendant. Attach charms using jump rings, and embellish with coordinating ribbon as desired.

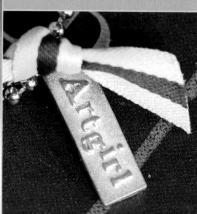

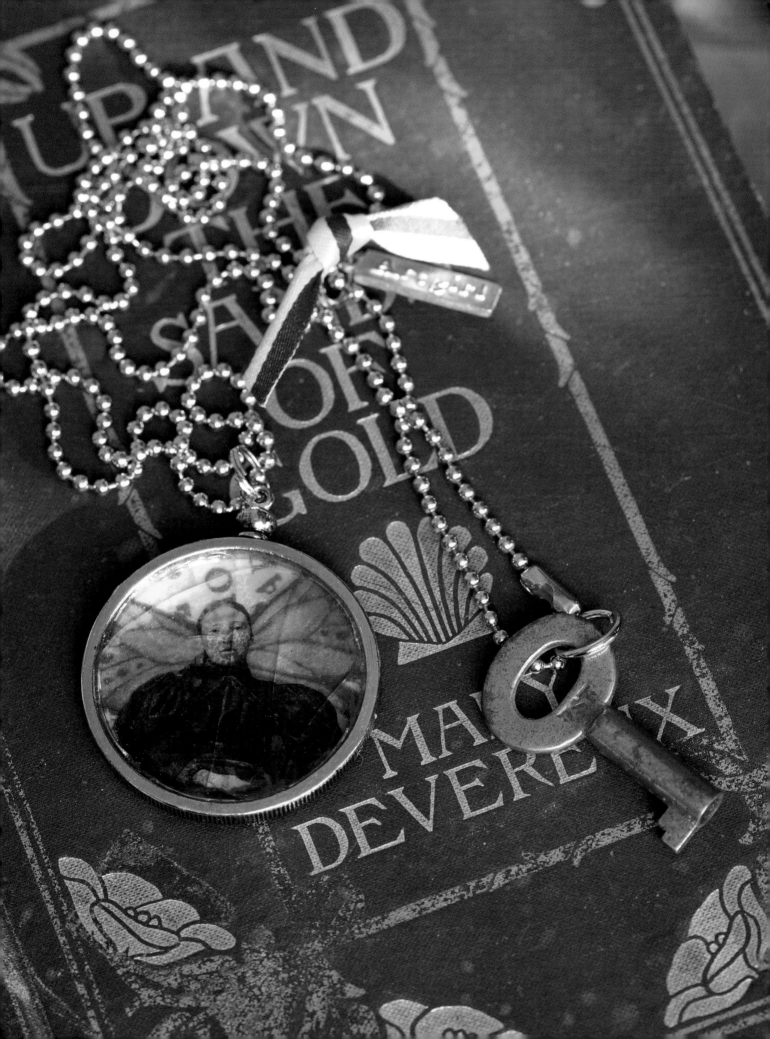

Family Bracelet

Materials:

$\frac{1}{16}$"-bit drill, 1" x $\frac{1}{8}$" wooden disks (5), 1" circle punch, clear protective nail polish, craft glue, dictionary page, jump rings (5mm and 10mm), photographs to fit 1" circle (4), pliers, sandpaper or nail file, silver clasp, silver spray paint

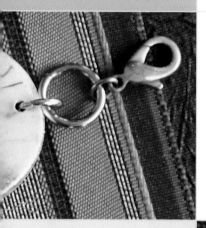

Instructions:

Drill two holes opposite one another in each disk, making certain the 5mm jump ring will fit in the holes. Sand wooden disks until smooth, spray one side of each with silver paint, and set aside to dry.

Punch 1" circles from the photographs and dictionary page. Using craft glue, adhere one circle to the non-painted side of each of the wooden disks. Sand the edges of the photos and allow entire piece to dry. Seal the disks with several thick coats of nail polish and allow to dry overnight.

To assemble, place one 5mm jump ring through each of the holes in the disks. Attach one or two 10mm jump rings between them to connect the bracelet as shown. Add the silver clasp, and wear your family with pride!

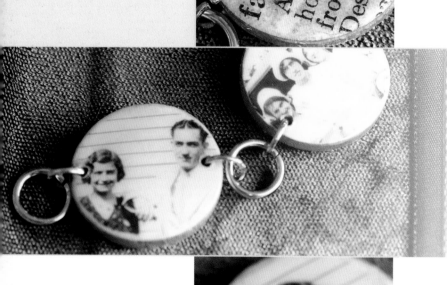

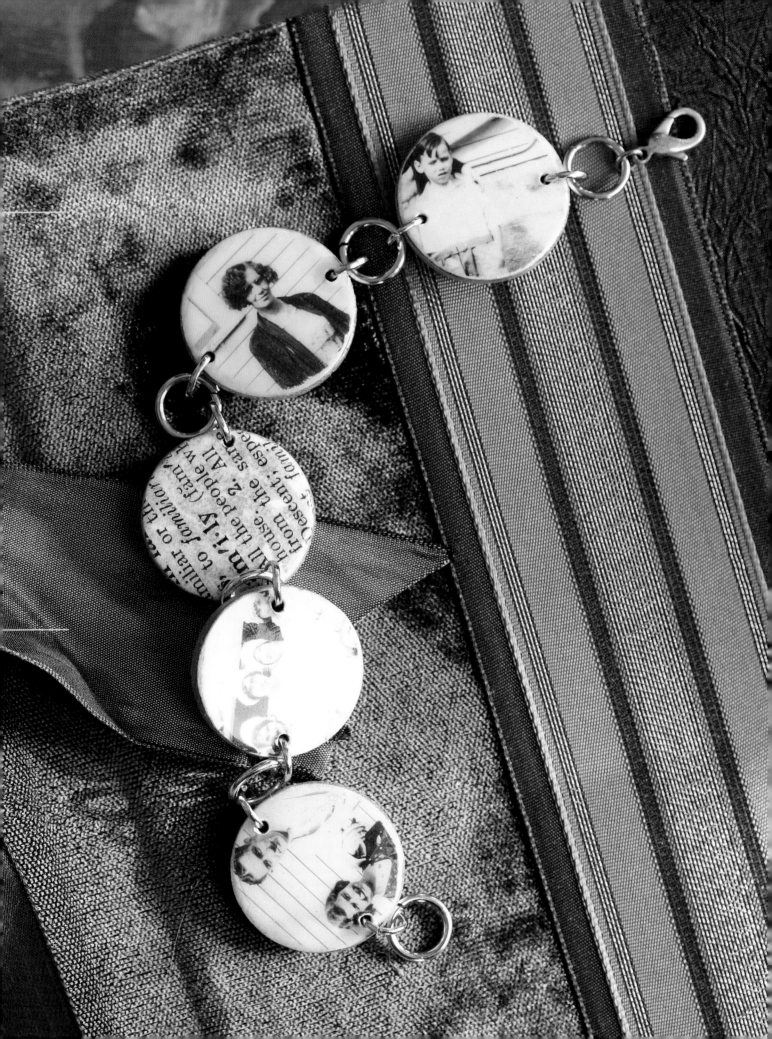

True Love Snow Globe

Materials:

3³/₈" plastic snow globe, 4" x ¼" cork coaster, black acrylic paint, clear protective nail polish, craft glue, craft knife, foam core, foam dots, letter stickers, paintbrush, patterned paper ("I love you"), pencil, photograph, scissors, vintage book pages

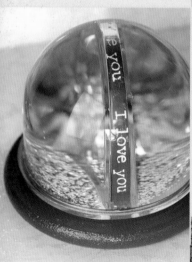

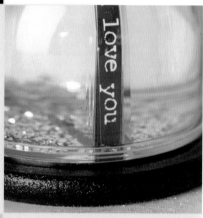

Instructions:

Using the insert as a template, trace the shape onto the foam core and cut out with the craft knife. Insert into the snow globe to ensure it securely fits.

Remove foam core from globe and adhere desired portion of vintage book pages to front of foam core. Cut a ¼"-wide strip of "I love you" paper and insert inside the photograph slot, pushing it to the very top of the slot. *Note: This strip is used in order to hide the foam core on the inside of the slot, while allowing the decorative paper to be seen from the outside of the globe.* Trim the people or other subjects from the photograph and adhere to foam core using foam dots.

Adhere desired portion of vintage book pages to back of foam core. Use remainder of the "I love you" paper to embellish foam core, wrapping around to the front and hiding ends behind the photograph. Embellish with letter stickers and insert into photograph slot.

Paint cork coaster black and allow to dry. Apply several coats of clear polish over the paint so that the coaster resembles black lacquer. Allow to dry. Adhere to the base of the snow globe using craft glue.

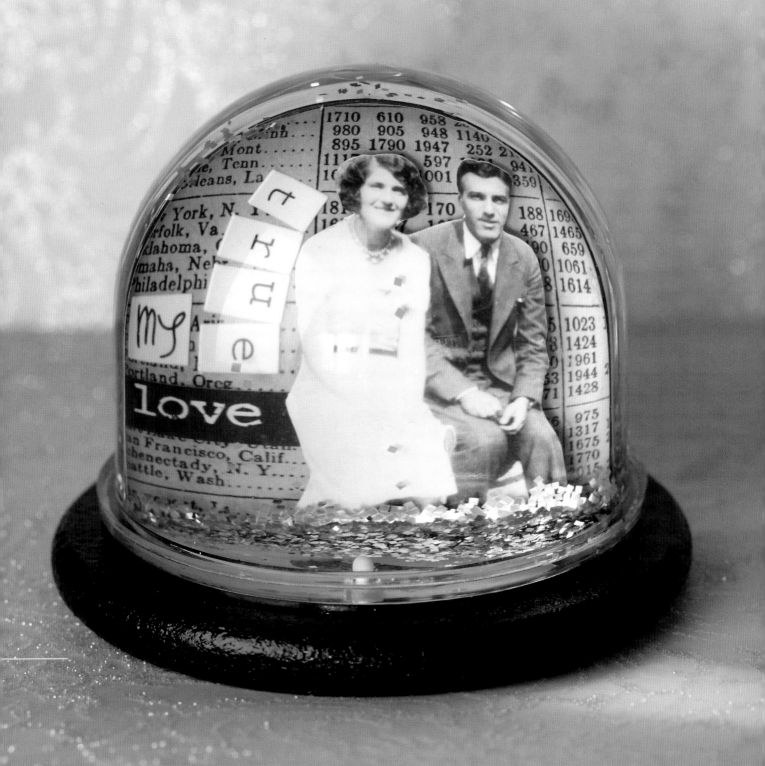

"Thank You" Paperweight

Materials:

circle cutter, computer and printer, craft glue, cream-colored cardstock, foam core (4" square), foam dots, linen tape, paperweight with metal base, patterned paper, photograph, scissors, self-adhesive felt, watch parts

Instructions:

With the circle cutter, cut a piece of foam core to fit inside the paperweight. Insert the foam core to ensure it fits snugly. Remove foam core base from the paperweight and adhere patterned paper with glue to the foam core. Allow to dry and trim away excess. Trim the background away from the photograph subjects and adhere to foam core base using foam dots.

Print the words "thank you" on cardstock and trim to a 1/2" strip. Adhere "thank you" strip to photograph using foam dots. Sprinkle watch parts inside the paperweight, insert collaged foam core, and secure using three pieces of linen tape. Cut self-adhesive felt to fit the base of the paperweight and adhere.

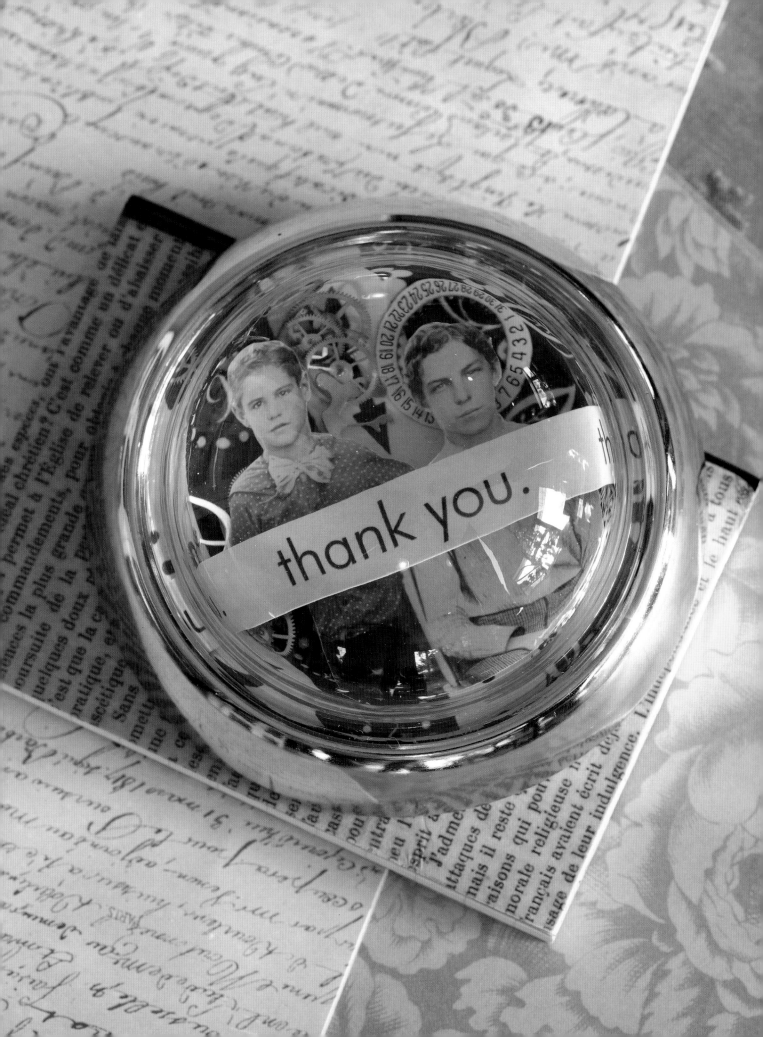

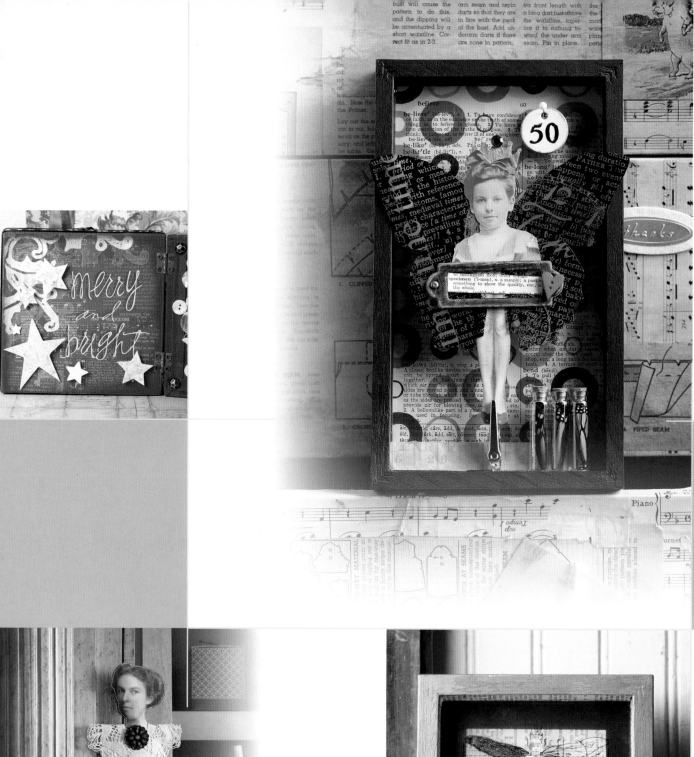

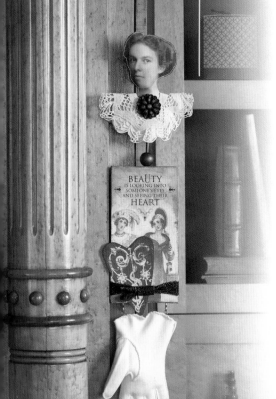

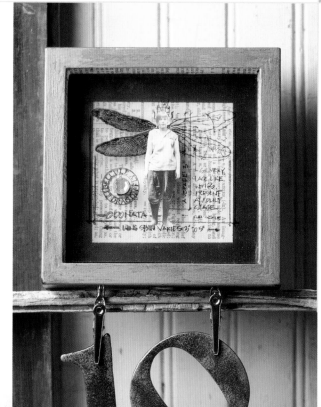

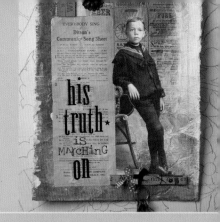

CHAPTER 3
adorning the walls

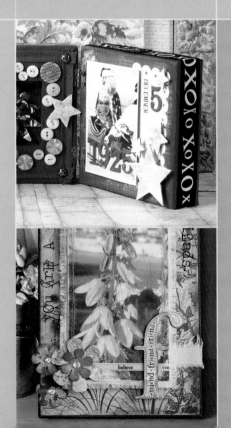

Art makes me happy. Seeing my art on any wall makes me even happier. In my eyes, being able to combine old photographs, vintage items, and materials to create art is a dream come true. As you gather the tools and supplies to make the projects in this chapter, think of those vintage photographs and how happy the people in them will be to get out of a dusty old box and become a piece of art! By turning them into something beautiful for your family and friends, you'll also be creating something to be smiled at each time your loved ones walk by.

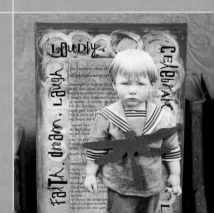

Specimen #50

Materials:

acrylic paint (gold, rust, and color of choice), alligator clip, brads, chipboard, chipboard crown, chipboard label holder, circular number tag, craft glue, decorative button, decorative pin, decoupage medium, drill, faux crystal, fine-tipped marker, foam core, foam dots, frame hanger (optional), glass vials, paintbrushes, paper trimmer, patterned paper, patterned transparencies (2), ruler, sandpaper, scissors, silk butterfly wings, vintage photographs, vintage ribbon or tape measure, wooden frame (approximately 5$\frac{1}{2}$" x 8$\frac{1}{2}$")

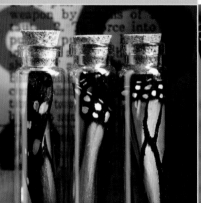

SECTION—PICTURE FRAMES AS SHADOW BOXES

These projects started with a trip to the frame shop to look around for inspiration. When I held these thick frames in my hands, I knew exactly what I wanted to do with them. Try looking through the discount bins in your local frame shop—you never know what amazing and inspirational finds you'll come across!

Instructions:

Drill one hole in the bottom edge of the frame to accommodate alligator clip. If the frame does not already have a frame hanger, attach one to the back. Measure the inner dimensions of the frame and cut a piece of foam core to fit this area. Set foam core aside. Paint the inside and top edges of the frame, then set aside to dry. Using paper trimmer, cut plain chipboard into $\frac{1}{4}$"-wide strips (you will need enough strips to line the inner edges of the frame) and paint the same color as the frame. Set aside to dry. Trim a sheet of patterned paper to fit the foam core and adhere using decoupage medium. Insert foam core into the frame. If foam does not fit snugly, use strong craft glue to reinforce placement. Working one side at a time, cut the painted chipboard to the exact lengths of each inner edge of the frame. Using craft glue, adhere chipboard strips to the sides of the frame to create spacers.

Place a patterned transparency sheet over the "Butterfly Template" on page 63. With the fine-tipped marker, trace butterfly, then cut out. Paint the back side of butterfly with rust-colored paint and set aside to dry. Trim away background of vintage photograph, then adhere the head and shoulders of photograph subject to butterfly wings as shown in project photograph. Adhere the photograph subject's legs underneath the wings. Sand chipboard label holder and adhere to front of butterfly, using brads at the edges to reinforce hold. Glue decorative button to the top of one of the brads and embellish chipboard label holder by adding text if desired. Paint chipboard crown and allow to dry. Adhere crown and faux crystal to subject's head and allow to dry.

Glue desired length of vintage ribbon or tape measure to the bottom of the second patterned transparency. Decide on the best place to position foam dots on the transparency in order to hide them from view as much as possible. Place a layer of foam dots onto patterned paper, then place transparency on top. Rest this layered piece snugly against the chipboard spacers. Add foam dots to the back of the butterfly piece, place her feet into the alligator clip, then insert clip into the hole drilled at the bottom of the frame. Use decorative pin to attach circular number tag, and assemble butterfly wing vials. Glue vials into place and allow to dry. Enjoy!

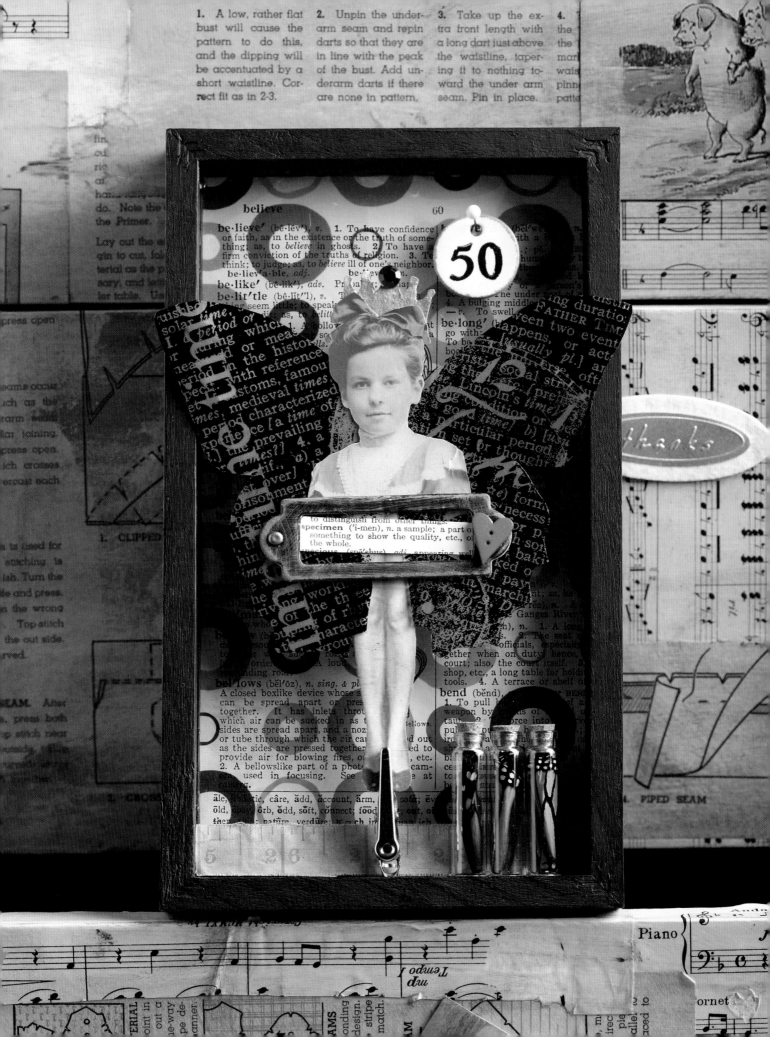

Specimen #10

Materials:

alligator clips (2), black acid-free solvent ink, blank transparency, brads, brass label holder, chipboard, chipboard numbers, clear spray-on glaze, craft glue, decoupage medium, dragonfly stamp, drill, faux jewel, foam core, foam dots, frame hanger (optional), patterned paper, rub-on creams (metallic green and color to match frame), ruler, scissors, vintage dictionary pages, vintage photograph, wooden frame (approximate size $5\frac{1}{2}$" x $5\frac{1}{2}$")

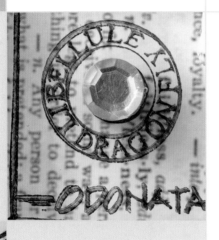

Instructions:

Drill two holes at the bottom edge of the frame to accommodate alligator clips. If the frame does not already have a frame hanger, attach one to the back. Measure the inner dimensions of the frame and cut a piece of foam core to fit this area. Set foam core aside. Apply metallic rub-on creams to the edges of the frame, matching the cream to the original color of the frame. Spray with a heavy coat of clear glaze to set the rub-on cream. Cut a piece of plain chipboard into $\frac{1}{4}$"-wide strips (you will need enough strips to line the inner edges of the frame) and apply metallic rub-on cream to coordinate with the frame. Set aside to dry. Trim a sheet of patterned paper to fit the foam core and adhere using decoupage medium. Insert foam core into the frame. If foam does not fit snugly, use strong craft glue to reinforce placement. Working one side at a time, cut the painted chipboard to the exact lengths of each inner edge of the frame. Adhere chipboard strips to the sides of the frame to create spacers. Adhere strips of dictionary pages to rim the inner edges of the frame, as shown in photograph.

Ink dragonfly stamp with black acid-free solvent ink and stamp in the center of blank transparency, then cut to the inner dimensions of the frame. Apply green metallic rub-on cream to the back side of one dragonfly wing. Using a vintage photograph in which the subject is the same height as the dragonfly body, trim away background and, using a sparing amount, glue body to the front of the dragonfly as shown. Glue faux jewel to transparency where desired and allow to dry.

Hiding foam dots beneath the photograph and faux jewel, adhere dragonfly piece to frame, resting transparency on the chipboard spacers. Insert alligator clips into drilled holes and reinforce hold using a sparing amount of glue. Allow to dry. Paint chipboard numbers as desired and apply metallic rub-on cream. Spray with clear glaze and allow to dry. Place the word "specimen" inside the brass label holder, as shown, and attach to numbers using brads.

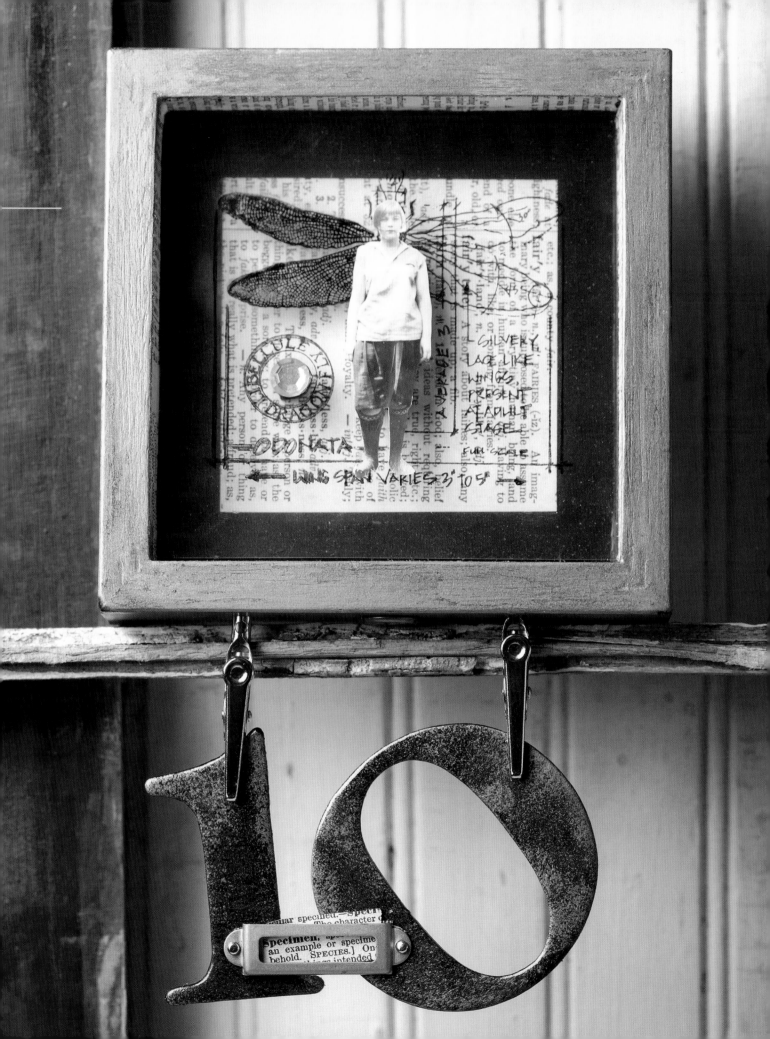

Merry and Bright Hinged Mantel Piece

Materials:

6"-square chunky canvas (3), acrylic paint (red and white), adhesive felt (optional), black rub-on letters, brown wax thread, chipboard numbers, chipboard stars in various sizes (14), craft glue, decoupage medium, foam dots, glue stick, hole punch, large faux diamond button, light gray brush marker, lined notebook paper, mica flakes, needle, paintbrush, red button, red ink pad, red patterned paper, red twill tape, scissors, small hinges (4), small sanding block, thin red ribbon, upholstery tacks, vintage china doll, vintage Christmas light reflector, vintage Christmas photograph, white buttons, white rub-on phrases or letters, wide printed black grosgrain ribbon

Instructions:

Paint the edges of all three canvases red, as well as the back side of the canvas that will be used in the center. While the paint is drying, trim two sheets of red patterned paper to 6" square. Spread a thin coat of decoupage medium over the front of the side canvases and apply patterned paper. Making sure paint is dry, sand the edges of the side canvases and ink as desired. Paint the chipboard stars white, apply white glue, and sprinkle with mica flakes.

Left Canvas: Apply "merry and bright" in rub-on letters. Shadow the letters with light gray brush marker. Adhere foam dots to six of the stars, and adhere to the left-hand side of the canvas as shown, or as desired.

Center Canvas: Cut four 6"-long strips of red twill tape and glue to the back of the canvas to hide channel, securing the corners with upholstery tacks. Measure the "shadowbox" center of the canvas. Cut red patterned paper to ½" larger on all sides and adhere inside the "shadowbox" with craft glue. Embellish the wooden portion of the frame with one red and several white buttons, as well as four stars.

Adhere Christmas light reflector to patterned paper with craft glue. Tie red ribbon around china doll and trim ends to ½". Use needle to poke two holes in the center of the light reflector, then use brown wax thread to secure the china doll to the canvas, using these holes to anchor the thread. Tightly knot. Tie faux diamond button to red ribbon as shown in photograph. Trim piece of adhesive felt to 6" square and apply to back of canvas, if desired.

Right Canvas: Paint chipboard numbers red and set aside to dry. Cut a strip of notebook paper to approximately 3" x 5", creating scalloped edges with scissors and hole punch as shown. Adhere to the right side of the canvas with craft glue. Add six foam dots to the back of the photograph (one at each corner and two in the center) and attach to canvas. Adhere numbers to the photograph and corner of scalloped-edge paper. Embellish with rub-on "December" and remaining stars adhered with foam dots.

Paint hinges red and set aside to dry. Adhere printed black grosgrain ribbon around the outermost edges of the left and right canvases, securing ends with upholstery tacks as shown. Assemble canvas pieces together as shown and enjoy!

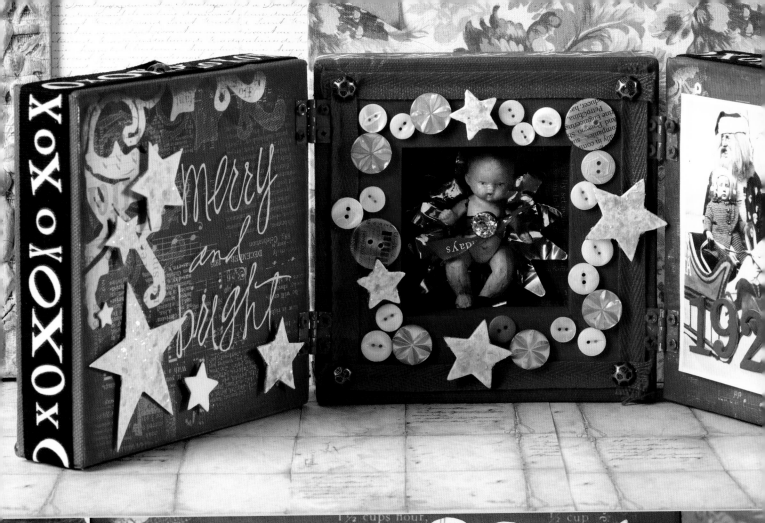

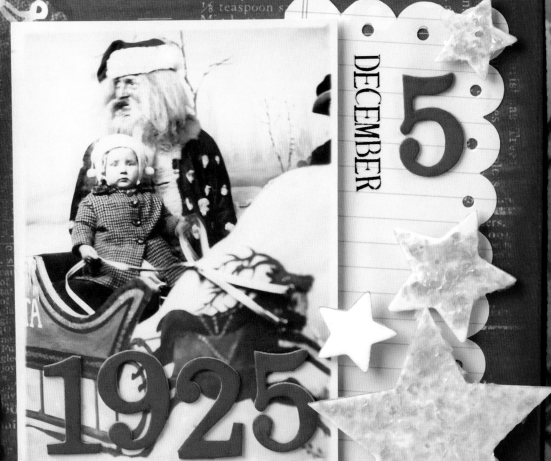

His Truth Canvas Piece

Materials:

¼" x 13" wooden dowel, 6" x 9" vintage newspaper classifieds page, brush marker, computer, craft glue, decoupage medium, duck cloth, inkjet fabric sheet, inkjet printer, letter stickers, pencil, pink acrylic paint, plastic trowel, red decorative tissue paper, red ink pad, ribbon, rolling pin or ink roller, rub-on letters, scanner, scissors, sewing machine, vintage keys, vintage measuring stick, vintage photograph, vintage ruler, vintage song sheet, vintage wooden flowers, wax thread, wet towel, white thread

Section—Wall Canvases

When I first saw a chunky canvas used as the base for a collage, I was hooked! Some people have an addiction to buying pens and paper, but ever since that day, I have had an addiction to buying chunky canvases and yards of canvas duck cloth. From ripping it, stitching it, and distressing it to crackling it, I think I have tried every technique there is for all types of prepared canvases and canvas fabrics. You won't be disappointed when you take the plunge and start using the many types of canvas pieces and raw canvases you find. You never know, you just might fall in love with canvas!

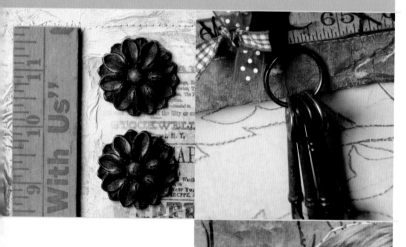

Instructions:

Rip duck cloth to 12" x 17". Create hem by folding the short edges over to the back and stitching with the sewing machine. *Note: Be sure to leave sufficient space in the top hem so that the dowel can be inserted through the hem later.* Pour a generous amount of decoupage medium in the center of the hemmed panel, and spread with plastic trowel. Place red decorative tissue paper over the decoupage medium and squeeze out excess with rolling pin or ink roller. *Note: You want to have wrinkles in the tissue paper, so do not try to remove them when rolling.* Allow to dry.

Using decoupage medium, adhere vintage advertisement page. Apply pink acrylic paint, then wipe off with a wet towel. *Note: This will cause the paint to settle in the cracks, giving the canvas an aged texture.*

Using "Butterfly Template" on page 63, trace shape onto advertisement paper. Scan photograph and, referring to manufacturer's instructions, print on inkjet fabric sheet. *Note: The sailor in my project is 10⅛" tall.* Cut background away from figure, leaving any interesting details, such as the chair in the sample project, then adhere with craft glue.

Adhere song sheet to the left side of the canvas as shown in photograph. Pencil a flower at the top of the song sheet, then stitch around it with white thread, continuing stitching around edges of song sheet and duck cloth as shown. Be sure to erase the pencil marks after stitching is complete. Stitch around the butterfly, then ink the inside of the butterfly with red ink.

Add desired title to the song sheet using letter stickers and rub-ons. Shadow the letters with the brush marker. Adhere wooden flowers and a scrap of the ruler to top of the canvas. Tie keys to the measuring stick with wax thread and embellish with several types of scrap ribbon. Adhere measuring stick to the bottom of the canvas so that the figure looks like it is standing on it. Insert the dowel in the top hem of the canvas, and tie the ribbon on each end to create hanger.

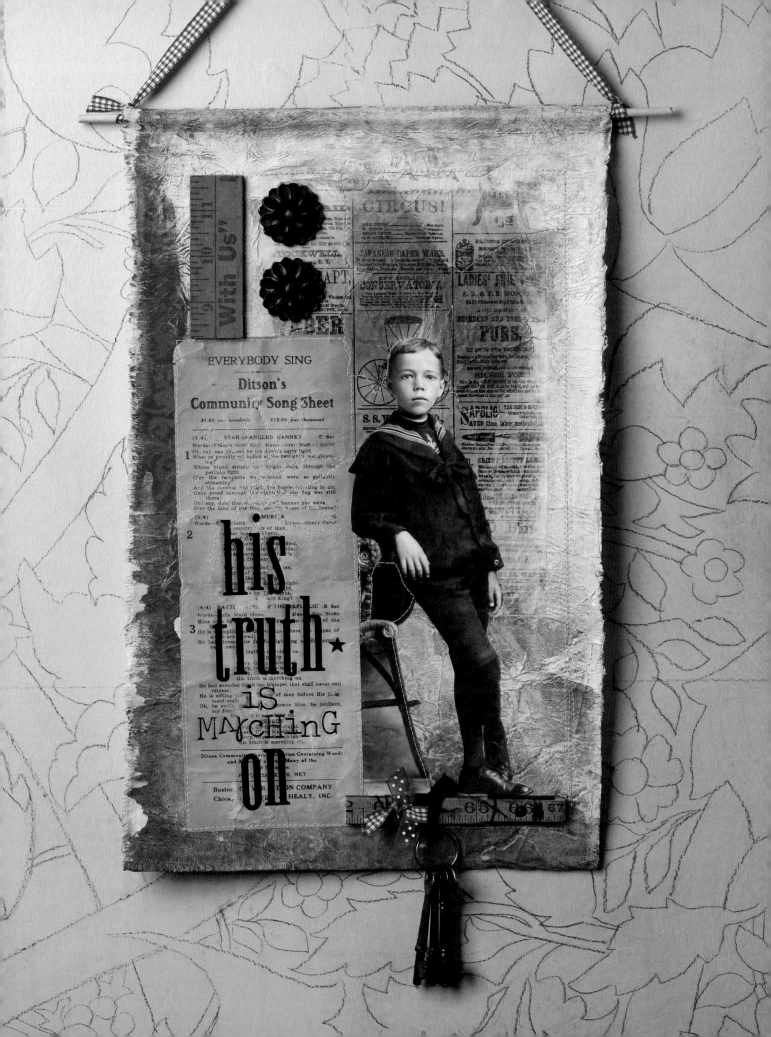

Have Faith Canvas

Materials:

6" x 12" canvas, acrylic paint (red, turquoise, white), brown ink pad, computer, crackle paste, crackle process medium, craft glue, foam dots, hammer, inkjet fabric sheet, inkjet printer, jump ring (10mm), metal dragonfly, nails, paintbrush, printed twill tape, rub-on letters, scanner, scissors, silver charm, silver-and-copper band from bottle, vintage agriculture book pages, vintage photograph

Instructions:

Trim one book page to $5^1/2$" x $11^1/2$". Spread an even layer of craft glue over the canvas and adhere book page, leaving $1/4$" of the canvas showing. Paint edges and random portions of the book page red. Spread an uneven layer of crackle paste over the top of the book paper. Paint random-sized circles around the edges of the canvas in white and turquoise, then coat circles with a layer of crackle paste and allow to dry.

Trim one of the book pages to $3^1/4$" x $8^1/4$" and adhere to the top center of the canvas with craft glue. Following manufacturer's instructions, spread Step 1 of the crackle process medium over this strip of book page and allow to dry. Spread Step 2 and allow to dry. Repeat this process until satisfied with the size and number of cracks that appear. Distress the cracks by randomly rubbing the brown ink pad over the page until satisfied with results.

Scan photograph and, referring to manufacturer's instructions, print on inkjet fabric sheet. *Note: Mine is approximately 10" tall.* Cut away the background, then adhere to canvas with craft glue. Rub on quote around the edge of the book page as shown in photograph, then tie printed twill tape around the bottom of the canvas. Position silver-and-copper band and secure with nails on the back. *Note: The band I used in the sample project is from a bourbon bottle.*

Affix foam dots to the back of the dragonfly and place on the photograph near the photograph subject's heart. Add jump ring to the silver charm and secure to twill tape.

36

LOUDLY. CELEBRATE

HAVE FAITH. dream. LAUGH

Life.

AND AROOSTOOK UNION SCC
arly grave, his sons, on the
commenced a farm in No 3
ostook road, about 20 years ag
as now an excellent farm, with goo
Stacy's farm is situated in one o
in western Aroostook— on the
l to Mt. Katahdin,
nce of good land in
1.00 to $1.50 pe
ing farther into th
appears from
sh, A. Cushma
ns, and Abner
brace the vari
English
ghboy."
th some grad
awarded to
e shown by
Darling, and
amsons, &c
eld Crops
Theodore of Golde
on corn—he raised
half acre.
l of Patten, the second pre
bushels per acre on one-ha
lden Ridge, the first premi
e of 18 3-4 bushels per acr
of Golden Ridge, the first
d at the rate of 72 bushels

f Golden Ridge, the sec
s per acre on one acre and

is a joy a boy is a joy a boy is

BASIL

Friend Canvas

Materials:

1"-wide x 10"-long strip of canvas ribbon, 8" x 12" canvas, black-and-white flower photograph, brown acrylic paint, brown ink, chipboard letter "f", chipboard flowers, computer, craft glue, cream burlap fabric, foam core, inkjet canvas, inkjet printer, nail file, patterned paper, photo markers, rub-on letters, sandpaper, scanner, scissors, self-adhesive crystals, sewing machine, spray fixative, thread (to match photo markers), upholstery tacks, yellow-print grosgrain ribbon

Instructions:

Scan flower photograph and, referring to manufacturer's instructions, print on inkjet canvas and allow to dry. Spray with fixative to set ink. Using photo marker, hand tint flowers and seal with spray fixative. Sand the edges of the image until they look slightly worn. Use sewing machine to stitch yellow ribbon to bottom of image, wrap ends to the back, then stitch canvas to cream burlap fabric. Machine quilt the flowers using threads that match the photo markers.

Glue patterned paper to the chipboard letter, trim away excess, and stitch letter to canvas. Add desired rub-on sayings to chipboard letter.

Cut a piece of foam core to $1/2$" smaller than the overall size of the burlap, and adhere burlap to foam core using craft glue. Set aside to dry.

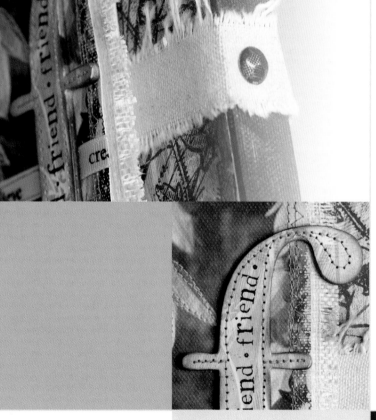

Paint sides of the 8" x 12" canvas with brown acrylic paint and allow to dry. Sand lightly. Trim patterned paper to $7^{3}/_{4}$" x $11^{3}/_{4}$" and adhere to canvas with craft glue. Lightly sand edges and distress the edges of the paper with brown ink. Using rub-on letters, add desired quote around the edges of the canvas. Glue canvas ribbon around the bottom of the canvas, approximately $2^{1}/_{2}$" from base. Secure ribbon with upholstery tacks.

Adhere patterned paper to chipboard flowers, trim away excess, and sand edges with nail file. Place self-adhesive crystals in the centers, and adhere flowers to canvas, as shown in photograph.

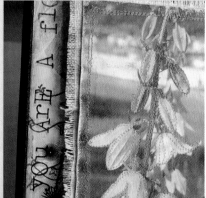

er In mY gArdEn O

yOu ArE A flOwE

Of friEnds

believe

friend · friend · friend

cre

· friend · friend ·

Beauty Canvas Puppet

Materials:

¼"-bit drill, ¼"-diameter wooden dowel, 1" wooden bead, 4" x 8" canvas, acrylic paint (brown metallic, cream, pink), black rub-on letters, computer, cotton batting, craft glue, decorative fabric, inkjet canvas, inkjet printer, jump rings (5mm), metal heart, paintbrushes, patterned paper, pencil, rice, sandpaper or nail file, scanner, scissors, screw eyes, sewing machine, stapler and staples, torn fabric strip, vintage doily, vintage glove, vintage photograph, white rub-on heart, white thread, wooden flower

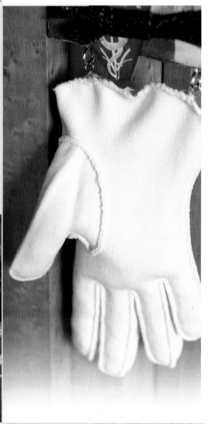

Instructions:

Puppet: Scan photograph and, referring to manufacturer's instructions, print on inkjet canvas. *Note: My beauty is 6" tall.* Trim away background. Leaving the bottom portion open in order to stuff and insert dowel, stitch beauty to decorative fabric to create bodice. Lay doily over image and trace the scalloped edge onto the bottom with a pencil. Carefully cut the scalloped edge from the fabric. Paint the bottom of the "bodice" pink and set aside to dry.

To create the decorative neckline, cut the center from the doily and pull over the beauty's head as you would dress a doll. Adhere in place with craft glue. Attach wooden flower at neckline to resemble a brooch. Stuff puppet with cotton batting and, leaving a space large enough to insert dowel, staple closed. Slip wooden bead onto dowel so that it rests in desired position. Paint dowel and wooden bead with brown metallic paint and allow to dry. Insert dowel into the back of the puppet and staple closed.

Canvas: Drill ¼" hole in the center of the top edge of the canvas. Make sure the dowel you are using with the puppet will fit the hole. Paint the edges of the canvas cream and allow to dry.

Trim patterned paper to 4" x 8" and adhere to canvas with craft glue. Sand edges of the paper. Trim a ¼" strip of patterned paper and adhere around the outer edges of the canvas, as shown in photograph. Using pink and metallic brown paint, paint the top portion of the patterned paper. *Note: I created the outline of the top of the heart in the bottom portion of the paint.*

Add rub-on quote to the top of the canvas. Place two screw eyes at the bottom of the canvas to hang glove. Add heart rub-on to metal heart, then adhere heart to canvas in desired location. Tie torn fabric strip around canvas and secure with a bow. Using craft glue, adhere dowel and puppet in the hole drilled at the top of the canvas.

Glove: Fill glove with rice and hand stitch closed. Sew two jump rings on the back side of the glove, making sure they coordinate with the placement of the screw eyes. Use jump rings and screw eyes to hang glove from canvas. Reinforce hold with craft glue if necessary.

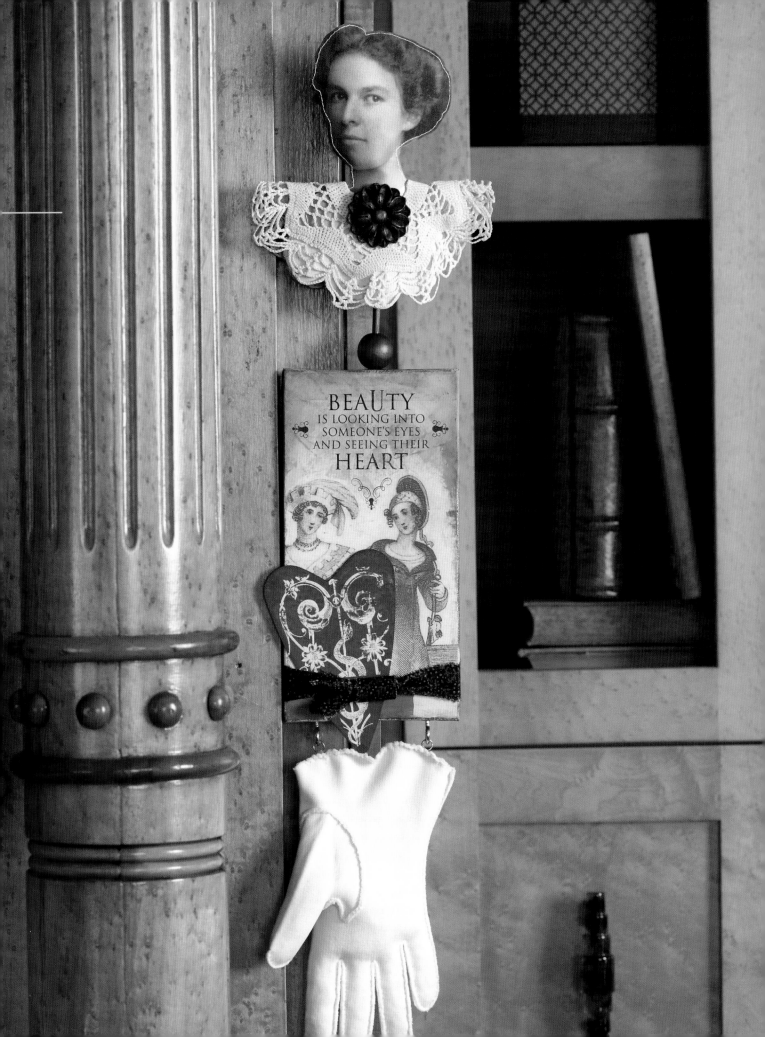

BEAUTY IS LOOKING INTO SOMEONE'S EYES AND SEEING THEIR HEART

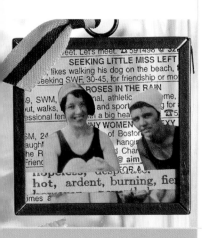

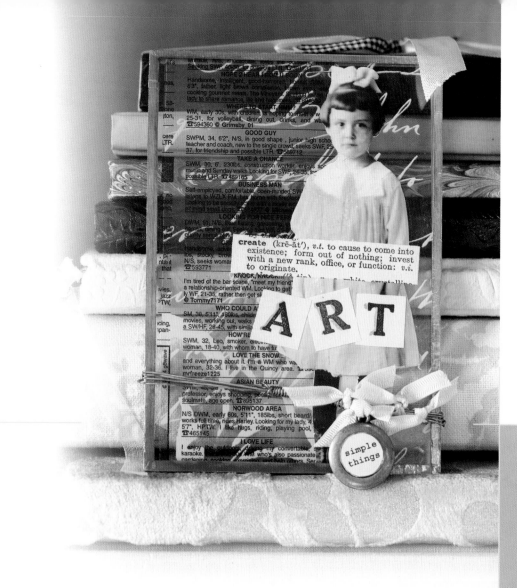

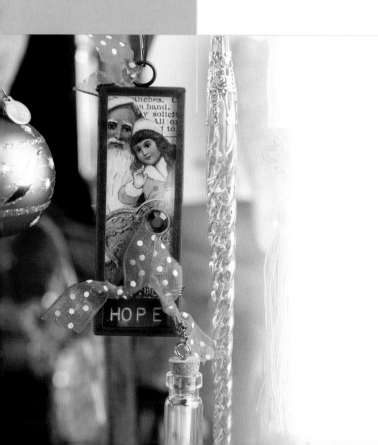

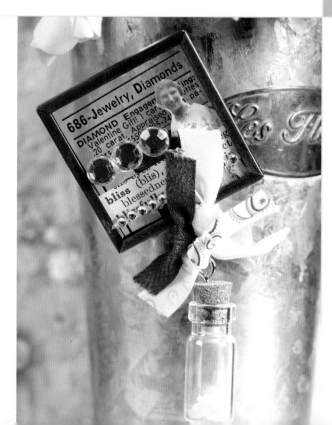

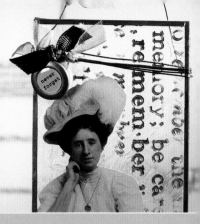

glass ornaments

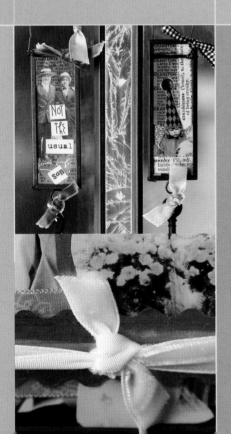

I have always loved to hang pretty things in my windows; however, making stained glass projects was just too painful for me! I often nicked my fingers while cutting the glass, then got the flux in the cuts. Unfortunately, the final result of my beautiful projects did not outweigh how it made my hands hurt. Eventually, I found ways to incorporate my love for pretty glass, photographs, ribbons, and metal findings to create striking window decorations, while avoiding the burning cuts. The following projects will teach you to make easy, unique, and beautiful gifts for any occasion.

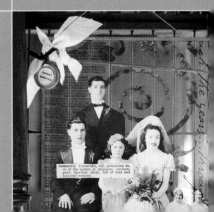

Sweet Memory

Materials:

½"-wide copper foil tape, 26-gauge copper wire, assorted ribbons, burnishing tool, clear glass, clear glue or double-stick tape, copper charm, decorative-edged tape, dictionary definition, epoxy sticker, glass cutter, photo markers, scissors, spray preservative, transparencies, vintage photographs or copies of vintage photographs

Instructions:

Determine the dimensions you would like your finished ornament to be. Trim background from two vintage photographs. *Note: For this piece, I used one 8" x 10" and one 2" x 3" photo.* Highlight a small portion of each photograph with photo markers, then spray with preservative. Using clear glue or double-stick tape, collage transparencies as desired to ornament dimensions. Make sure adhesive is sufficiently hidden by collage elements. Adhere dictionary definition and a length of ribbon across the bottom of the piece, and place the small photograph on top as shown in photograph.

Referring to "Basic Glass Cutting" on page 10, cut two pieces of clear glass to the same size, then sandwich your art between them. *Note: It is not recommended that transparencies or photographs be directly adhered to the glass. This way, if the glass breaks or you decide you would like to change the collage, the ornament can easily be repaired or updated.* Cut a piece of foil tape long enough to run the entire perimeter of the piece. Remove a few inches of the protective paper on the back of the tape, and center on the outer edge of the pieces of glass. Make sure there are no gaps between the two sheets of glass, then lightly press the foil against the outer edges of glass sheets. Do not fold the tape over the edges yet. Carefully work around the piece, securing the tape to the glass. Working one side at a time, fold over the edges of the foil tape to the front of the art piece, then to the back, burnishing out any folds or bubbles with the burnishing tool. Work carefully at the corners to create neat folds.

Cut a 3-foot length of copper wire and make a small loop in one end. Twist wire about ten times to secure loop. Hold the loop at the back of the glass and thread remaining end of wire through it. Pull wire taut and wrap around ornament several times. Loop 10" of wire at the top for a hanger, reserving enough wire to secure the tail. Wrap tail end of wire around bundle of wire to create a nice, clean coil. Trim excess with scissors and tuck behind the bundle of wire.

Using decorative-edged tape, add a border that will sit over the center of the ribbon placed at the bottom of the piece. Wrap ribbon around and tie. Decorate copper wire with velvet and silk ribbons. Stick epoxy sticker to copper charm, then attach to ornament.

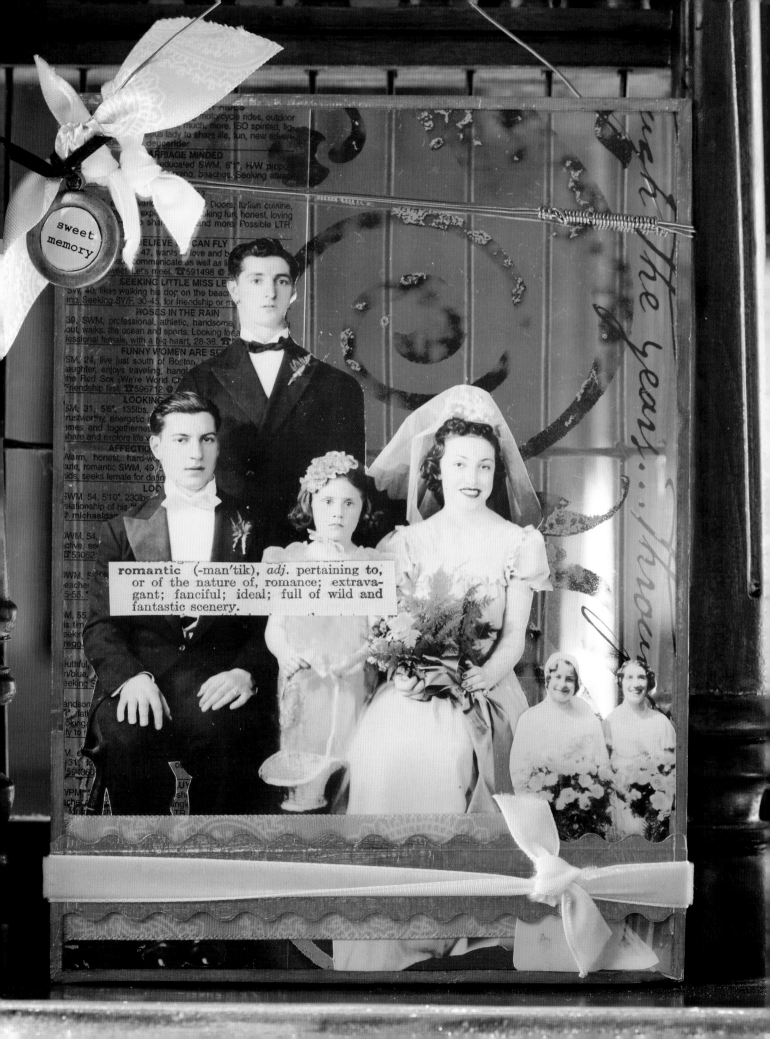

Create Art

Materials:

½"-wide copper foil tape, 26-gauge copper wire, burnishing tool, charms, glass cutter, glue stick, newspaper-print transparency, photo markers, plain or clear decorative glass, ribbons, spray preservative, title for piece (dictionary definition, rub-ons, or other desired material), vintage photograph of a child, vintage words of choice

Instructions:

Determine the dimensions you would like your finished ornament to be. Trim background from vintage photograph. Tint remainder of photograph with photo markers, then spray with preservative. Trim transparency to ornament dimensions. Adhere photograph to transparency, along with title and vintage words, as shown in photograph.

Referring to second paragraph of Sweet Memory on page 44, sandwich art between two pieces of plain or decorative glass. Cut a 3-foot length of copper wire and make a small loop in one end. Twist the wire about ten times to ensure the loop will not come out. Hold the loop at the back of the glass and thread the remaining end of the wire through it. Pull the wire taut and wrap around the art several times. Make sure to reserve enough wire to secure the tail. Wrap the tail end of the wire around the entire bundle to create a nice, clean coil. Trim excess with scissors and tuck the end behind the bundle of wire. Decorate with ribbons and charms.

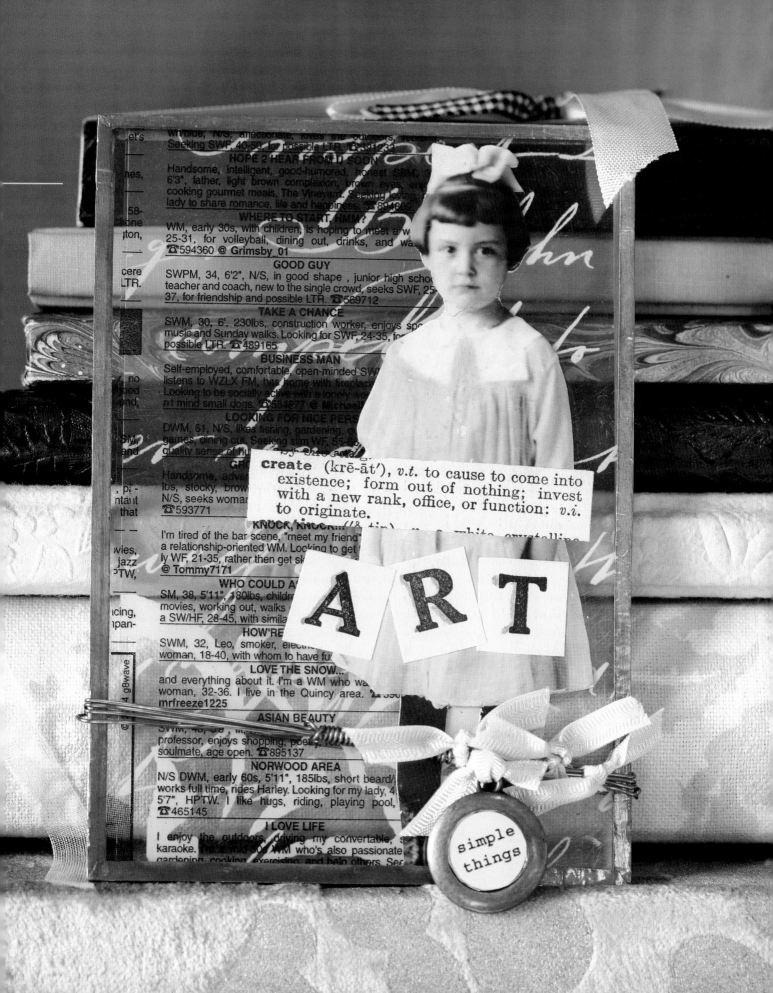

Remember

Materials:

1/2"-wide copper foil tape, 26-gauge copper wire, burnishing tool, charms, clear decorative glass, glass cutter, glue stick, photo markers, plain glass, ribbons, scissors, spray preservative, transparency, vintage dictionary definition, vintage lady cabinet card

Instructions:

Determine the dimensions you would like your finished ornament to be. Trim background from one vintage lady cabinet card. Tint with photo markers, then spray with preservative. Trim transparency to ornament dimensions. Adhere photograph to top of transparency and add dictionary definition.

Referring to second paragraph of Sweet Memory on page 44, sandwich art between one piece of plain and one piece of clear decorative glass. To create hanger for the ornament, refer to the third paragraph of Sweet Memory. Embellish ornament as desired with ribbons and charms.

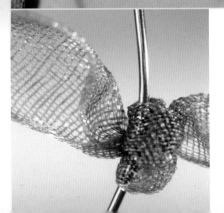

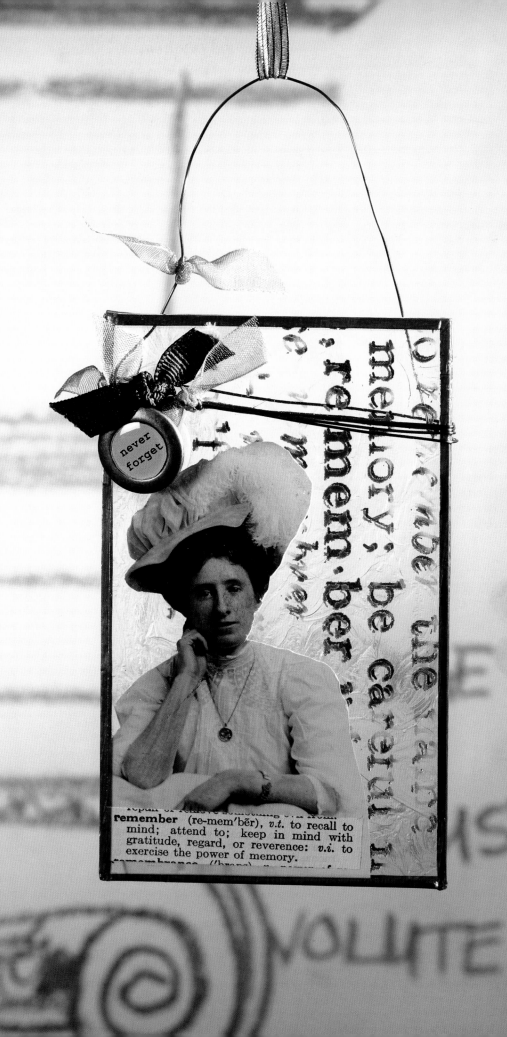

(1)Kindred, (2)Hot, or (3)Beautiful

Materials:

1½"-square clear precut glass (6), 1½"-square copper frames (3), double-stick tape, newspaper-print transparency, paper cutter, photo markers, ribbon, scissors, small photographs, spray preservative, vintage thesaurus page

Instructions:

Use the paper cutter to trim transparency into 1½" squares. Trim away the background from the photograph subjects and stick subjects to transparency squares using double-stick tape. Color as desired with photo markers, then spray with preservative. Add a strip cut from the thesaurus page. Sandwich art pieces between squares of glass and insert into frames, referring to manufacturer's instructions. Embellish attached jump ring with ribbon as shown in photograph.

SECTION—MINI-ORNAMENTS

Make your own ornaments or window decorations— without cutting any glass or folding over any copper tape! All of the items listed can be purchased precut or premanufactured, to make the process of altering your memories that much easier.

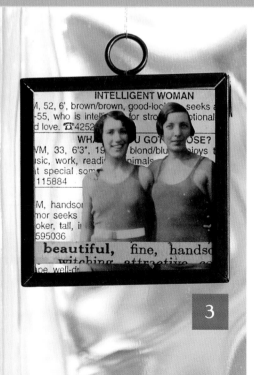

Bliss

Materials:

1 1/2"-square clear precut glass (2), 1 1/2"-square copper frame, double-stick tape, magnet, newspaper-print transparency, paper cutter, ribbons, rice, scissors, small bottle with cork, self-adhesive rhinestones, small photograph, small screw eye, three-dimensional gloss medium, vintage thesaurus page

Instructions:

Use the paper cutter to trim transparency into 1 1/2" squares. Trim away background from photograph subject and stick subjects to transparency using double-stick tape. Add a strip cut from the thesaurus page. Sandwich art piece between squares of glass and, making sure attached jump ring is positioned at the bottom, insert glass into frame, referring to manufacturer's instructions.

Set self-adhesive rhinestones as shown or as desired. *Note: I placed three large and five small rhinestones around the thesaurus entry for added interest.*

Fill bottle with rice and adhere cork into place using three-dimensional gloss medium. Insert screw eye into cork, then attach to jump ring. Embellish with a variety of ribbons, as shown in photograph. Adhere magnet to the back of the frame using three-dimensional gloss medium.

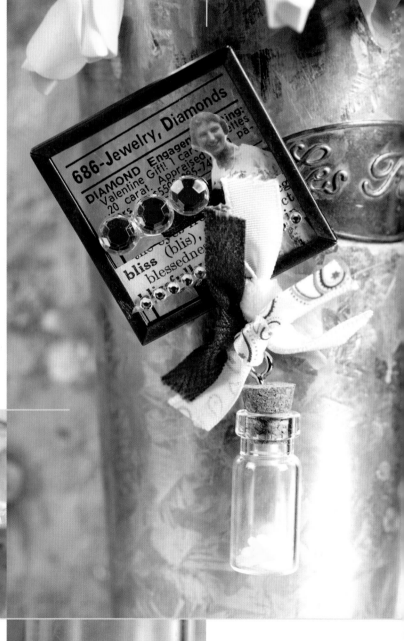

(1)Not the Usual Son or (2)Cranky

Materials:

1" x 3" clear precut glass (4), 1" x 3" copper frames (2), 26-gauge copper wire, double-stick tape, newspaper-print transparency, paper cutter, ribbon, scissors, small photographs, self-adhesive rhinestone, stickers, vintage keys, vintage papers

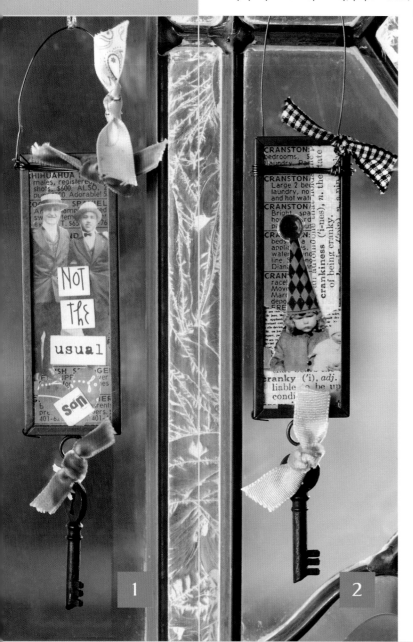

Instructions:

Use the paper cutter to trim transparency into 1" x 3" rectangles. Trim away background from photograph subjects and stick subjects to transparency using double-stick tape. Adhere vintage papers and stickers as desired and sandwich art pieces between rectangles of glass. Making sure attached jump ring is positioned at the bottom, insert glass into frames, referring to manufacturer's instructions. Set self-adhesive rhinestone as shown. Use jump ring to attach vintage keys to frame and embellish with ribbon.

To create a hanger for the glass, cut a 3-foot length of copper wire and make a small loop in one end. Twist the wire about ten times to ensure the loop will not come out. Hold the loop at the back of the glass and thread the remaining end of the wire through it. Pull the wire taut and wrap around the art piece several times. Loop about 3" of wire at the top for the hanger. Make sure to reserve enough wire to secure the tail. Wrap the tail end of the wire around the entire bundle of wire to create a nice, clean coil. Trim excess with scissors and tuck the end behind the bundle of wire. Embellish wire with ribbon.

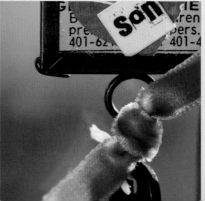

Hope

Materials:

1" x 3" clear precut glass (2), 1" x 3" copper frame, 26-gauge copper wire, double-stick tape, key sticker, miniature Christmas list, paper cutter, patterned paper, ribbons, rub-on letters, scissors, self-adhesive rhinestone, small bottle with cork, small screw eye, three-dimensional gloss medium, vintage picture of Santa and girl

Instructions:

Use paper cutter to trim patterned paper to 1" x 3". Trim away background from Santa and girl and stick subjects to patterned paper using double-stick tape. Spell out the word "Hope" with rub-on letters and place key sticker as desired. Sandwich art piece between rectangles of glass and insert into frame, referring to manufacturer's instructions. Set self-adhesive rhinestone as shown.

Insert miniature Christmas list into bottle and adhere cork into place with three-dimensional gloss medium. Insert screw eye into cork and attach bottle to frame with wire. Embellish as desired with a variety of ribbons.

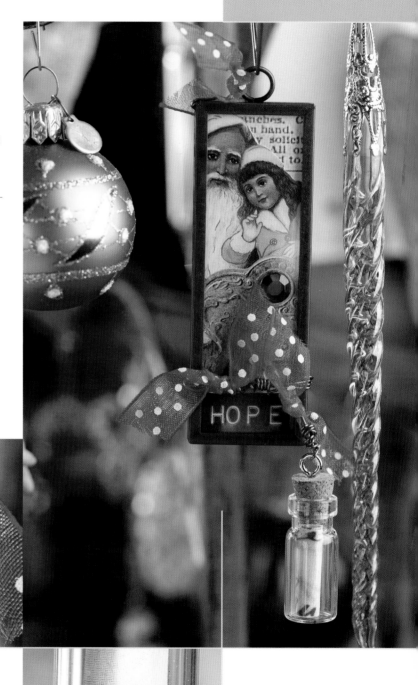

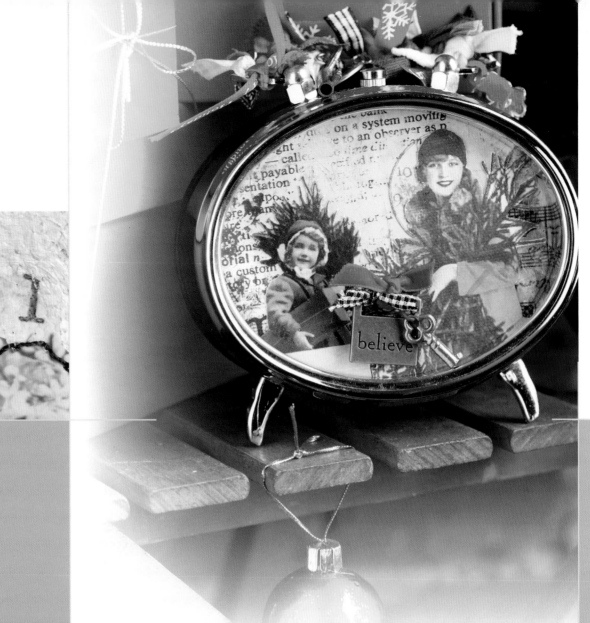
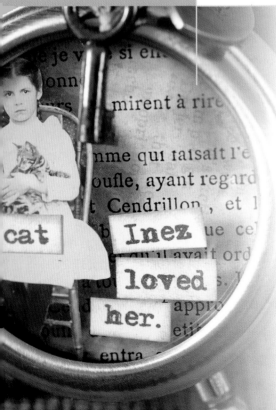
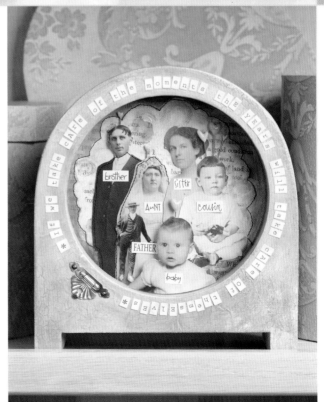

5

clock shrines

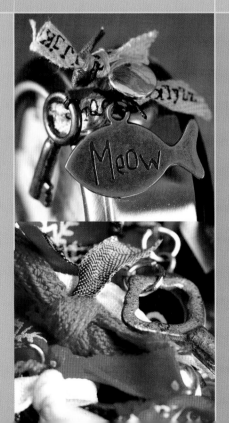

Do you have some favorite small trophies or pieces of jewelry, perhaps a broken doll or some rusty old keys, hiding in your jewelry box that you would like to encase and show off? Or an old holiday postcard or favorite vintage advertisement that you would like to dig out of a box? If so, this chapter is the perfect place to follow along in order to put these trinkets on display for the world to see.

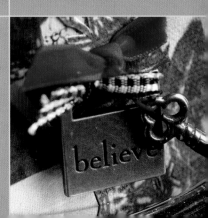

Believe

Materials:

acrylic paint (pale blue, white), cardstock or chipboard, clock, computer, craft knife or circle cutter and circle blade, decoupage medium, eyeglass screwdriver, glass mat, glue stick, needle (large), paintbrushes, paper plate, patterned tissue paper, photo markers, printer, printer-compatible canvas, rub-on words, ruler, sharp scissors, silver and pewter charms, spray preservative, transparency, various types and styles of ribbon, vintage image, vintage miniature keys, waxed thread

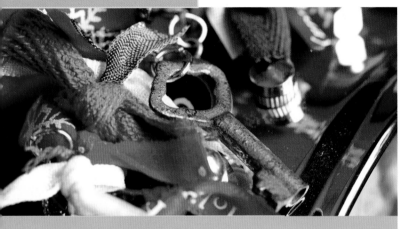

SECTION—CLOCK SERIES

Although these clocks no longer tell time, they work perfectly as mini-shadowboxes—a unique "box" in which to house my creations! I love taking clocks apart and replacing the insides with pretty pictures and embellishments. They are easy to move around, keep any memorabilia safe and dust-free, and make a decorative addition to any mantel or end table. These creative pieces are also great for giving as a small token of affection. All you'll need to take the clock apart is a small eyeglass screwdriver.

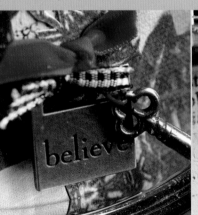

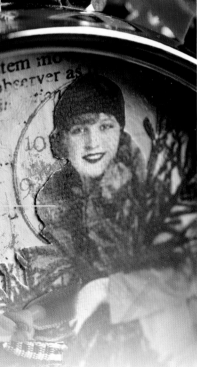

The overall size of this clock is approximately 5" wide by 6" tall.

Instructions:

Disassemble clock by removing any screws that hold the battery housing, legs, handles, or insides of the clock together. *Note: To avoid losing any of these small pieces, I recommend keeping a paper plate nearby on which to place all the screws, washers, or other bits for safekeeping.*

Remove the clock face and using it as a guide, cut the transparency and patterned paper to size, using a sharp craft knife and glass mat. Be careful not to cut yourself. If the clock face is round, a circle cutter can be used.

Print vintage image in black-and-white on printer-compatible canvas, following manufacturer's instructions. Spray canvas with preservative and allow to dry. Cut a piece of cardstock to fit inside the clock. Using decoupage medium, adhere a layer of patterned tissue paper to cardstock and allow to dry. Lightly brush white paint over desired portion of layered cardstock and tissue paper and allow to dry. Repeat with light blue paint and allow to dry. Apply desired word rub-ons to painted cardstock and tissue paper, as shown in photograph or as desired. Adhere patterned paper as desired.

Using light-colored photo markers, hand-color the photograph. Using sharp scissors, trim away photograph's background. Adhere photograph to cardstock and patterned paper background. Pierce two holes through canvas with large needle and secure desired charm into place using waxed thread. Attach miniature key to charm using waxed thread. Embellish project with ribbons. Reassemble clock in the order it was taken apart (sans unnecessary parts), tying ribbons and charms to the handle as desired.

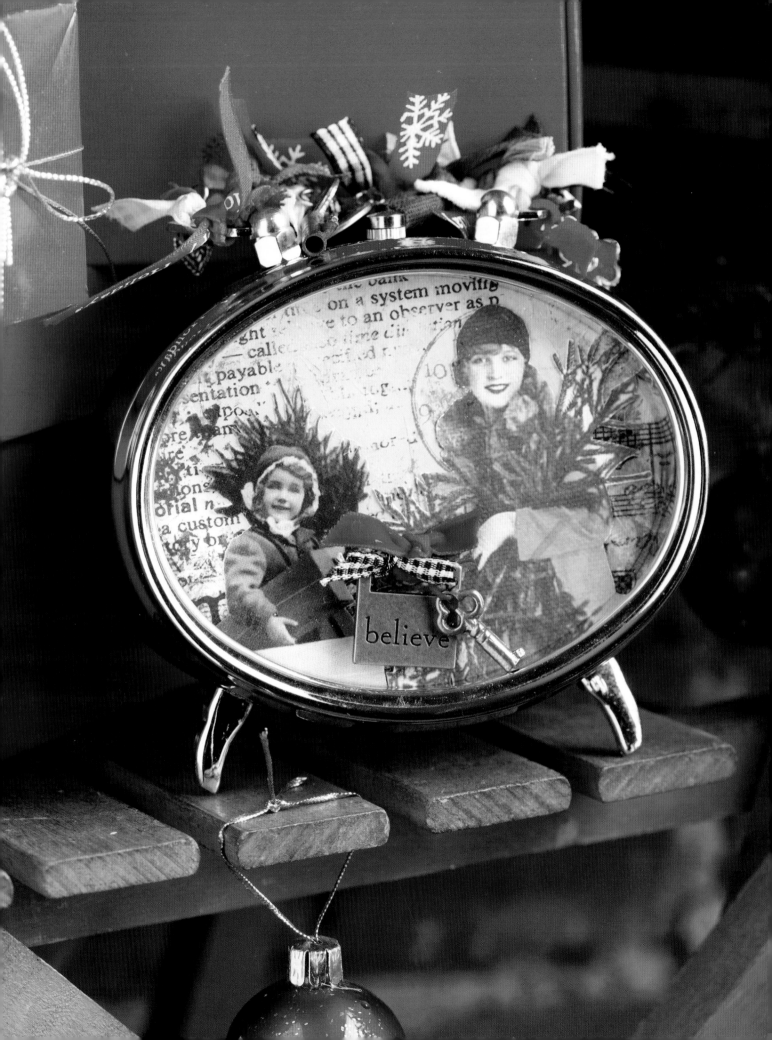

Inez Loved Her

Materials:

all-purpose craft glue (optional), circle cutter and circle blade or craft knife, cocoa-colored ink, computer and printer, double-stick tape, eyeglass screwdriver, foam dots, glass mat, paper plate, patterned paper, pewter charms, photo markers (optional), photograph, ribbon, ruler, scissors, small brushed nickel Big Ben-style clock, sticker machine, transparency photocopied from old book

This clock is approximately 3" in diameter.

Instructions:

Disassemble clock by following the first paragraph of instructions for Believe on page 56.

Choose a small photograph that will fit inside the clock, then carefully cut around the edge of the subject. Create a title for your piece in any word processing program and print. Trim around the edges of the title. Following the sticker machine manufacturer's instructions, create one or more stickers out of the printed title. Ink the edges of the stickers and stick to transparency. Remove the clock face and measure the circumference of the circle. Cut this size circle from transparency and patterned paper using a circle cutter and glass mat. If you do not have these items, use the plastic clock face as a guide to cut the circle using a sharp craft knife, being careful not to cut yourself.

Using double-stick tape, attach photograph to the transparency, then hand-color using markers, if desired. Place a double layer of foam dots on the back side of the transparency, hiding them underneath the photograph. *Note: This will elevate the photograph, giving the piece a more three-dimensional quality.* Make sure the foam dots do not show. Replace the clock face with the circle of patterned paper, using all-purpose craft glue or double-stick tape to ensure permanent attachment. Glue the transparency to the patterned paper. Reassemble clock in the order it was taken apart (sans unnecessary parts) and embellish with ribbons and charms as desired.

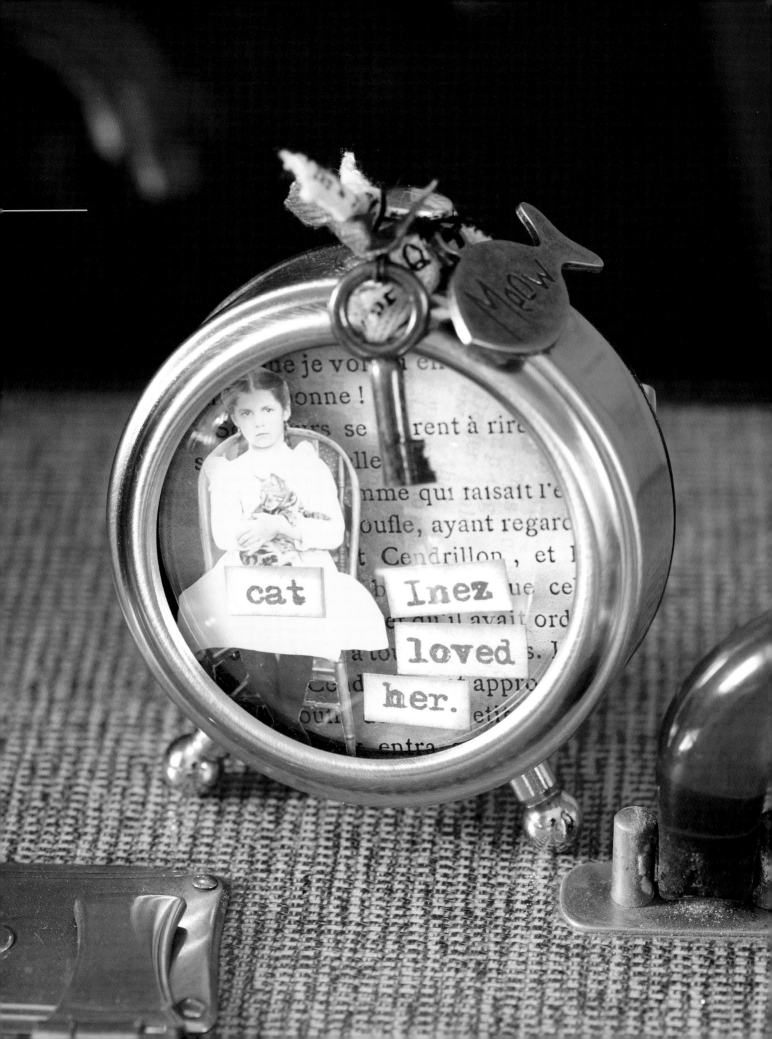

Wooden Moments Mantel Clock

Materials:

acrylic paint (metallic gold, pale blue, white), black thread, brown ink pad, computer and printer, crackle process medium, craft glue, decorative brass finding, decorative pins, eyeglass screwdriver, family word stickers, foam dots, letter stickers, matte acrylic varnish, paintbrushes, paper plate, paper towel or paint cloth, pencil, printable canvas, ruler, sanding block, scanner, scissors, sewing machine, vintage book page, vintage photographs (6), watercolor pencils, wooden clock

This clock is approximately 7 1/2" x 8 1/2".

Instructions:

Disassemble clock by following the first paragraph of instructions for Believe on page 56. Sand clock as necessary, then paint white. Apply as many coats of paint as is required for the particular clock you have purchased. Allow to dry.

Following manufacturer's instructions, apply Step 1 of the crackle process medium and allow to dry. Apply Step 2 and allow to dry. If you do not get the desired results, reapply Steps 1 and 2 until cracks are adequate. Making sure the crackle medium is thoroughly dry, seal with a thick coat of matte acrylic varnish and allow to dry. Wipe on metallic gold paint, then wipe off excess with a paper towel or paint cloth so that the metallic paint settles in the cracks of the crackle finish. Brush on white and blue acrylic paint in random spots as desired and allow to dry. Seal with matte varnish, then antique with the brown ink pad. Set aside.

Scan the vintage book page and print on printable canvas, following manufacturer's instructions. Measure the circumference inside the clock, or remove appropriate clock component to use as a template. *Note: My clock had a plastic frame that I was able to trace for the base of my collage.* Trace appropriately sized circle onto the canvas with a pencil, then cut out. Using acrylic paint and watercolor pencils, embellish background with swirls, circles, and a scalloped edge. For added interest, machine stitch the scalloped edge using black thread.

Trim away background from all six photograph subjects and adhere foam dots to backs. Adhere photographs to canvas in desired arrangement. Insert decorative pins at the back of their heads as shown in photograph, and identify each person in the collage with the appropriate family sticker. Insert canvas into clock, then reassemble, discarding any unnecessary clock parts.

Add quote around clock perimeter with letter stickers. If space allows, adhere the brass finding for additional decoration.

About the Author

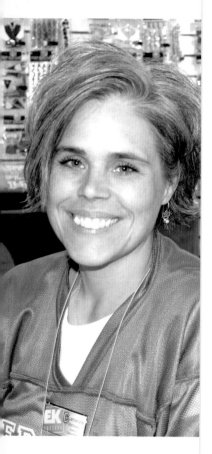

Catherine Matthews-Scanlon was raised in rural Maine, where she has lived for the majority of her life. After traveling the country with her husband while he served in the United States Navy, Catherine returned to settle in Maine, where she currently lives with her husband, son, and rat terrier.

Catherine is also the author of *Scrapbook Techniques: Sewing on Paper*. She holds a degree in Printing Technology and Graphic Design and currently teaches scrapbooking and altered art classes in New England. She is also a Creative Artist Team Member for EK Success as well as a Design Team Member for an online scrapbook store.

More of Catherine's work can be seen in *Somerset Gallery*, *Legacy Magazine*, *Sew Somerset*, and *Creative TECHniques Magazine*.

For questions regarding the projects and techniques found in this book, teaching inquiries, contract work, and design opportunities, Catherine can be contacted at luvlife@gwi.net

Acknowledgments

I would like to give a big thanks to my aunt, Joan Matthews, who so generously provided vintage pictures, clippings, and textiles for me to use in this book.

To my husband and son, who so often went off and found things to do so that I could spend hours and hours creating these works.

To my parents for so generously housing us while our own home was being built AND I spent my days and nights focused on writing and creating.

And to Ana Maria Ventura, for her encouragement, AWESOME editing, and dedication to making this book a wonderful success!

Butterfly Template

This template is used on pages 28 and 34.

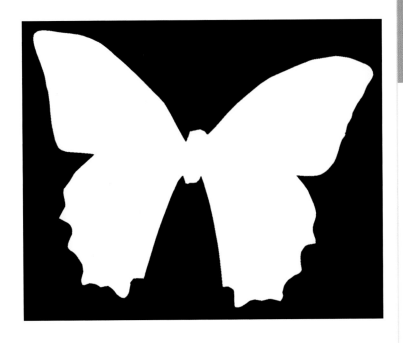

Metric Equivalency Charts

inches to millimeters and centimeters							
inches	mm	cm	inches	cm	inches	cm	
1/8	3	0.3	9	22.9	30	76.2	
1/4	6	0.6	10	25.4	31	78.7	
3/8	9	1.0	11	27.9	32	81.3	
1/2	13	1.3	12	30.5	33	83.8	
5/8	16	1.6	13	33.0	34	86.4	
3/4	19	1.9	14	35.6	35	88.9	
7/8	22	2.2	15	38.1	36	91.4	
1	25	2.5	16	40.6	37	94.0	
1 1/4	32	3.2	17	43.2	38	96.5	
1 1/2	38	3.8	18	45.7	39	99.1	
1 3/4	44	4.4	19	48.3	40	101.6	
2	51	5.1	20	50.8	41	104.1	
2 1/2	64	6.4	21	53.3	42	106.7	
3	76	7.6	22	55.9	43	109.2	
3 1/2	89	8.9	23	58.4	44	111.8	
4	102	10.2	24	61.0	45	114.3	
4 1/2	114	11.4	25	63.5	46	116.8	
5	127	12.7	26	66.0	47	119.4	
6	152	15.2	27	68.6	48	121.9	
7	178	17.8	28	71.1	49	124.5	
8	203	20.3	29	73.7	50	127.0	

yards to meters											
yards	meters	yards	meters	yards	meters	yards	meters	yards	meters		
1/8	0.11	2 1/8	1.94	4 1/8	3.77	6 1/8	5.60	8 1/8	7.43		
1/4	0.23	2 1/4	2.06	4 1/4	3.89	6 1/4	5.72	8 1/4	7.54		
3/8	0.34	2 3/8	2.17	4 3/8	4.00	6 3/8	5.83	8 3/8	7.66		
1/2	0.46	2 1/2	2.29	4 1/2	4.11	6 1/2	5.94	8 1/2	7.77		
5/8	0.57	2 5/8	2.40	4 5/8	4.23	6 5/8	6.06	8 5/8	7.89		
3/4	0.69	2 3/4	2.51	4 3/4	4.34	6 3/4	6.17	8 3/4	8.00		
7/8	0.80	2 7/8	2.63	4 7/8	4.46	6 7/8	6.29	8 7/8	8.12		
1	0.91	3	2.74	5	4.57	7	6.40	9	8.23		
1 1/8	1.03	3 1/8	2.86	5 1/8	4.69	7 1/8	6.52	9 1/8	8.34		
1 1/4	1.14	3 1/4	2.97	5 1/4	4.80	7 1/4	6.63	9 1/4	8.46		
1 3/8	1.26	3 3/8	3.09	5 3/8	4.91	7 3/8	6.74	9 3/8	8.57		
1 1/2	1.37	3 1/2	3.20	5 1/2	5.03	7 1/2	6.86	9 1/2	8.69		
1 5/8	1.49	3 5/8	3.31	5 5/8	5.14	7 5/8	6.97	9 5/8	8.80		
1 3/4	1.60	3 3/4	3.43	5 3/4	5.26	7 3/4	7.09	9 3/4	8.92		
1 7/8	1.71	3 7/8	3.54	5 7/8	5.37	7 7/8	7.20	9 7/8	9.03		
2	1.83	4	3.66	6	5.49	8	7.32	10	9.14		

Index

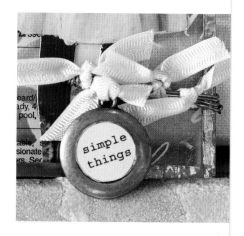